W9-CZP-140

Rita Hayworth

A PHOTOGRAPHIC RETROSPECTIVE

Rita Hay

A PHOTOGRAPHIC RETROSPECTIVE

Caren Roberts-Frenzel

HARRY N. ABRAMS, INC., PUBLISHERS

This book is dedicated to Paul Frenzel

Project Manager: Elisa Urbanelli

Editor: Nicole Columbus

Designer: Maria L. Miller

Library of Congress Cataloging-in-Publication Data

Roberts-Frenzel, Caren.
 Rita Hayworth : a photographic retrospective /
 Caren Roberts-Frenzel.
 p. cm.
Includes index.
ISBN 0–8109–1434–4
 1. Hayworth, Rita, 1918–1987—Portraits. I. Title.

PN2287 .H38 .R63 2001
791.43'028'092—dc21
[B] 2001022878

Copyright © 2001 Caren Roberts-Frenzel

Published in 2001 by Harry N. Abrams, Incorporated, New York
All rights reserved. No part of this book may be reproduced
without the written permission of the publisher.
Printed and bound in Japan
10 9 8 7 6 5 4 3 2 1

 Harry N. Abrams, Inc.
100 Fifth Avenue
New York, N. Y. 10011
www.abramsbooks.com

Introduction

She was known as the "Love Goddess"—a mythic title that no mortal woman could possibly live up to. But Rita Hayworth truly was a goddess of love and beauty to the American public, who flocked to her films and avidly followed the ups and downs of her personal life for over four decades.

Rita Hayworth would say of this adulation, in characteristic modest fashion, "A girl is . . . well, a girl. It's nice to be told you're successful at it." In reality, Rita abhorred the lack of privacy and life as "public property" that accompanied the career of a famous actress. A shy, unassuming person in real life, she would have preferred a solid marriage, a stable home life for her children, and a serene day-to-day existence that consisted of painting or playing golf. Although Rita enjoyed acting and dancing, and in later years complained of not getting decent roles, the bitter rivalries and fickleness of Hollywood bothered her.

Yet whatever her misgivings about show business, the world benefited from her decision to make films. Rita Hayworth was arguably the most beautiful motion-picture actress in movie history. She was also a gifted dancer, comedienne, and dramatic actor.

Unfortunately, the climb to success took a toll. As she herself once candidly admitted, "I haven't had everything from life. I've had too much." Although her five marriages ended in divorce, in later years, Rita would declare that she never regretted any of her marriages. "What surprises me in life are not the marriages that fail, but the marriages that succeed," she would say. The joys of her life were the two lovely daughters that resulted from her marriages to Orson Welles and Prince Aly Khan. "The greatest thing that ever happened to me was having them," she said.

Because she was one of the most photographed women on earth, many of Rita Hayworth's triumphs and tragedies were recorded on newsreel film and in still pictures. There was no room for privacy in her world. To view the public and private woman through photographs is to see Rita Hayworth as she's never been seen before. She is no longer just the "Love Goddess" but a flesh-and-blood woman with whom we can identify.

Rita Hayworth died of Alzheimer's disease on May 14, 1987. News of her illness and death brought an international awareness of the disease that resulted in a massive increase of funds for care and research. In the same way that she was proud of the fact that her wartime pinup helped lift the spirits of thousands of servicemen, Rita would have been proud that her celebrity was responsible for helping thousands of others who suffered from Alzheimer's disease. Perhaps this is her greatest legacy of all.

A
Photographic
Retrospective

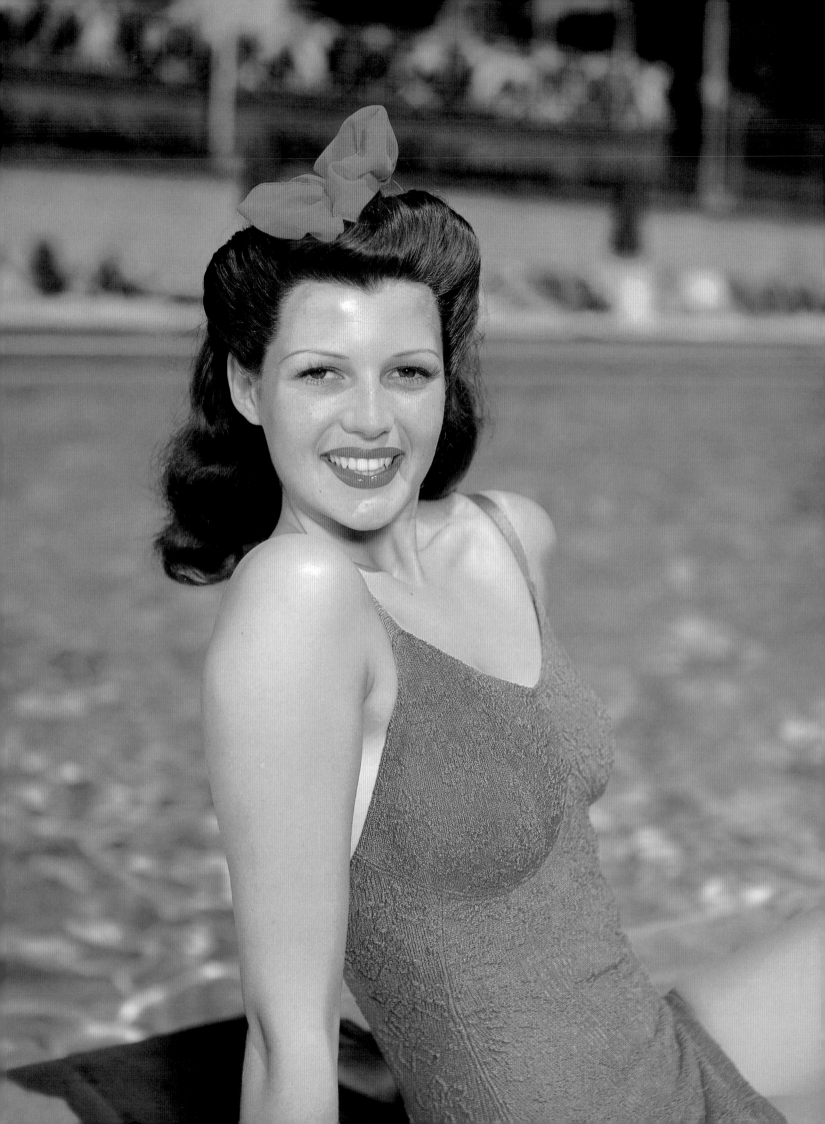

Rita

in

Technicolor

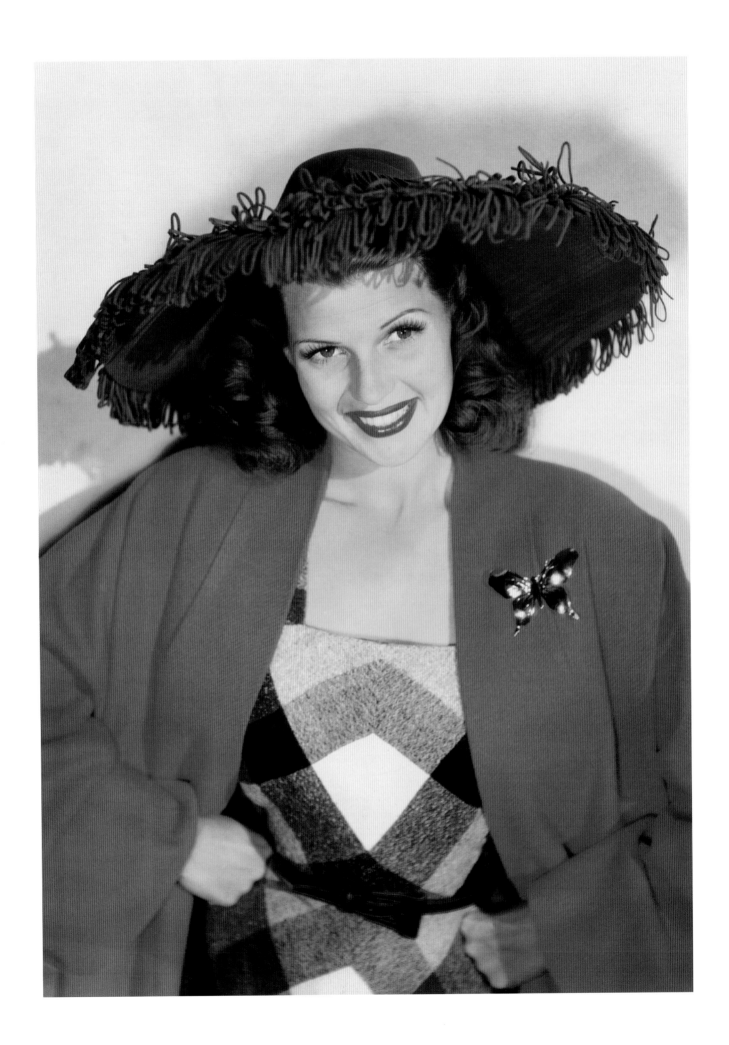

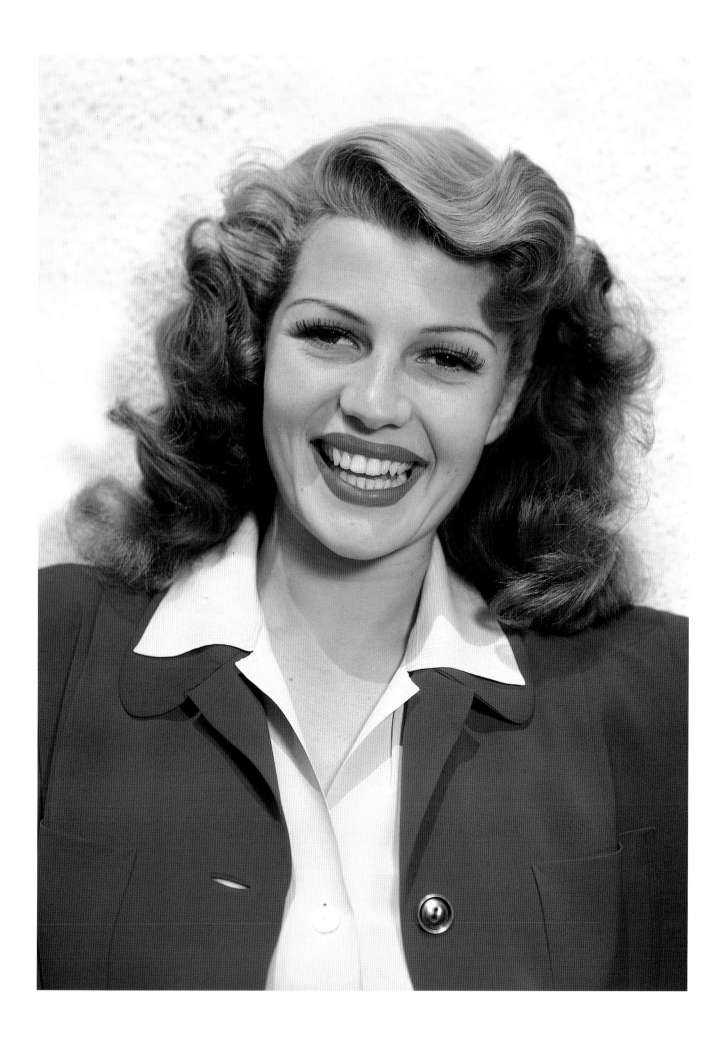

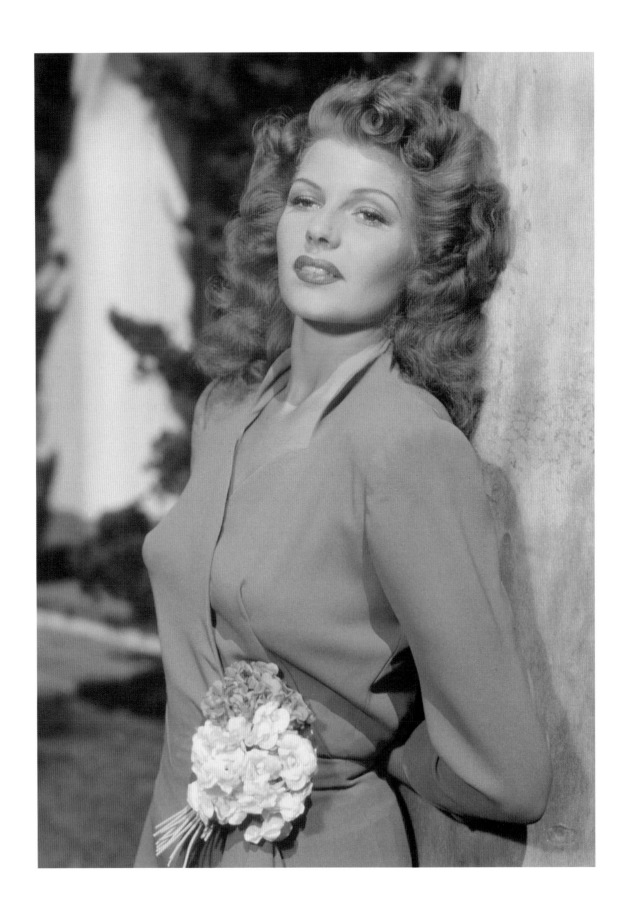

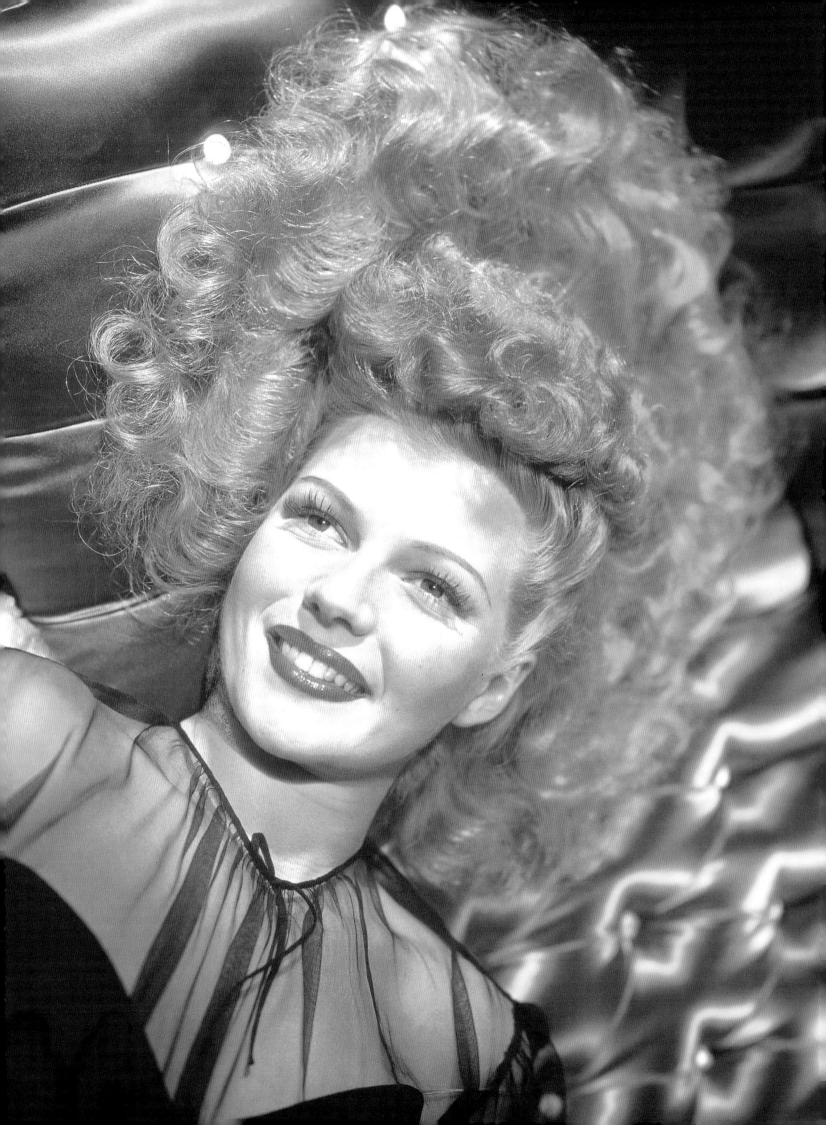

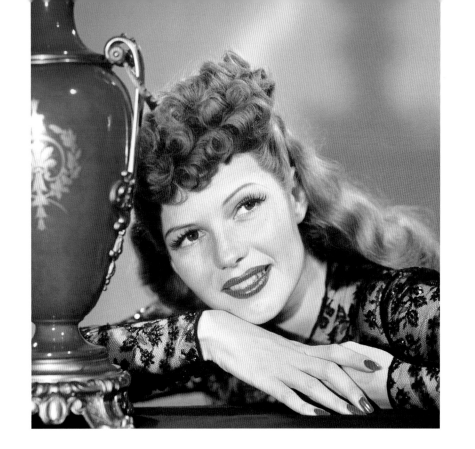

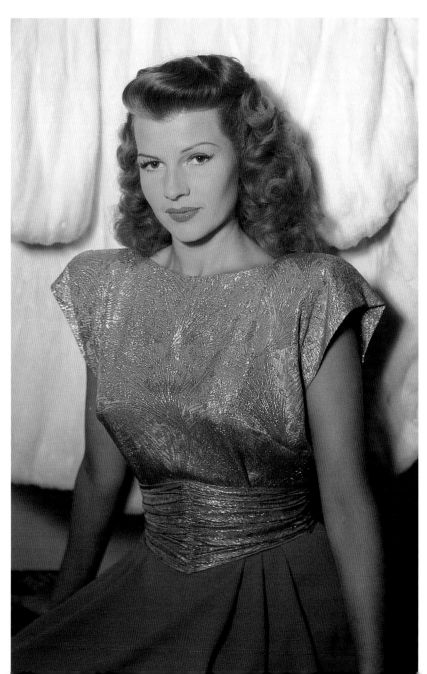

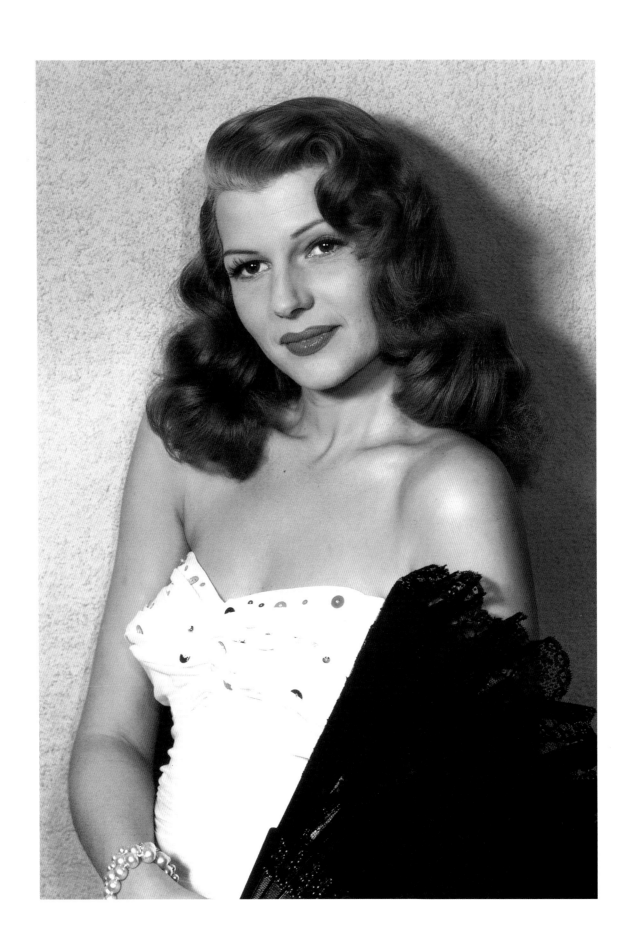

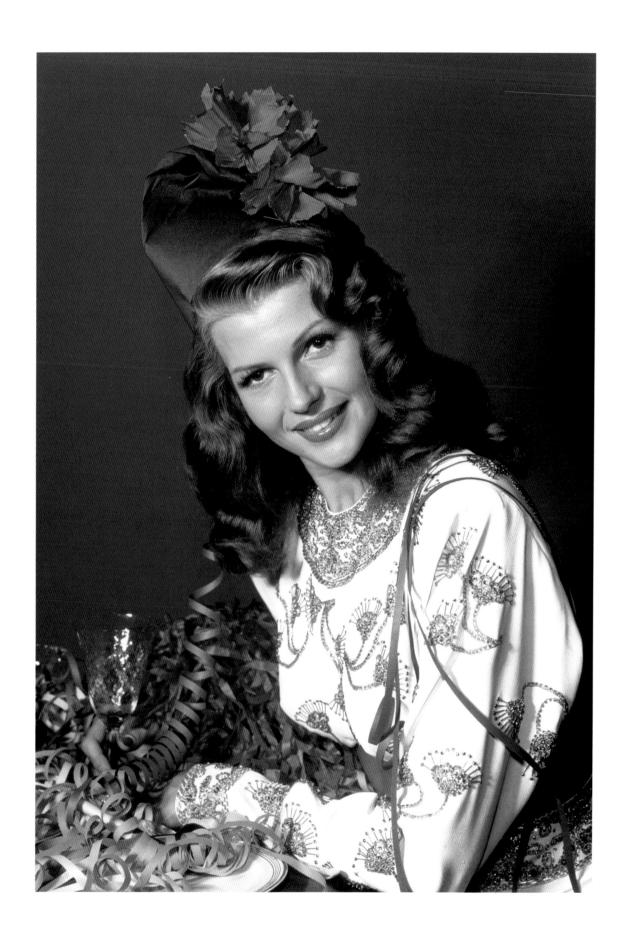

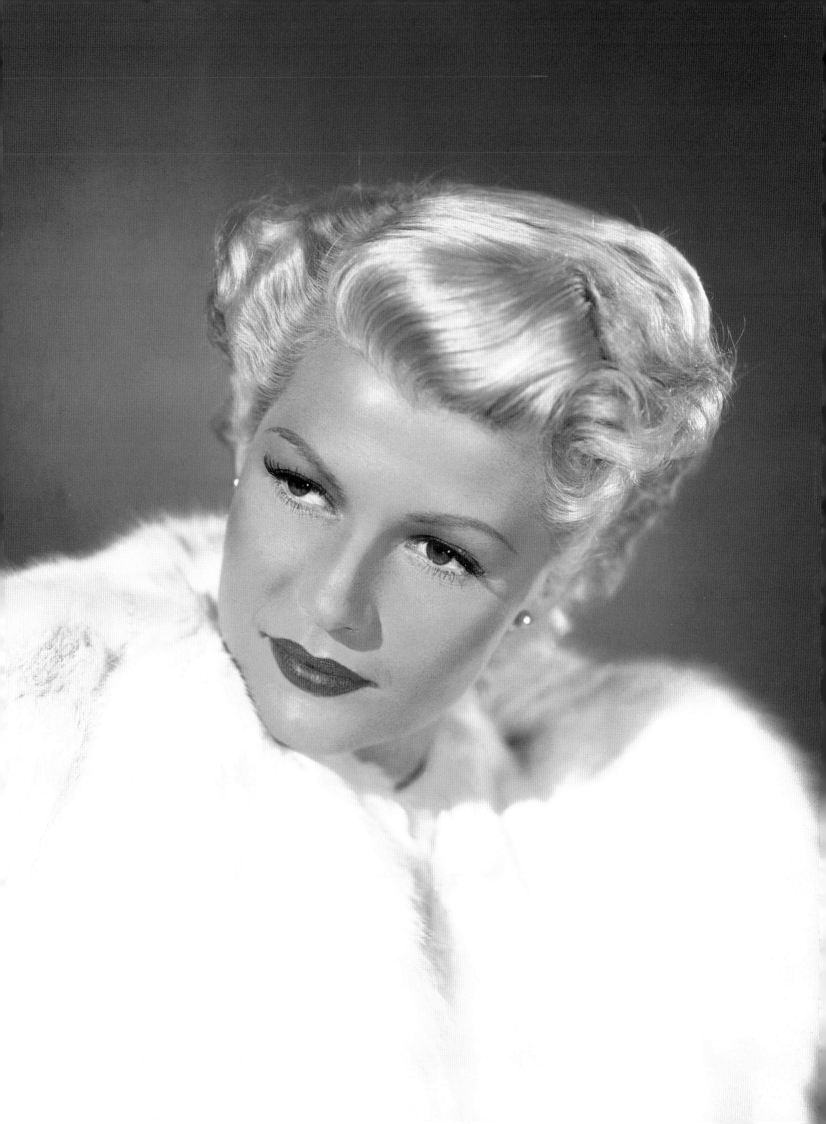

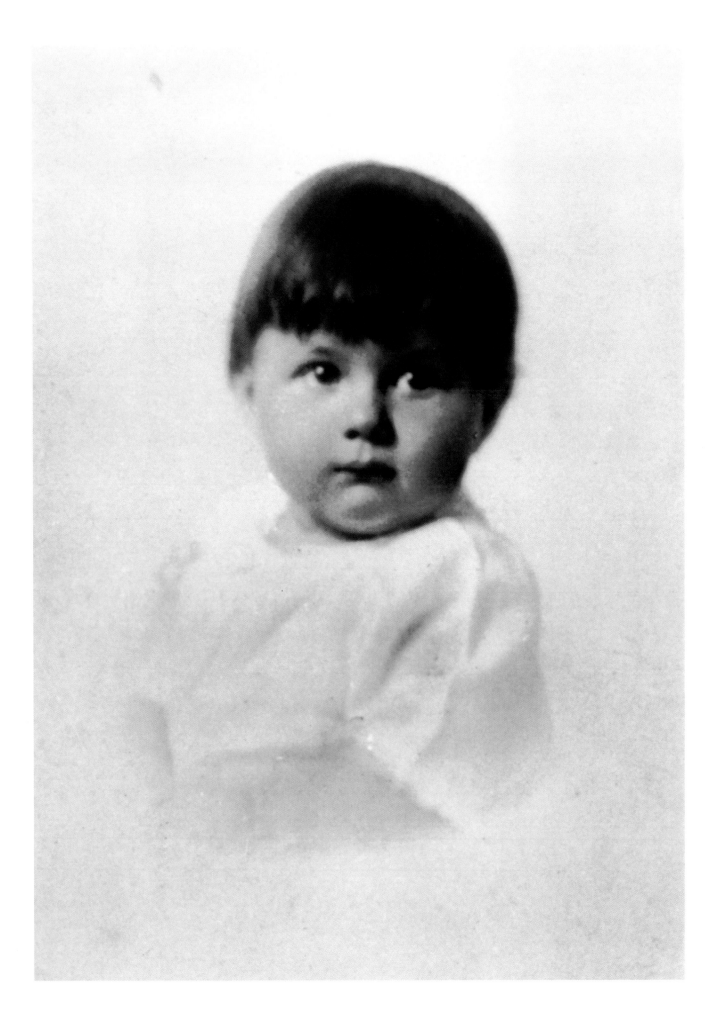

From

Cradle

to

Castanets

‹ When Margarita Carmen
Cansino was born on October 17,
1918, in New York City, her father
Eduardo lamented that the baby
wasn't a boy. "What could I do with
a girl?" the Spanish dancer later
stated when discussing the birth of
his famous daughter. Fortunately
for him, Margarita had inherited his
dancing ability and the beauty of
her mother, former Ziegfeld Follies
chorus girl Volga Hayworth. In
this photograph, nine-month-old
Margarita Carmen Cansino is
already photogenic.

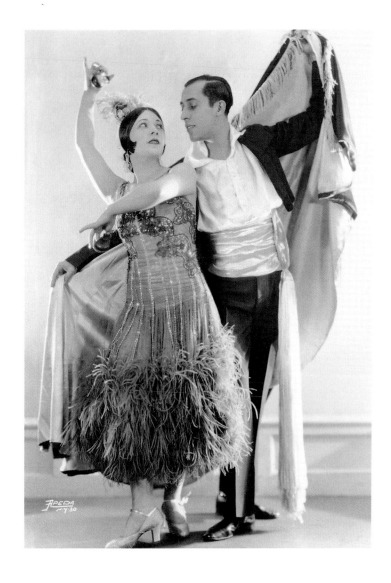

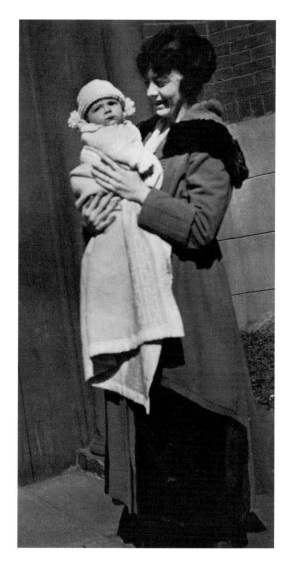

❮ Rita's father, Eduardo, made his living as a dancer, as had his father and siblings. "The Dancing Cansinos" was a traveling dance troupe made up of whatever family members were available at the moment. Eduardo and his sister Elisa (shown here in the early 1920s) became an extremely popular act on the road show and vaudeville circuits. One fan was fellow vaudevillian Fred Astaire.

➤ Volga Hayworth Cansino holds baby Margarita, 1919. Practically every article and biography written about Rita Hayworth has stated that her mother's maiden name was spelled "Haworth" and that when Rita chose her professional name she added the "y." In fact, this change seems to have been made much earlier, by Volga's father, before Volga was even born. Volga's birth certificate indicates that she was born "Volga Hayworth."

➤ The Cansino children in 1924. From left: Vernon, Eduardo, Jr., and Margarita. As early as four years of age, Margarita was experiencing a less than ordinary childhood. "Instead of a rattle, I had castanets," Rita later recalled of her youth in Brooklyn and Jackson Heights, New York, and later in Chula Vista, California. Generations of Cansino men had been talented dancers, but neither of Margarita's brothers was encouraged to dance. More pressure was placed on Margarita, while Eduardo, Jr., and Vernon were free to enjoy the normal pleasures of childhood. Even they could see, however, that their older sister was different—underneath a quiet exterior was an expressive, emotional young girl who was becoming very proud of her accomplishments as a dancer.

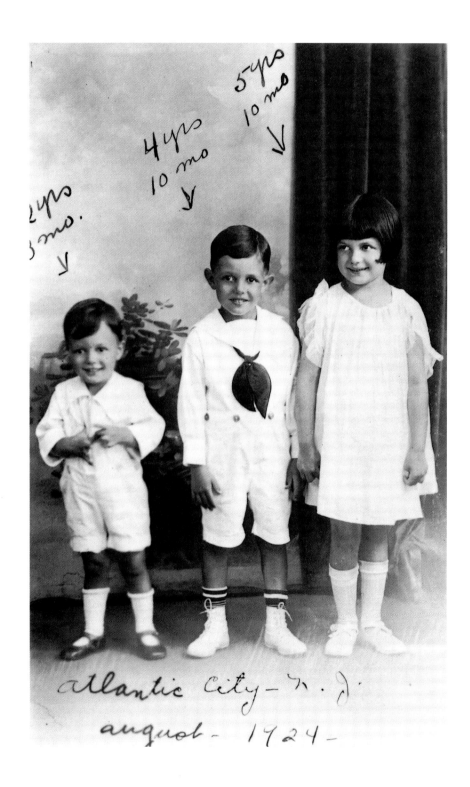

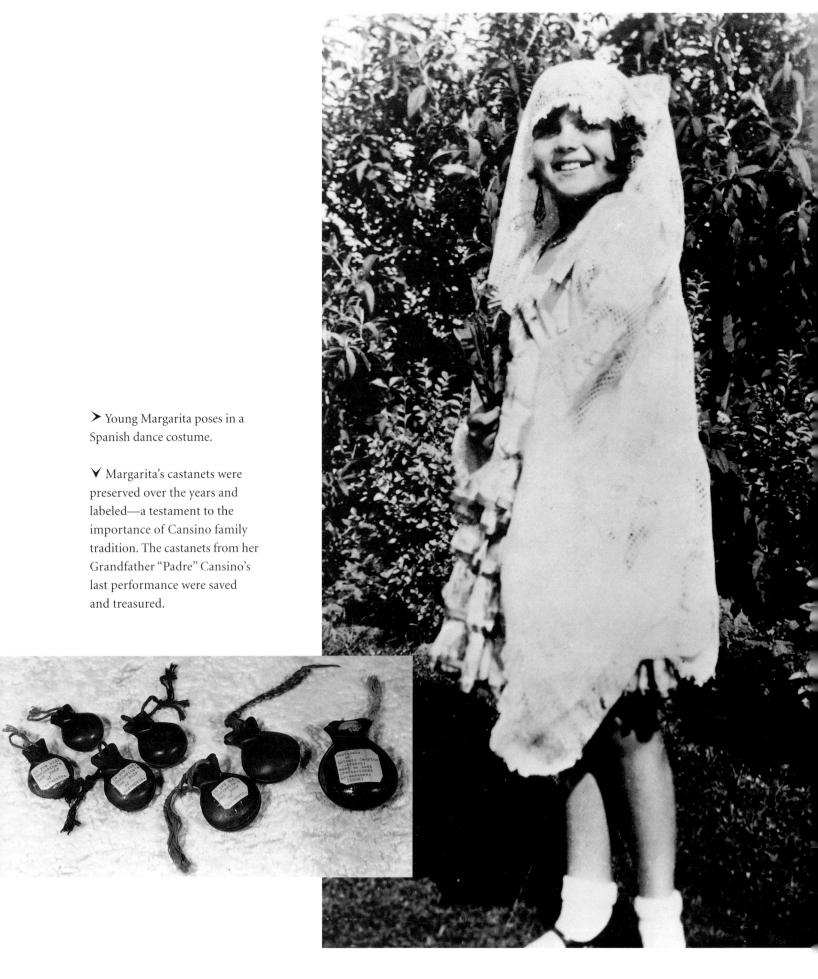

➤ Young Margarita poses in a Spanish dance costume.

▼ Margarita's castanets were preserved over the years and labeled—a testament to the importance of Cansino family tradition. The castanets from her Grandfather "Padre" Cansino's last performance were saved and treasured.

> Rita at six years of age. Although she did attend public school, it was not the focus of her life. "Rehearse, rehearse, rehearse. That was my girlhood," Rita said. She appeared briefly on the stage with "The Dancing Cansinos" while in New York, but only in very short appearances designed to show off her cuteness. She made her film debut in a 1926 Vitagraph short subject in which her father and Aunt Elisa appeared. No sparks flew and no talent scouts started knocking down the door afterward; on the contrary, Margarita had many years of hard work ahead of her before another film opportunity would come her way.

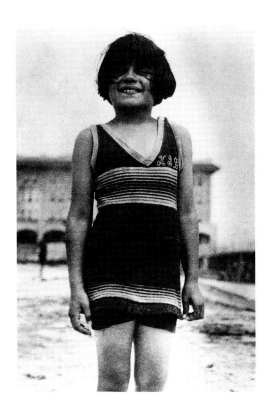

∨ The Cansino family in 1926, shortly before they moved to California. From left: Vernon, Eduardo, Jr., Margarita, Eduardo, and Volga. Eduardo Cansino was convinced that Margarita would be able to carry on the family tradition successfully, and when he opened a dance school in California, he enrolled her in every class. After school she would run home to spend the rest of the evening practicing her dance routines. She was becoming an exceptional dancer, which encouraged Eduardo to push her more. Margarita's innate shyness prevented her from rebelling against this strict regime. To supplement the income from his dancing school, Eduardo obtained work in the movie industry as a choreographer. His days as a vaudeville hoofer were now behind him, and he realized that the still novel but expanding world of sound films was the place to make money. Margarita was now a plump eight-year-old who dreamed of becoming a beautiful dancer.

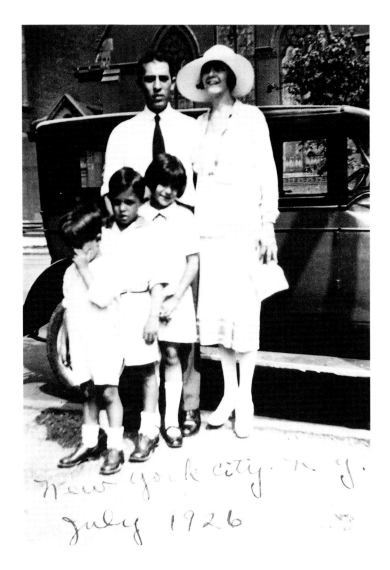

New York City, N.Y.
July 1926

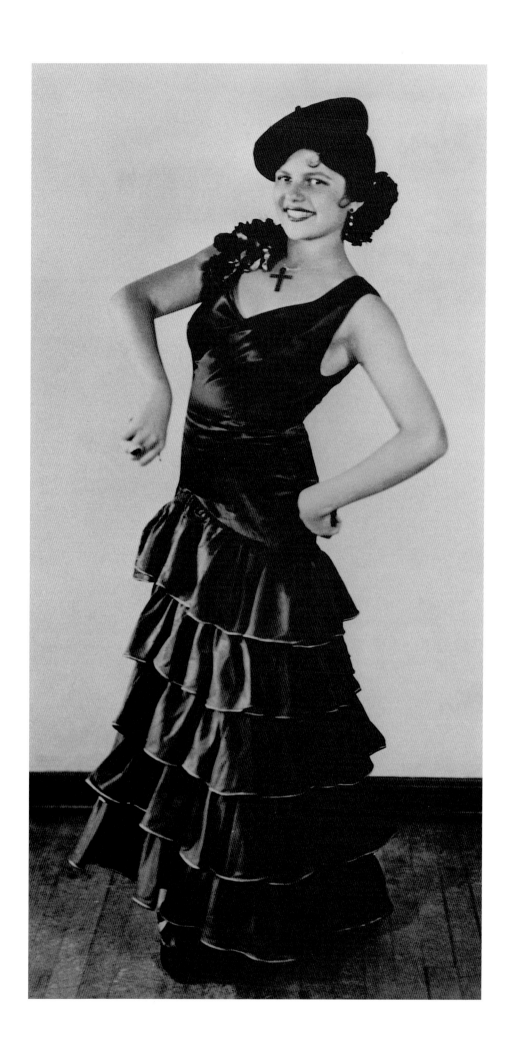

➤ Margarita, age 13, poses in one of her first professional dancing outfits, sewn by her mother. Unfortunately for the Cansinos, the stock market crash resulted in loss of film work for Eduardo, and a diminished number of students enrolled in his dance school. He was forced to find other ways of making money.

▼ Eduardo began to choreograph
what were then known as "pro-
logues," stage shows that took place
before first-run films. It was at the
prologue for the 1931 film *Back
Street*, at the Carthay Circle Theater
in Los Angeles, that 13-year-old
Margarita made her first professional
stage appearance, dancing with her
cousin Gabriel Cansino (far left).
The crowd applauded wildly. As
Eduardo would later exclaim,
"Hey, she don't look like no baby
anymore! That's when I decided
that it was time to start her off, and
that the way to do it would be for us
to do a routine together." And so
began Margarita's ascent to stardom.

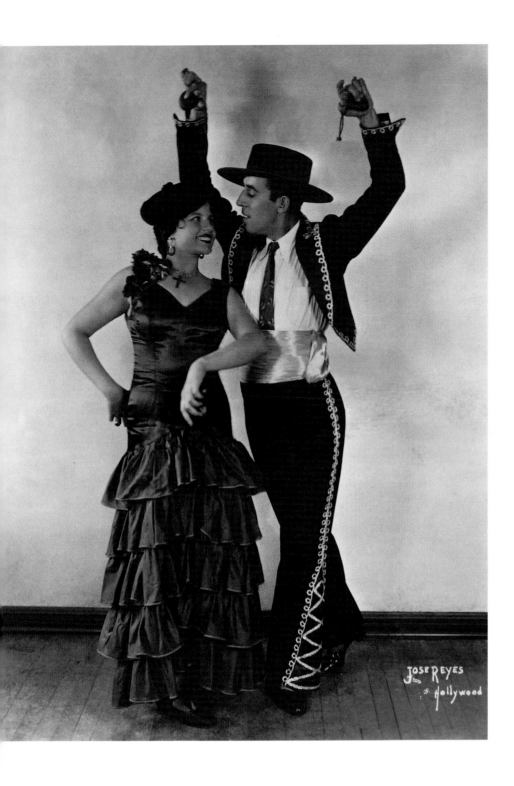

JOSE REYES
Hollywood

❮ Margarita looked much older than her teenage years. Her natural grace and style, combined with her provocative costumes, made the father-daughter dance team look more like a husband-wife duo. Their ability to obtain engagements was limited by the fact that Margarita was still a minor and unable to work legally in the California nightspots that served liquor. Still billed as "The Dancing Cansinos," she and her father danced on gambling ships anchored three miles off the shore of California and at nightclubs below the Mexican border. They eventually landed solid work as headliners at the Foreign Club in Tijuana and at Agua Caliente, a resort that was popular with film industry folk. Gambling, drinking, and other assorted pleasures not appropriate for a teenage girl were the attractions at these clubs. Eduardo and Volga were very protective of their young daughter, and she often stayed in her dressing room between shows. The act performed as many as four or five shows a night.

❯ Margarita continued to dance with her father during her adolescence. Dates with young men and friendships with children her own age were virtually nonexistent for the young girl, whose exhausting schedule barely allowed enough time for homework. Margarita longed to break free from this restricted lifestyle, but she recognized her obligation to her family. "I secretly rebelled and planned to run away," she said many years later, recalling her isolation. "But I never ran. My mother knew, she understood. Any sensitive adult would." Rita had a close relationship with her mother, and on more than one occasion, Volga was seen watching young Margarita dance, her eyes brimming with tears of pride.

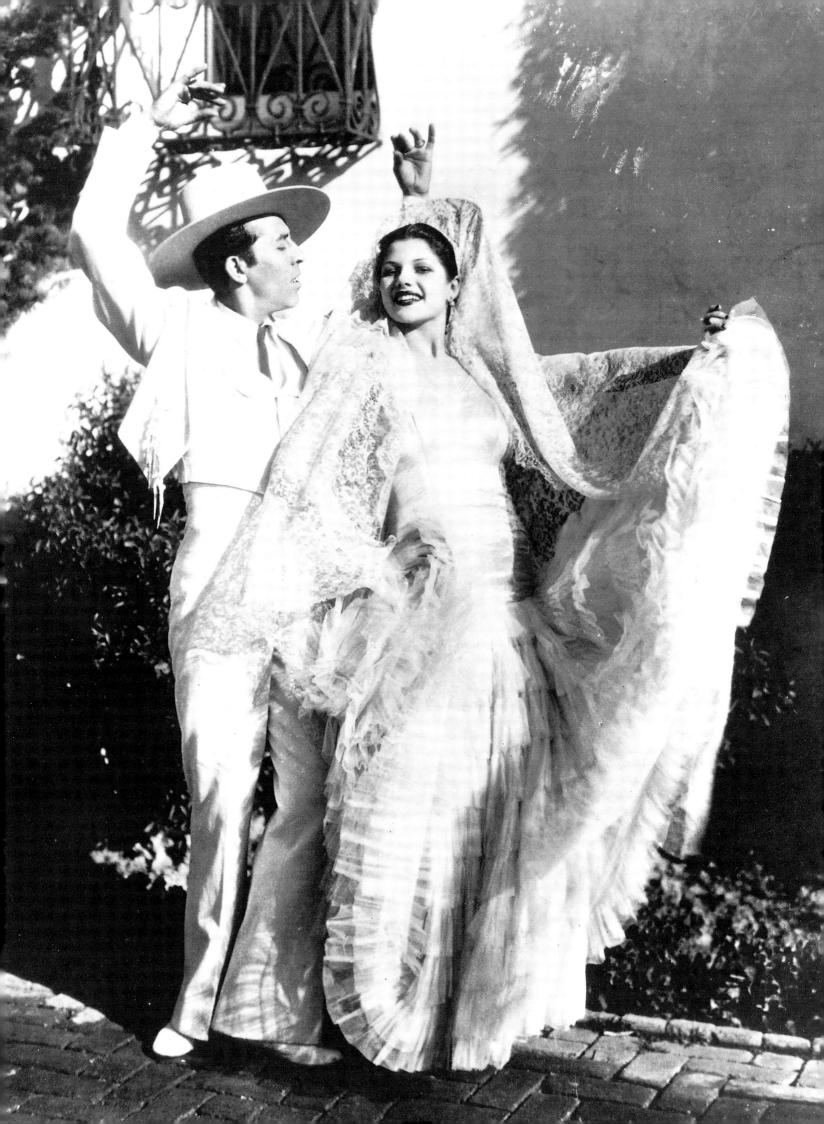

◄ It was only a matter of time before Margarita was noticed by one of the many Hollywood executives who frequented the Caliente Club at Agua Caliente. Winfield Sheehan, who was production head at Fox Film Corporation, was the man responsible for the discovery of Margarita Cansino. On the night he saw the act, his dinner companion was Hollywood gossip columnist Louella Parsons. She would later say that she could find nothing about the girl that indicated she had the makings of a movie star. "She was overweight and her hairline was quite low. Her skin was good but not luminous, and she turned out to be painfully shy." Despite Louella's protestations, Sheehan invited Margarita to Hollywood to make some screen tests. In an amazing quirk of fate, expert cameraman Rudy Maté, who would later shoot some of the most exquisite footage of Rita in some of her most successful films at Columbia Pictures, was the lensman assigned to shoot her screen tests. The results were so stunning that Sheehan signed Margarita to a short-term contract. He felt her shortcomings could be remedied with a typical studio "overhaul." Indeed, she was immediately put on a diet and given lessons on everything from diction to fencing. She posed for silly publicity photos such as this one (fake snow courtesy of the Fox publicity department). Although she had appeared as an extra in several pictures before signing her Fox contract, Margarita's film experience was minimal. Any experience she could gain—even if it was before a still camera—was of benefit to the novice actress.

◄ Margarita appears in a 1934 Fox Spanish-language production that was barely shown in the theaters. It was her first assignment under her new Fox contract and destined to become a "lost" Hayworth film.

➤ Margarita began filming her first notable film at Fox in late 1934. The film, *Dante's Inferno* (1935), was an epic drama starring Spencer Tracy and Claire Trevor. Margarita's name had been shortened to "Rita," and her role consisted of a brief dance number with Gary Leon (pictured here). Cameraman Rudy Maté was again photographing the picture, a stroke of luck for Rita. Those on the set of *Dante's Inferno* were amazed that this horribly frightened girl could transform herself into the exotic and sensual dancer who appeared before the cameras. Throughout the filming, Rita would experience such nervousness that her hands would literally shake. Spencer Tracy once called *Dante's Inferno* "one of the worst pictures made anywhere, anytime." He would also say of Rita's involvement with this film, which turned out to be a critical and financial disaster, "Anybody who survived that deserved all the recognition that they got later on."

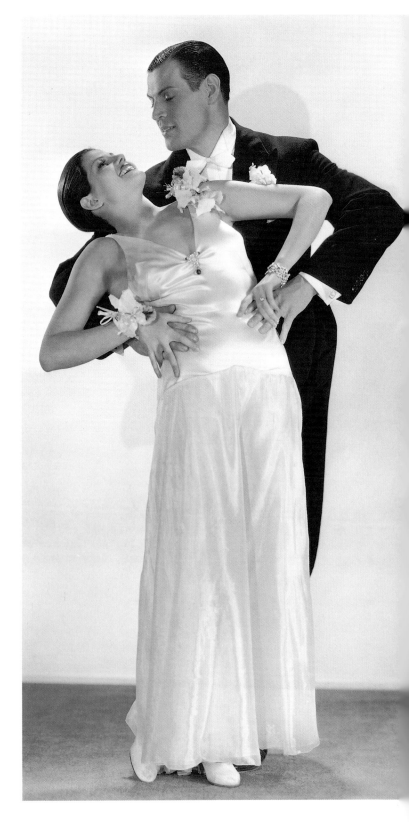

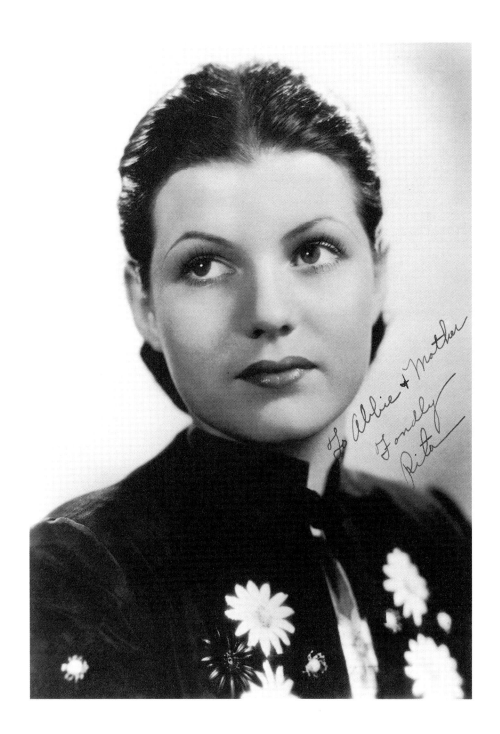

To Abbie + Mother
Fondly
Rita

Λ One wonders what would have become of Margarita's career had she not been transformed into such an all-American female; this striking photograph rivals many of her later portraits. This was the real Margarita Cansino—quite naturally, a beautiful girl.

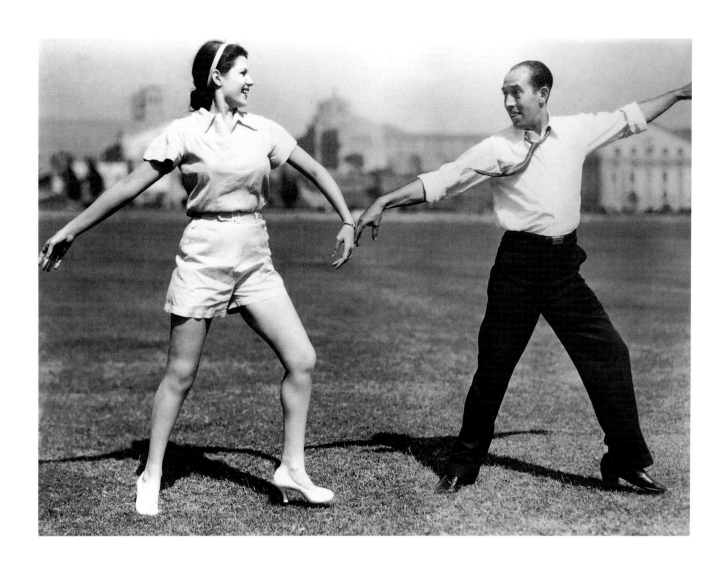

◄ Rita displays her dance steps for father/teacher Eduardo during production of *Under the Pampas Moon* (1935). Rita's first experience with dialogue occurred during the making of this film, and it was one she never forgot. As she later described it, "It was a disaster. They'd given me a nine o'clock call and I misunderstood. When I came in at nine, without makeup or costume, a dozen people were running around the set yelling, 'Where's Miss Cansino?' I was so upset I couldn't get my mouth open two hours later when I was finally made up, dressed and in front of the camera. I've never been sure, but I'll bet they dubbed the dozen lines I had!"

◄ Rita and Pat Paterson express horror at the latest murder in *Charlie Chan in Egypt* (1935), in which Rita played the part of Nayda, the servant girl.

➤ Rita's naturally dark hair was heavily pomaded and dyed "midnight black" for the complete Spanish look.

> Rita was cast in several other exotic roles at Fox, but none excited her more than the title part in the film *Ramona*. With Winfield Sheehan pulling the strings, Rita was promised her first role as leading lady. Unfortunately, the corporate merger of Fox Film Corporation and Twentieth-Century Pictures took place during this time, and Sheehan was ousted from his executive position. Rita was left without a mentor and, subsequently, without a contract or the coveted part of Ramona. The role eventually went to Loretta Young, and Rita remembered it as the most difficult moment of her young career. Decades later she was still able to recite much of the *Ramona* dialogue from memory.

< Four Fox starlets trying to make their way in Hollywood smile for Fourth of July celebration photos. Rita, second from right, poses with Frances Grant, Rosina Lawrence, and Barbara Blane.

▼ Rita Hayworth, Jacqueline Wells, and Beatrice Blynn try to dramatically outdo each other in this publicity pose for their film, *Paid to Dance* (1937). Rita was aware of the competition between starlets in Hollywood, and she worked twice as hard as any of them to overcome her insecurities and become a good actress.

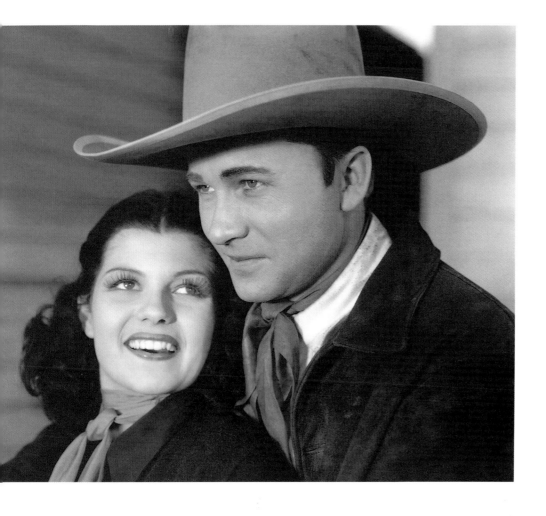

Rita with costar Tex Ritter in *Trouble in Texas* (1937). Inasmuch as she later laughed about the small parts she played during this period of her life, she recognized the training ground it provided for her as an actress. She had many roles in low-budget Westerns (her fear of horses was only one more hurdle to overcome), starring with the likes of Ritter and Tom Keene. Her early costars would often comment that moviemaking seemed agonizing to Rita—her nervousness and apprehension overwhelmed her, often to the point of tears. Rita would later say, however, that her desire during this period was to become the biggest movie star she could be. "Sensitive, shy—of course I was. The fun of acting is to become someone else," she later explained.

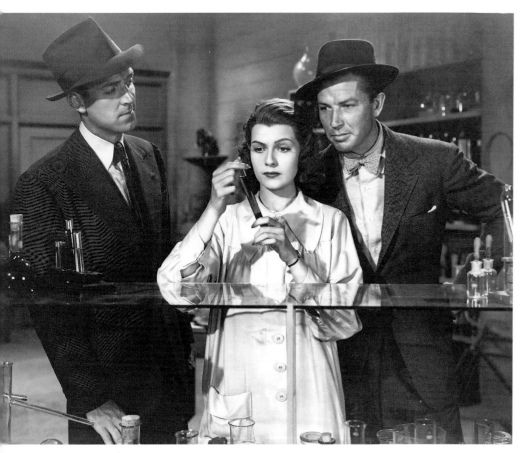

Rita's talents are put to the test in the role of a chemist in *Homicide Bureau* (1939), with costars Robert Paige and Bruce Cabot. She was now billed as "Rita Hayworth" and her hard work had been noticed by one individual, at least, who was destined to become one of the strongest influences in her life. A mystery man who claimed to be everything from a foreign car salesman to an "oil entrepreneur" had recently been introduced to Rita, and his persuasive ways with the studio bigwigs landed her some small parts. It was just the first step he would take to transform her into the superstar Rita Hayworth.

◀ Rita would later describe Edward C. Judson as "my first date, and my first husband," but their relationship was much more complicated than that. Who and what Eddie Judson was, no one in Hollywood really knew. What they did realize was that he was a canny promoter. After seeing Rita in a screen test for the film *Ramona,* Judson arranged to meet Rita's father and obtained his permission to begin dating her. It is likely that Eduardo recognized that Judson could help Rita's fledgling career and believed Judson's many promises for her future. Indeed, one must credit Judson for having a good eye: he saw something in Rita that other industry folk had failed to see, and he was more than willing to take charge of what was later described as Rita's "transformation process."

Rita fell in love with Eddie Judson, and they eloped on May 29, 1937. She was eighteen, he was forty. "I guess I wanted to get away from home, like a lot of teenagers do," Rita later recalled of her decision to marry Judson. "I wanted to feel independent." She would soon realize, however, that independence was not something she would experience with Judson.

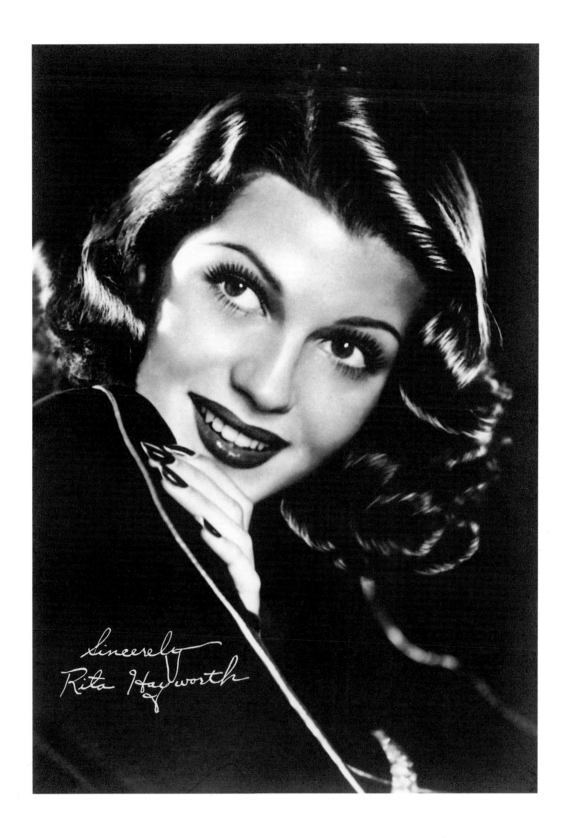

Sincerely
Rita Hayworth

∧ ➢ The subtle changes in Rita's appearance, on the advice of Judson, are already apparent in these publicity photos of Rita. Looking alternately glamorous and sporty, Rita's severe black bun is gone and replaced with a softer, more sensuous hairdo.

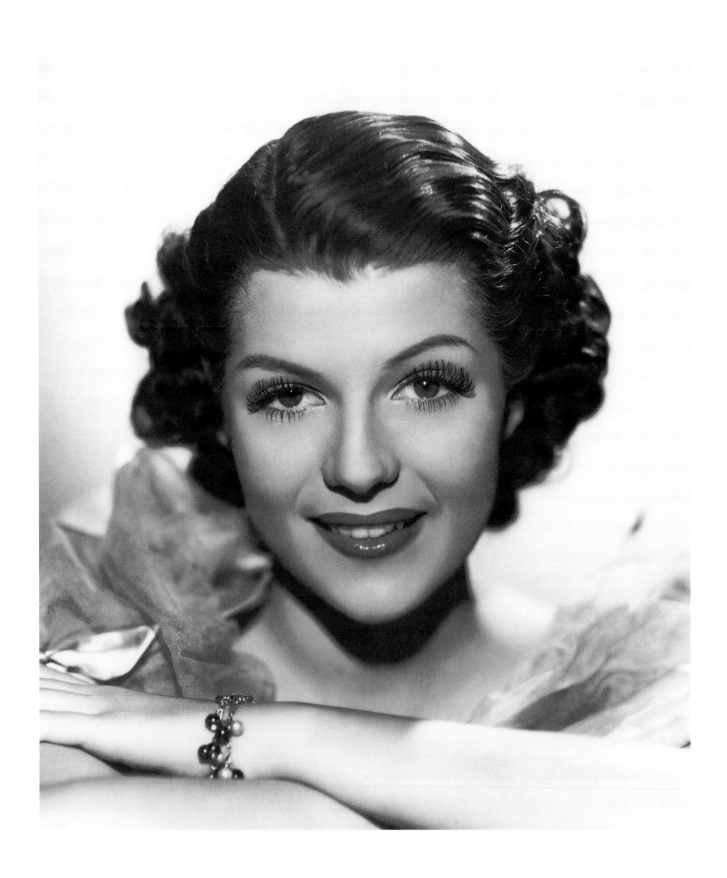

◄ Rita's hard work in "B" pictures finally paid off, with quite a bit of help from Ed Judson. Utilizing his slick sales techniques and his knack for knowing where to be and whom to talk to, Judson began a promotion of Rita that captured the attention of Hollywood. Rita's feminine grace and dignified carriage were her natural gifts, and Judson knew how to capitalize on them. He changed the way Rita dressed, the way she styled and colored her hair, and the way she socialized. He hired a press agent, Henry Rogers, who notified the photographers whenever Rita went to the Trocadero, the Cocoanut Grove, or other hot spots in Hollywood. He persuaded designers to let Rita wear their creations— after all, the free publicity was worth much more than the cost of the dress. Because of Rita's striking appearance and the number of times she was beginning to appear in magazines and newspapers, it wasn't long before people started asking, "Who is she?"

After many nights of seeing Rita on the town, Columbia Pictures executives finally took notice and signed her to a seven-year contract. The girl they signed, however, was quite different from the one who had appeared in earlier pictures. This "new woman" had taste, class, and a talent for publicity, thanks to a shrewd husband who was just beginning to mold her into the goddess with whom the American public would fall in love.

‹ Rita pulls out all the dramatic stops in this publicity shot as a murder victim in the 1938 film *Who Killed Gail Preston?* Her first few Columbia films were again "B" pictures, but Rita took advantage of the resources available at the studio. She posed in the portrait galleries for hours on end, engaged in novel publicity stunts to capture attention, and continued the many different types of lessons the studio offered, such as drama and diction.

One of the most talked about "changes" that Rita undertook during these years was the raising of her hairline through electrolysis, a long and painful process. Rita endured the procedure for two years until her hairline was raised. The difference was delicate but extremely effective, and Rita felt that it was worth the pain.

➤ Rita and Don Terry in an unusual pose to publicize *Who Killed Gail Preston?*

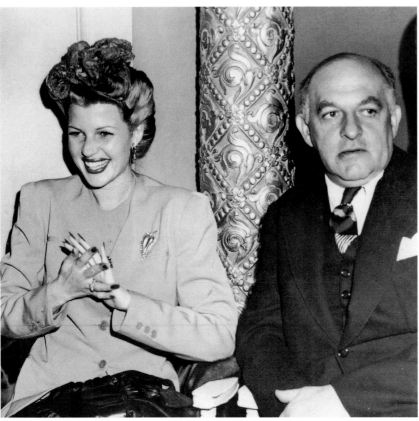

‹ On the brink of fame, Rita contemplates her future as she sits in director Howard Hawks's chair on the set of her next film, *Only Angels Have Wings* (1939).

⌄ One of the few people in the world whom Rita Hayworth didn't get along with was, unfortunately, also her boss. Harry Cohn (shown here with Rita later in her career) has gone down in history as one of the most difficult men in show business. He was vulgar, tasteless, and quick to criticize Rita, even years after she became the studio's biggest star. Because of her inherent diffidence, Rita was often the recipient of his abusive tendencies. Another likely source of his wrath was Rita's rejection of his romantic advances. "In front of people Harry Cohn would say, 'I never put a hand on her,'" Rita later recalled. "Of course he hadn't put a hand on me—as if I would let him!"

➤ Whatever his feelings were for Rita, Harry Cohn recognized in her a possible candidate for stardom. Tinseltown legend has it that Rita lobbied for the role of the femme fatale, Judy MacPherson, in the "A" picture *Only Angels Have Wings* by buying an expensive new dress and dazzling both Harry Cohn and director Howard Hawks with her beauty on the dance floor of a Hollywood nightclub. Whether this tale is true or not is irrelevant. Cohn gave her the part, and for the first time Rita was working with a cast of superb and well-known actors such as Richard Barthelmess, Cary Grant (seen here with Rita and director Hawks), and Jean Arthur, who at the time was Columbia's biggest star. It was Rita's most prestigious role to date, and it led to bigger and better ones. Rita was understandably nervous with this

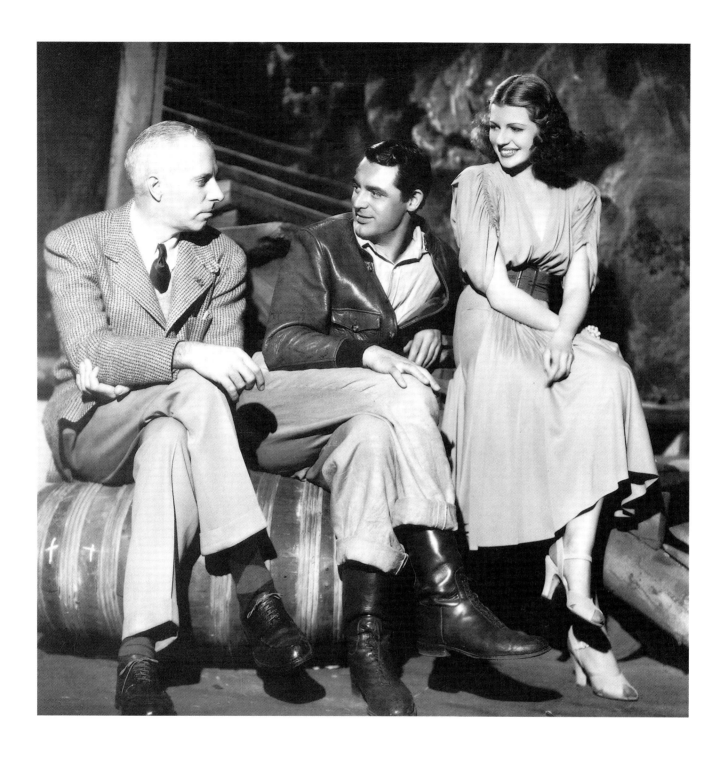

stellar cast, and Howard Hawks was sensitive to her limits as an actress. For one scene in which she was supposed to appear intoxicated, he had ice-cold water spilled on her head to get the drunken reaction he desired. The tension Rita felt is not noticeable in the film, however —a credit to her budding talent as an actress. Rita's allure, according to several of her directors, was the result of her ability to take direction. She often had to be instructed move by move in order to achieve the desired "sexiness," a situation that didn't seem to bother Rita or her directors in the least. It didn't matter how she achieved the effect, as long as she came across as enticing on the screen. Audiences responded to her immediately, and everyone involved with *Only Angels Have Wings* felt that this novice had great potential.

> Rita strolls arm in arm with costar Tony Martin on the set of *Music in My Heart* (1940). Despite her recent success, Columbia continued to put Rita into low-budget pictures. It was clear, despite the "B" status of these films, that Columbia was grooming her for better roles and that Rita was becoming more comfortable and natural onscreen. Recognizing the profit he could make and knowing there were no roles available for her currently at Columbia, Harry Cohn willingly loaned Rita out to other studios. It was another step in the right direction, and Rita's services were often requested for one film or another. Cohn eventually found a role for Rita at Columbia that paired her with another young actor of great promise: Glenn Ford.

*To Jacky
Sincerely
Rita Hayworth*

◀ Rita, wearing the latest fashion, poses for a fan.

⌄ Rita plays femme fatale with the cast of the *Blondie* series of films, Larry Simms, Penny Singleton, and Arthur Lake, in a publicity still for *Blondie on a Budget* (1940).

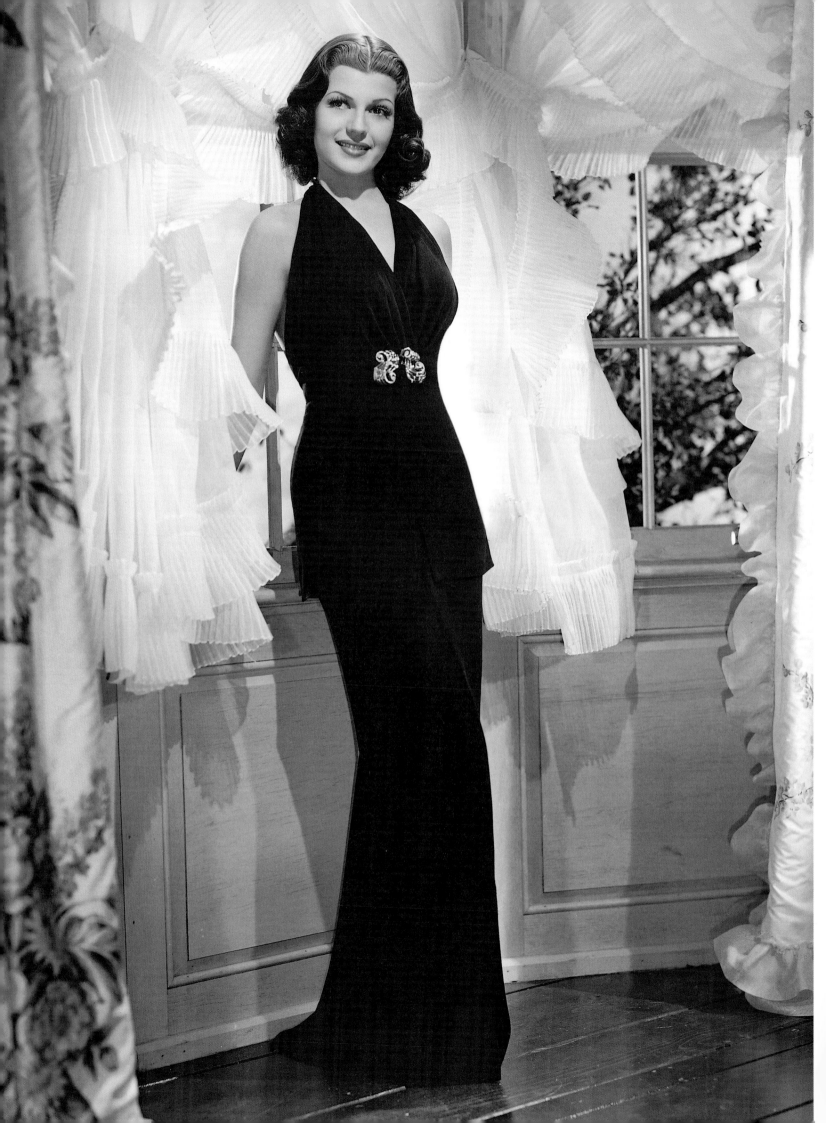

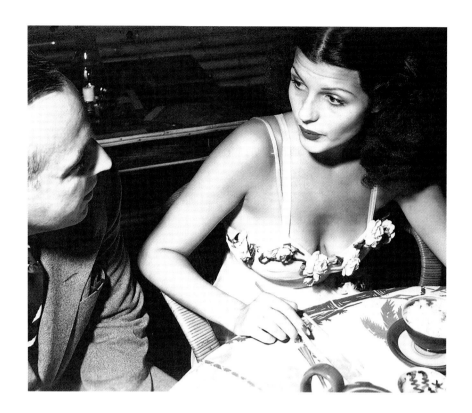

Rita poses on the set of *Susan and God* (1940) in a beautiful gown designed especially for her by the renowned designer Adrian. Rita's services were loaned to MGM for this picture, in which she played a supporting role. The cast, which included such superstars of the day as Joan Crawford and Fredric March, was superbly directed by famed "women's director" George Cukor, who had specifically asked for Rita. "She had natural elegance," he said many years later. "I knew, right away, she wasn't just another pretty girl. Rita made some of her material better than it was." Rita was thrilled to be working with such an experienced director, and she never forgot the many lessons he taught her about acting.

An uncommon sight: Rita holding court while husband Ed Judson listens. The lack of retouching on Rita's cleavage indicates that this photograph slipped through the Hollywood censor's fingers.

Rita's hair is styled by Columbia's chief hairstylist, Helen Hunt. Hunt would be responsible for the many color changes and hairdos that Rita would wear over her thirty-year career at Columbia, including the famous flowing red tresses that would become Rita's trademark. "It was Helen who suggested I become a redhead," said Rita. "That was the turning point in my career." Helen would later good naturedly admit frustration when Rita, never one to exhibit vanity, barely looked at her hair once Helen was finished coiffuring—undoubtedly a rare occurrence in the egocentric world of show business.

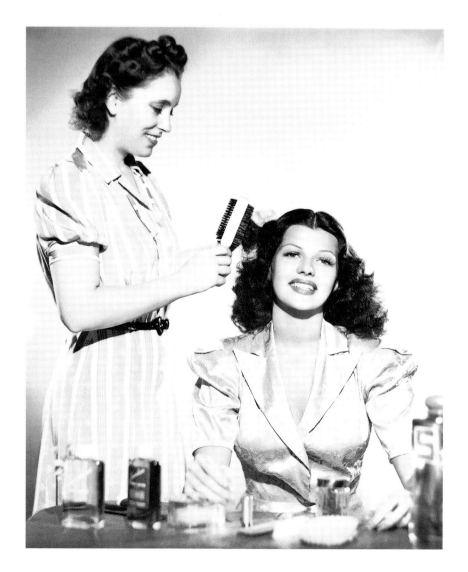

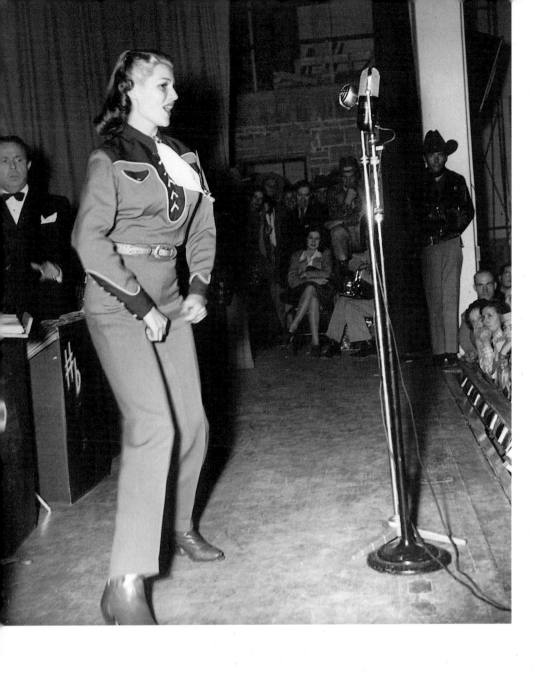

◀ ⌄ In April 1939, as part of a negotiation in which Rita was loaned out to Warner Brothers studios, Rita was sent on a publicity junket promoting three Warner films, *Virginia City*, *Santa Fe Trail*, and *Dodge City*. Along with Rita, several big-name stars such as Errol Flynn (pictured below), Jane Wyman, and Gilbert Roland were sent by train from Hollywood to Dodge City, Kansas. A huge parade featuring marching bands, masked horsemen, and a fleet of fifty airplanes added to the excitement. Above left, Rita performs before a live audience as part of the festivities.

➤ During periods when Columbia was unable to find a suitable role for Rita, they kept her busy posing for pinup photos such as this one. Pictures of Rita exercising, modeling clothing, dancing, and being made up for a film took up much of her time and were instrumental in her growing celebrity. These studio sessions were often extremely wearisome, but much to the delight of the photographers, Rita would enliven the monotony by playing her favorite music and dancing around the room.

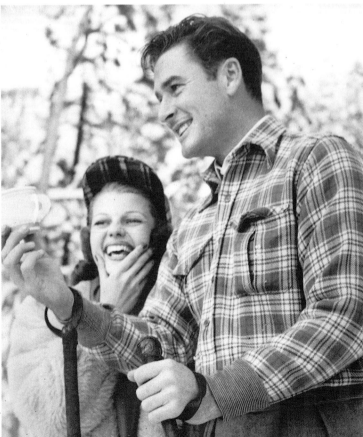

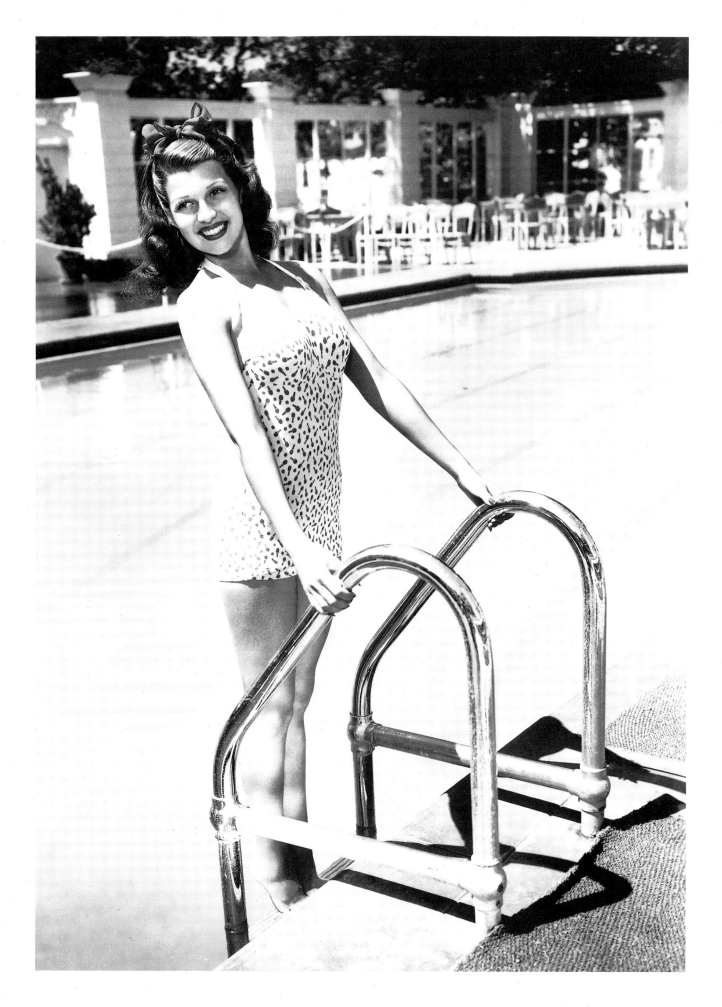

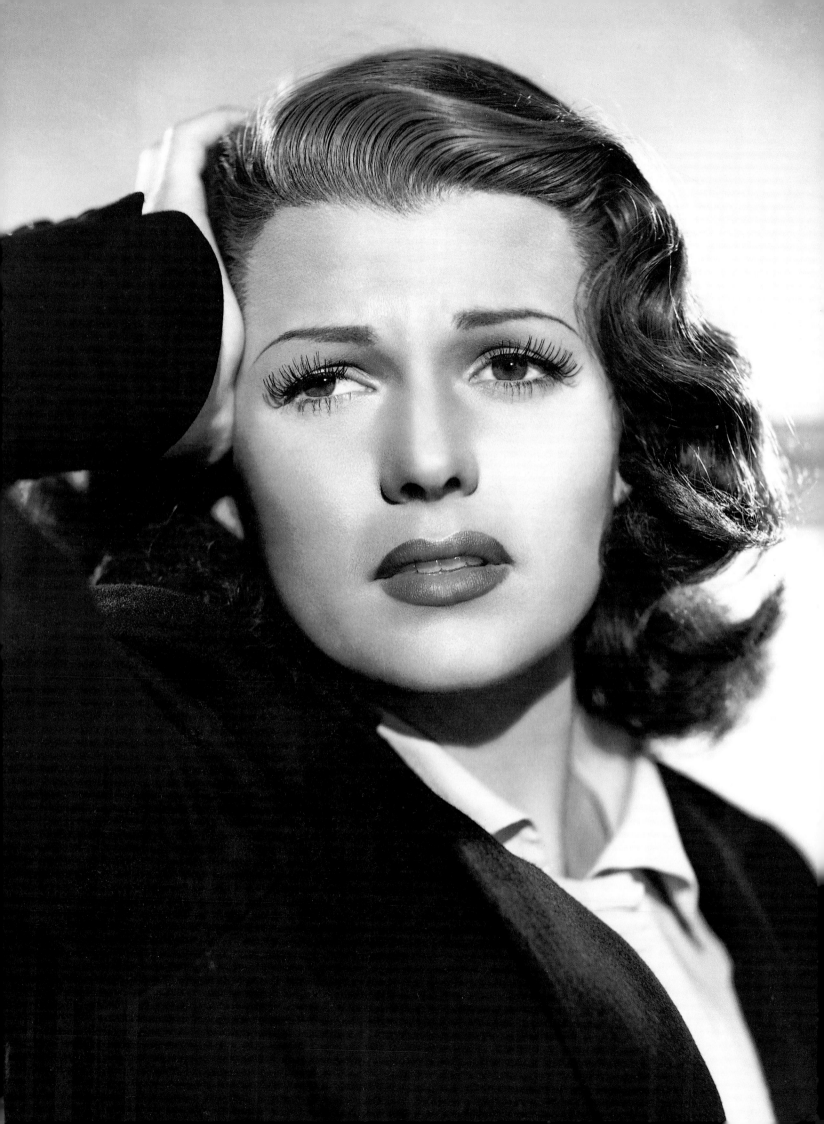

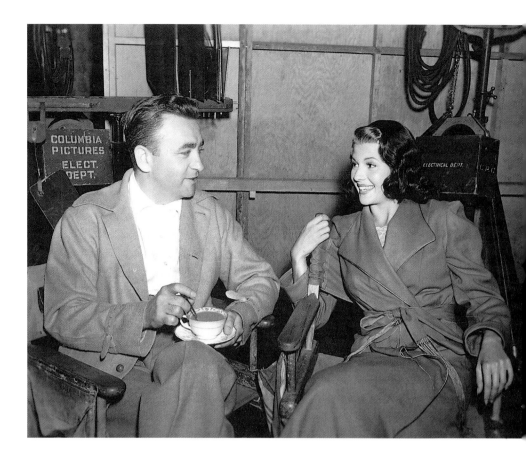

◄ Rita strikes a dramatic pose for *The Lady in Question* (1940).

➤ *The Lady in Question* was the first of four films Rita made that were directed by Charles Vidor (left), whose ability to respond to Rita's feelings and moods made him her favorite director and, ultimately, a good friend. (He was one of the few Hollywood people invited to Rita's wedding to Prince Aly Khan many years later.) Vidor was careful to shoot her scenes in the morning, when she was freshest. "Her best 'take' is usually the second, sometimes the third," he explained. "After that, if you don't get it, you are in trouble. For she is all emotion and arrives at everything emotionally. After the third take, she is emotionally exhausted." Rita's acting matured under Vidor's tutelage, and he later admitted that she was his favorite star to direct.

➤ It's hard to imagine that Rita Hayworth and Glenn Ford, two novices working together for the first time, would six years later steam up the screen with their extraordinary chemistry in *Gilda*. *The Lady in Question* portrayed them as sweet, good-natured kids, which was in essence what they were. The two quickly became friends and would remain so—on and off—until the end of Rita's life.

∧ ➤ Despite the leverage she was gaining at Columbia, Rita's life with Judson was eroding. Judson was the boss, and Rita made few decisions for herself. Magazine articles expressed amusement when they reported that Rita's home with Judson was devoid of furniture (their living room was completely empty except for a model railroad that Judson purchased for Rita's amusement)—most of their money was invested in the promotion of Rita. Rita had never considered her involvement with Judson a great love story, but she was now becoming aware that it was more like a business relationship.

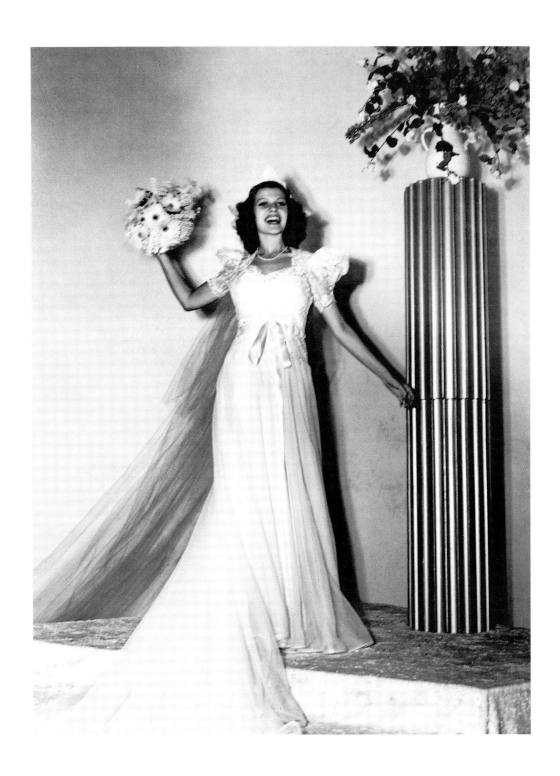

ʌ In her home, Rita displayed this
beautiful photograph of herself
modeling a bridal gown—one of
the few overt signs that perhaps she
would have preferred a more
traditional marriage and home life.

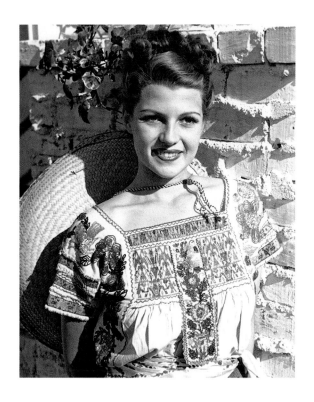

‹ The sweetness and shyness that defined her can be seen in this 1940 photograph of a youthful Rita at home.

˅ On the set of her next film, *Angels Over Broadway* (1940), Rita plays telephone with her stand-in, Ruth Peterson. A stand-in did not have to look like the star as much as she had to have the same height and coloring. Ruth Peterson was Rita's stand-in on several films, among them *The Lady in Question, You'll Never Get Rich,* and *Gilda.*

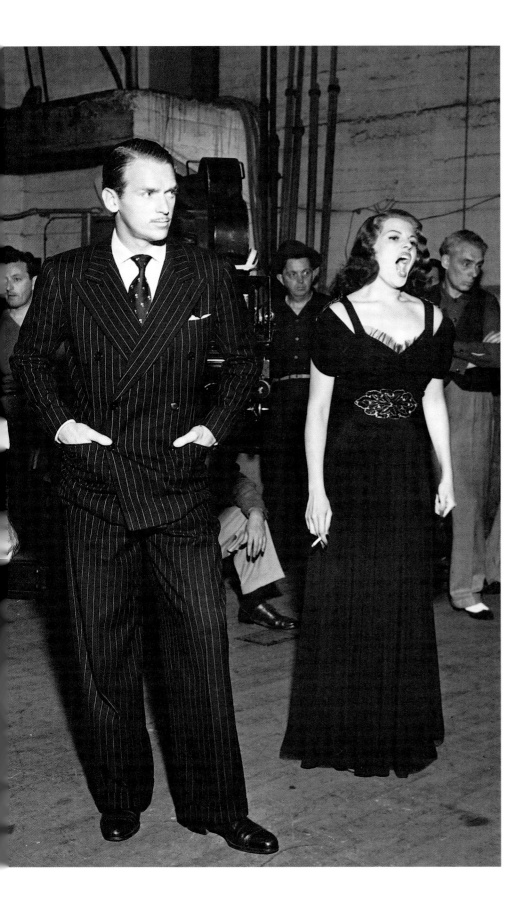

◄ Rita exhibits fatigue during one of the many interminable waits while filming *Angels Over Broadway*, written by Ben Hecht and co-starring Douglas Fairbanks, Jr. (left) and Thomas Mitchell. The film was not well received, but Rita, as struggling chorus girl Nina Barona, was singled out in the reviews. Douglas Fairbanks, Jr., would later comment that Rita was "*so* new and so shy . . . that even I hesitated to use any expletive more earthy than 'darn' or 'gosh,' in her presence." *Angels Over Broadway* became the last film Rita made for Columbia as a supporting player. For her next three films, she was loaned out to other studios, and the astute role choices they made for her resulted not only in a triumphant return to her home studio, but in the realization that life would never be the same.

∧ ≻ In a publicity stunt that attracted seventy-five reporters, photographers, and fashion experts, Rita models "the world's most costly gown." The thirty-pound dress was made of 80,000 pearls valued at $250,000, and each pearl had been meticulously sewn on by fifteen embroiderers. It was taken by armored car and police escort to the exclusive Los Angeles Town House, where it was then modeled by Rita. During the party at which she wore the dress, Rita was followed by an I. Magnin department store employee who picked up every pearl that happened to pop loose. The Imperial Pearl Syndicate, which owned the gown, later auctioned it off for war relief and Red Cross charities. Photographs of Rita wearing the dress made all of the major newspapers and magazines, another coup for Rita and the publicity-savvy Ed Judson.

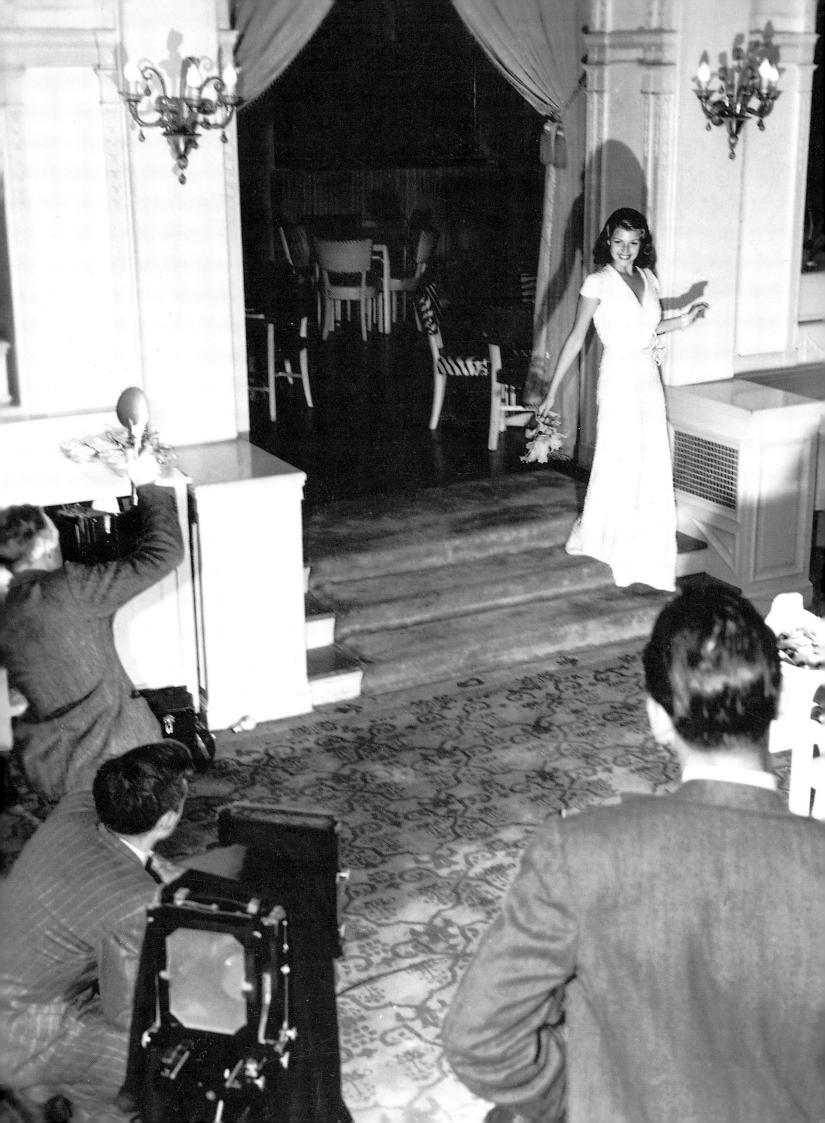

An outtake from the photo session that landed Rita her first *Life* magazine cover on July 15, 1940.

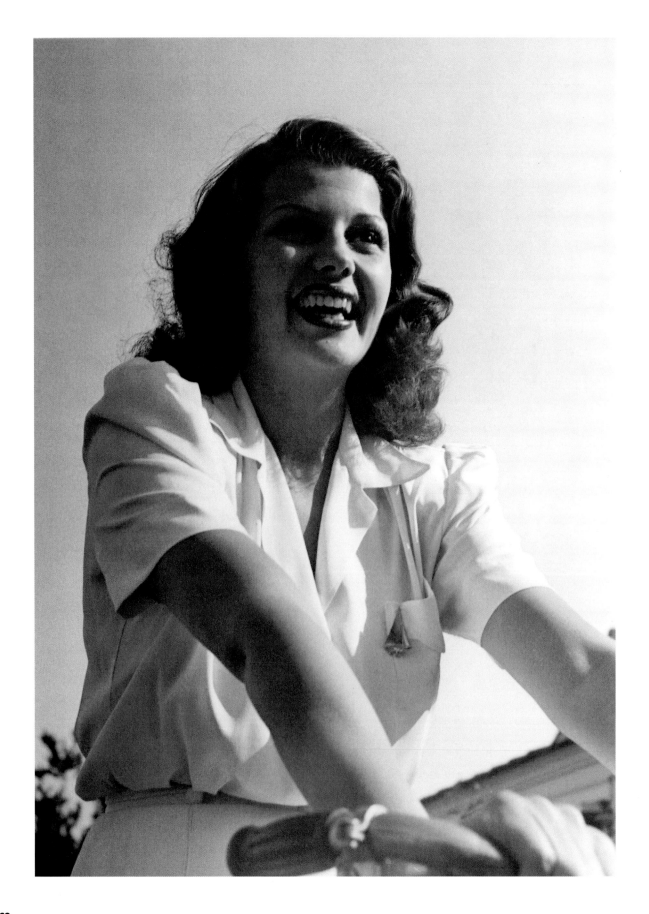

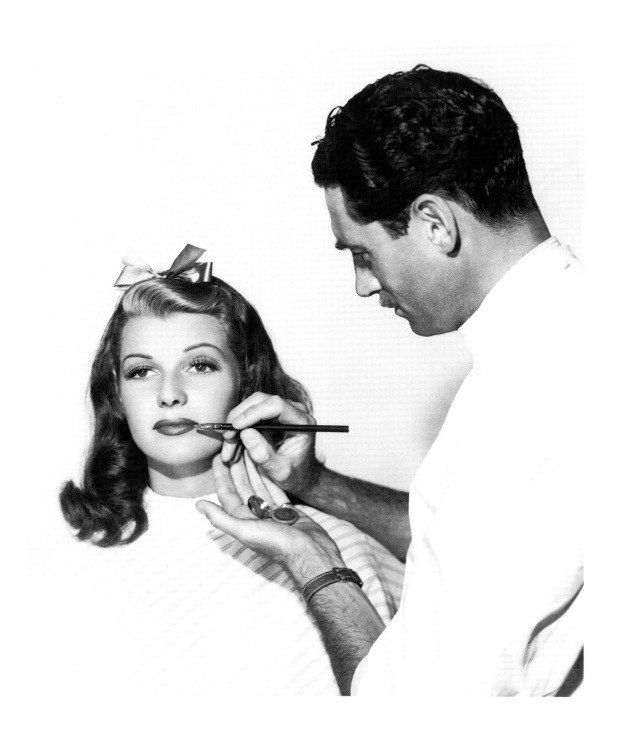

ʌ Rita, still considered a starlet, models as makeup man Clay Campbell demonstrates the art of transforming a pretty girl into a glamorous movie star. The makeup artists on the movie sets were probably the most informed people in Hollywood: an average makeup session would last a couple of hours, during which time they would inevitably be privy to every piece of gossip, rumor, and fact that existed in show business.

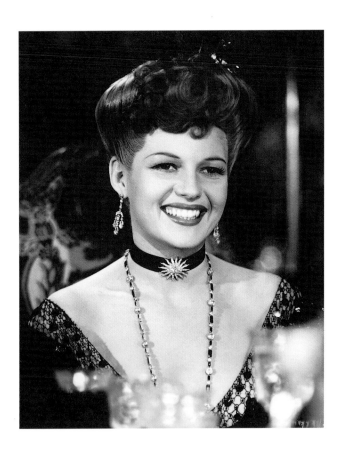

Rita's first film release of 1941 was the Warner Brothers picture *The Strawberry Blonde,* a light, enjoyable period piece that was another landmark in her career. Rita was again in superb company, this time starring with Olivia de Havilland and James Cagney. Dressed in period costume with upswept hairdos, Rita proved that she was believable in any decade. Her spirited and vivacious performance as the scheming Virginia Brush, under the direction of Raoul Walsh, resulted in more publicity and more fan mail than ever before.

Rita waits between scenes with director Raoul Walsh (standing, wearing eye patch) and costars Jack Carson, de Havilland, and Cagney. A crowd of curious onlookers can be seen in the background.

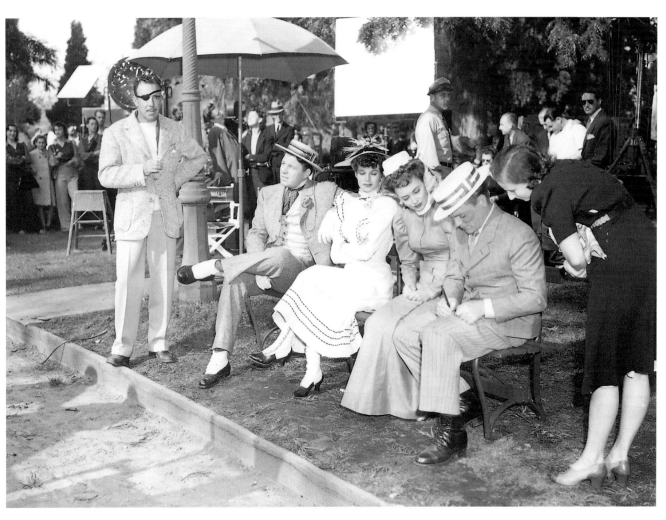

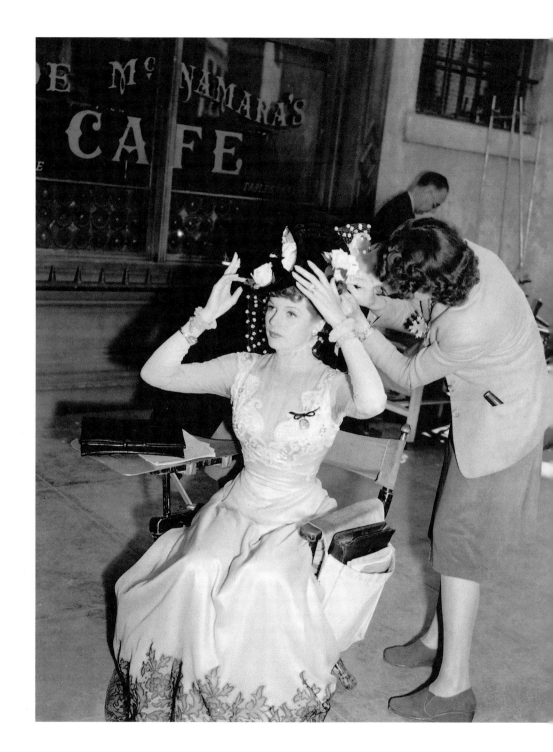

➤ Cigarette in hand, Rita's hair and costume are touched up on the set of *The Strawberry Blonde.* For the role of Virginia Brush, Rita was required to change her hair color once again, this time to a soft red. She was so delighted with the result that she maintained the color. Rita would stay at Warners for one more film, *Affectionately Yours* (1941), which was not successful. In retrospect, it hardly mattered, because the role that would catapult her to stardom was awaiting her.

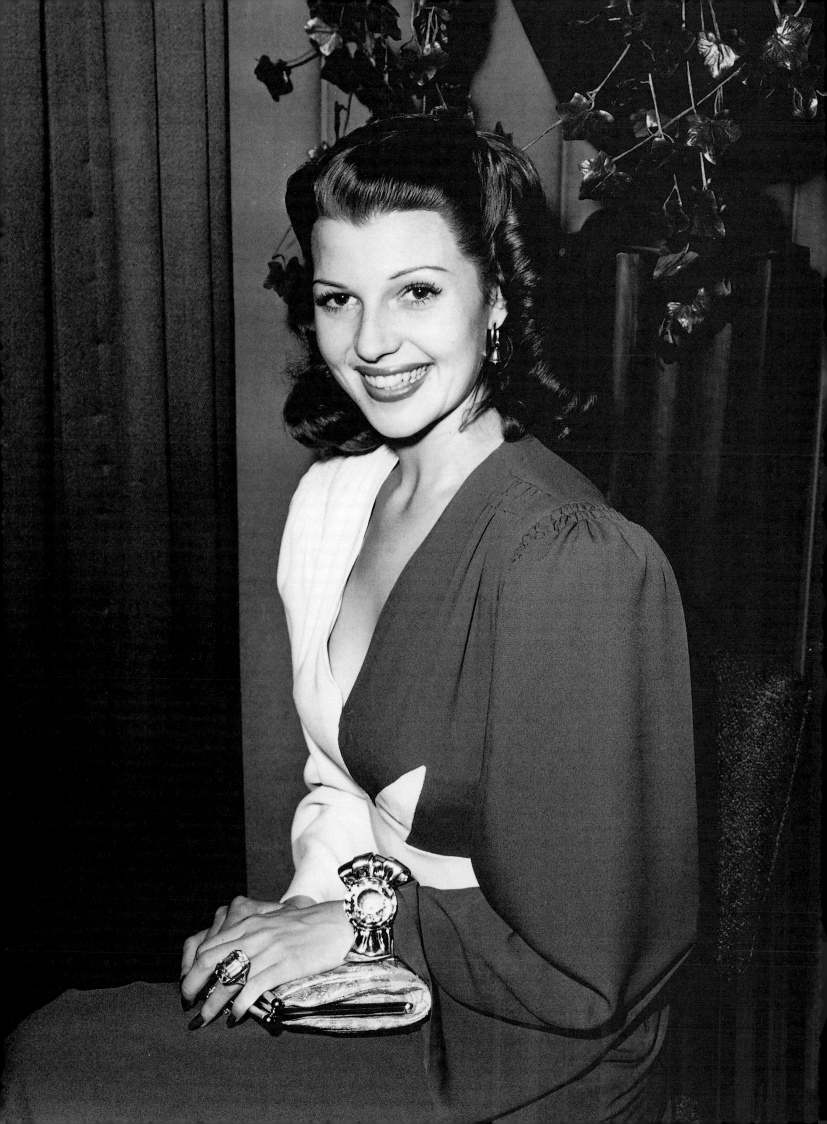

Ascent to Stardom

◄ Rita, who wasn't particularly fond of Hollywood parties, seems to be having a good time as the photographer catches her sitting alone. Despite the ups and downs that had occurred in her life thus far, Rita's natural kindness and sincerity remained. She considered herself nothing more than a hard-working woman who was doing her job. Her no-frills attitude, coupled with her innate warmth, set her apart from the typical Hollywood starlet, and Rita quickly won the hearts of every crew and cast member with whom she worked.

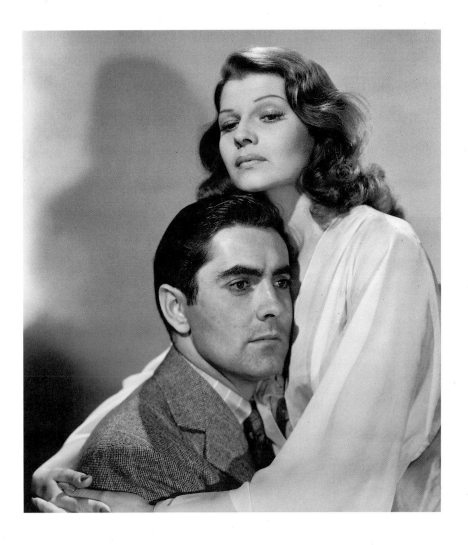

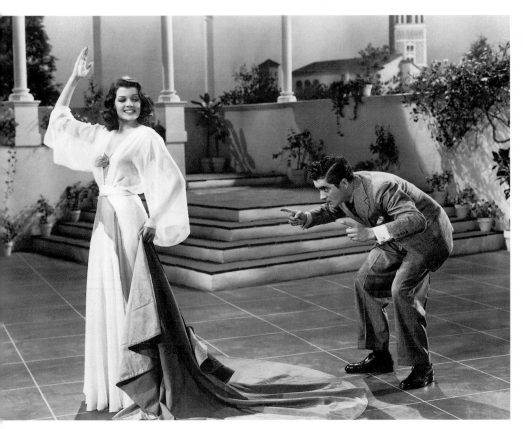

<In this unretouched photograph, Rita poses with Tyrone Power, her formidable costar in Twentieth-Century Fox's *Blood and Sand* (1941). The role of the temptress Doña Sol was much sought after by actresses. When Fox executives took a look at Rita Hayworth, however, it seemed the part had been written with her in mind. Columbia agreed to loan Rita to Fox, the very studio that had dropped her option only a few years before. "The moment I saw Rita Hayworth walk, I knew I had my Doña Sol," remembered Rouben Mamoulian, the director of *Blood and Sand*. "She had something more, a feline sort of movement that was subtle—and insinuating—exactly the kind of animation I imagined Doña Sol would possess." Every man in America who witnessed Tyrone Power succumbing to the charms of Rita Hayworth—destroying his life in the process—could empathize. Rita's vocals were dubbed by Graciela Párranga, a most unlikely choice since Párranga's voice hardly matched Rita's. Carole Landis, a popular actress under contract to Twentieth-Century Fox at the time, was originally slated for the part of Doña Sol, but she refused to color her blonde hair the red shade required for the character. Rita wisely agreed to color her hair for the role, another step toward the "look" that would become distinctively hers.

< The character of Doña Sol, a cold-blooded vixen who seduces men and then callously tosses them aside, would become one of the roles forever associated with Rita but the furthest in character from the real woman. "Rita always re-minded me of a little girl," her close friend choreographer Hermes Pan commented. (Pan choreographed

the seductive "bullfight" dance for Rita and Tyrone Power in *Blood and Sand*). "People would think of her as the glamorous Love Goddess, and yet she was just a little eight-year-old girl. You couldn't believe the two were the same person!"

➤ Rita with Anthony Quinn in a sensual scene from *Blood and Sand* that continued off the screen as well. He would later say that Rita was the most desirable woman he had ever known.

∨ Even Rita Hayworth as Doña Sol isn't perfect, as evidenced by the studio's desire to airbrush the veins in her hands and arms! Making their stars appear otherworldly was the goal of the studios; living up to the fantasy was the burdensome fate of the all-too-human actors.

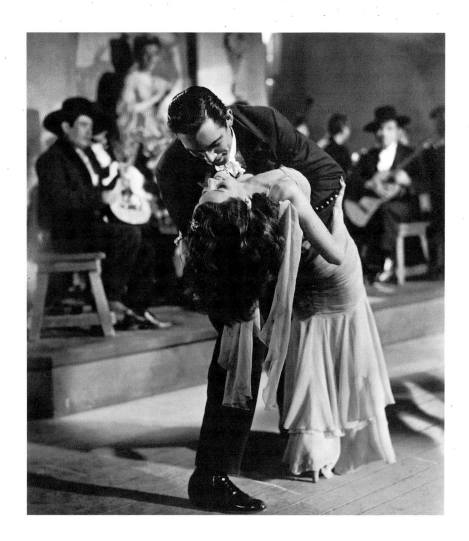

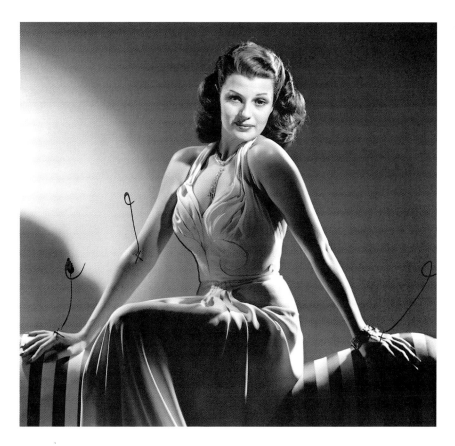

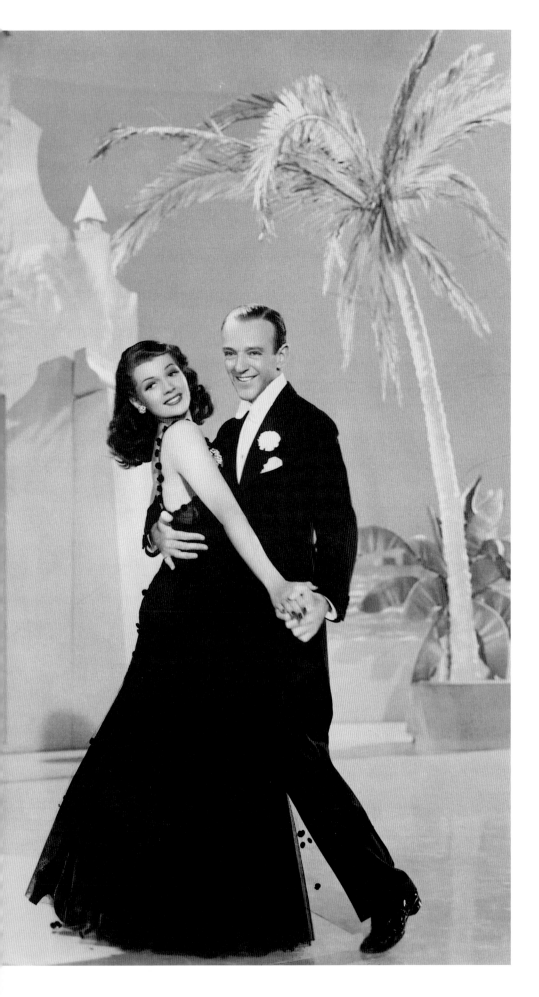

Rita would later describe the films she made with Fred Astaire as "the only jewels of my life." Astaire, who was an acquaintance and fan of Rita's father, had specifically asked to work with Rita in his film at Columbia, *You'll Never Get Rich* (1941). Rita was grateful to Astaire for recognizing what "those dumb-dumbs at Columbia didn't know," which was that her true talents were dancing and comedy. He would later declare that Rita was one of his favorite dancing partners. "She learned steps faster than anyone I've ever known," Astaire, who had a reputation as a perfectionist, recalled. "I'd show her a routine before lunch. She'd be back right after lunch and have it down to perfection. She apparently figured it out in her mind while she was eating." Unbeknownst to Astaire, however, Rita would arrive home every night in a state of exhaustion. Rita credited her hard-driving father and her early years of constant rehearsing with giving her the stamina to keep up with Astaire.

In *You'll Never Get Rich*, Rita and Fred Astaire perform one of the most beautiful dances on film to the tune of Cole Porter's "So Near and Yet So Far" (pictured here). Watching these two professionals dance together is to witness perfection. Astaire and choreographer Robert Alton drew on Rita's Spanish dance background and shaped the dances to her sensual style, making the performances both romantic and sexy. Although some felt that Rita was a bit too voluptuous for the rail-thin Astaire, their pairing was very successful and audiences clamored for more.

≺ Fred Astaire seldom allowed cameras into the rehearsal hall. This rare shot catches Rita and Astaire as they rehearse "The Wedding Cake Walk" with the Robert Alton dancers.

⌄ The wartime patriotism of "The Wedding Cake Walk" number borders on camp with a giant, white wedding-cake tank, stars-and-stripes background, and dancing war brides. Astaire always regretted that his films with Rita were filmed in black and white; wartime budgeting prevented Columbia from shooting in color.

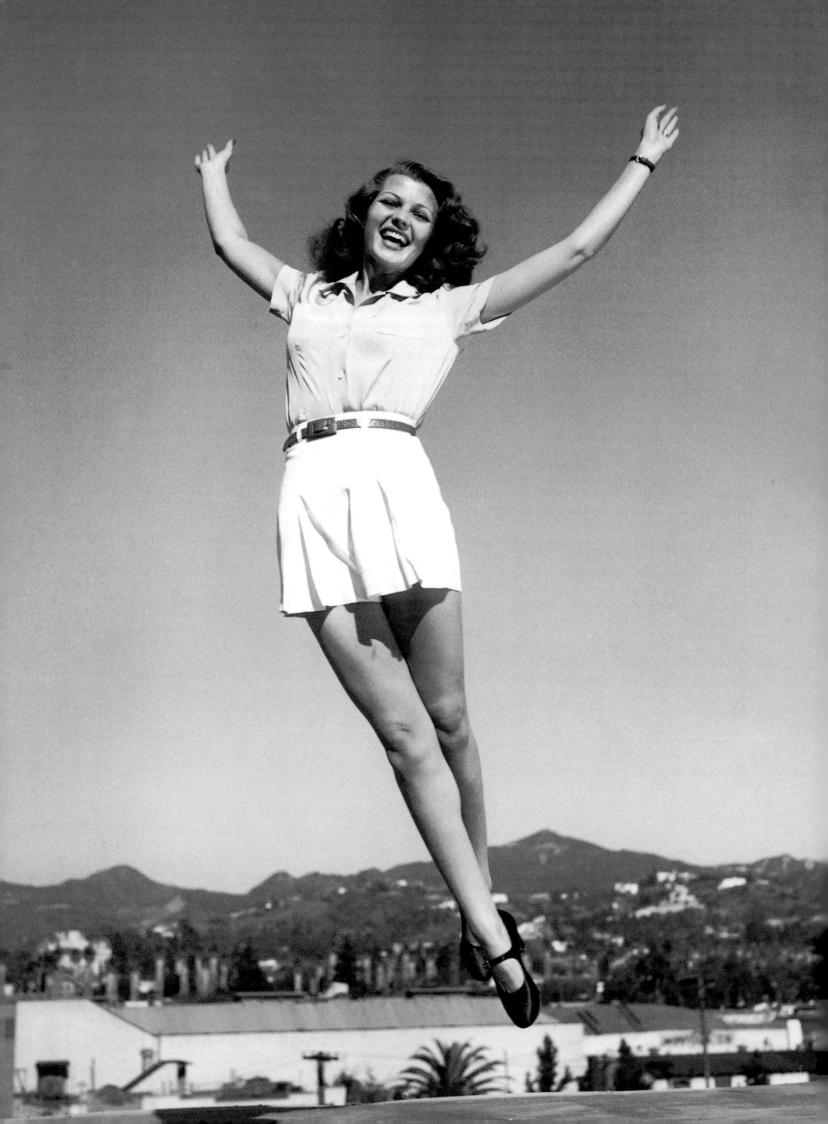

◄ On the roof of Columbia studios, Rita jumps for joy at her newfound success: *You'll Never Get Rich* was a box-office triumph. *Time* magazine called Rita "the best partner Astaire has ever had," and *Life* magazine stated that Rita "made people almost forget Ginger Rogers." Rita showed quite a flair for comedy, and Columbia executives were again pleasantly surprised at the versatility of their rising star. Plans were already under way to make another film with the Hayworth and Astaire team.

➤ A starlet's work is never done: Rita relaxes at home with a game of ping-pong but not without the ever-present publicity photographer chronicling her every move.

⋎ An unusual, candid pose taken at the beach by *Life* photographer Bob Landry. Rita wears a robe with the initials of her character from *You'll Never Get Rich*, Sheila Winthrop. That same day, Landry would produce a photograph of Rita that would alter her life forever.

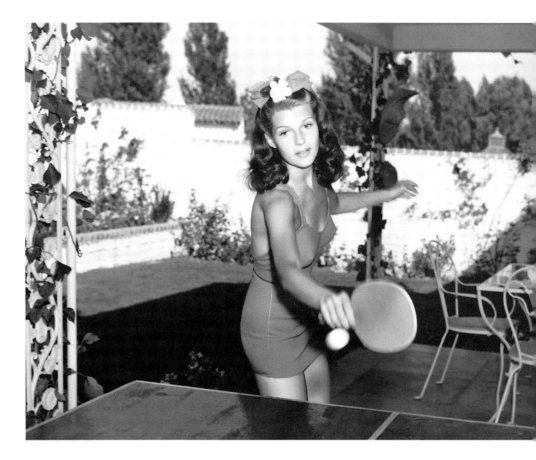

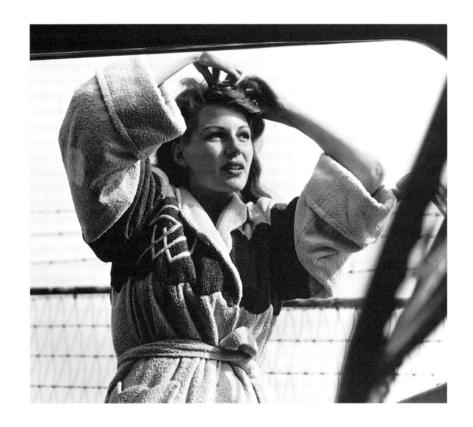

> In the August 11, 1941, issue of *Life* magazine, Rita appeared in a photograph taken by Bob Landry that became one of the most popular wartime pinups, second only to the famous Betty Grable over-the-shoulder pose. (Another photo of Rita appeared on the cover of the same issue.) Legend has it that the shadows that highlight Rita's figure so sensuously were a happy accident that resulted when a flashbulb failed to go off. The photograph was taken at Rita's home, on her own bed. In addition to showcasing other attributes, the photograph allows a good view of Rita's hands—thought to be the most beautiful in Hollywood and which she considered to be her prettiest feature. Bob Landry later said that the photograph was "a World War II morale booster, for countless thousands of GIs throughout the world who requested it, and for the lucky photographer who made it—me." The image became the most reproduced picture of a star in the history of *Life* magazine, not only because of its historical importance but because of its timeless allure. "I'm proud of that photo," Rita declared. "Not just because the servicemen told me I looked good, but because of what the photo meant to so many of them: a link with home." Rita wept when she was told that the photograph was pasted on a test atomic bomb that was dropped on Bikini Atoll in 1946.

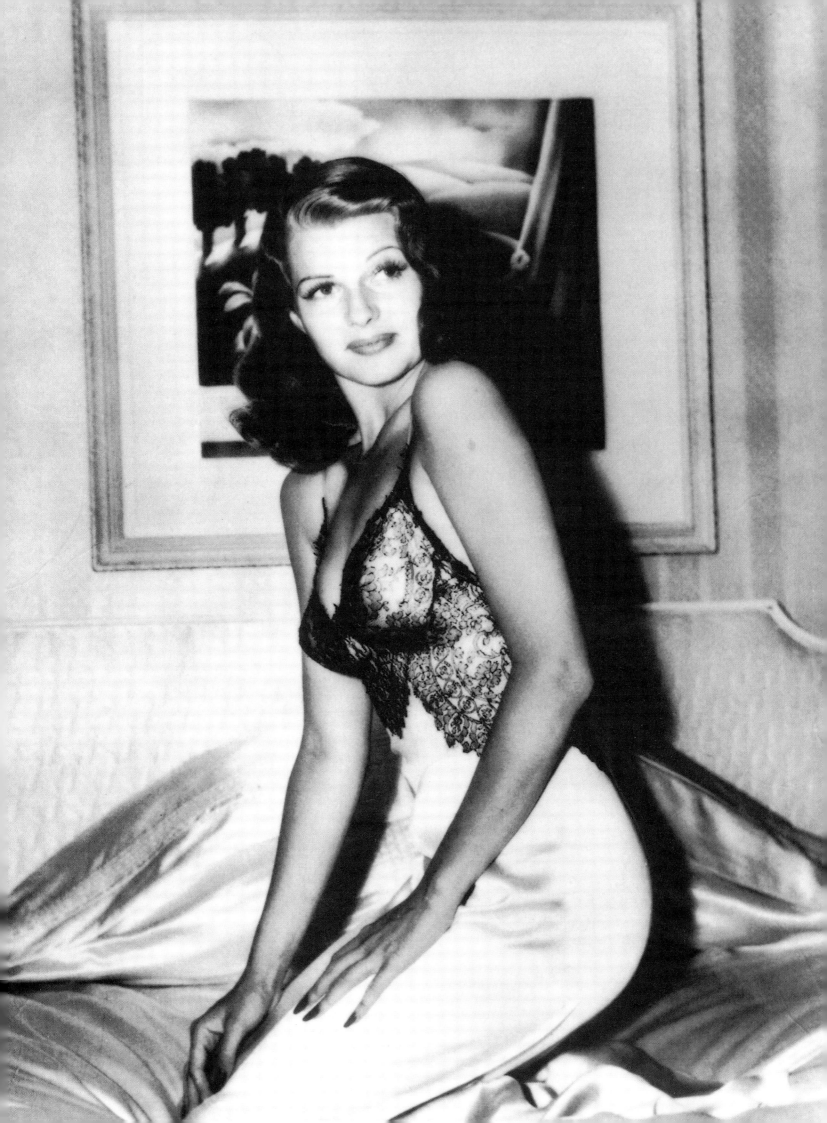

‹ Ed Judson picks up Rita at the end of her day's work at Columbia during filming of *You'll Never Get Rich*. It was just a few months before the end of their marriage. As much as she was enjoying her success (she appeared on the cover of *Time* as well as dozens of movie magazines), Rita was saddened at the prospect of a divorce.

⌄ Rita pacifies the 1,000 Navy men who complained that her latest film, *You'll Never Get Rich*, favored the Army. A party was given for them at the San Diego Naval Training Station, and one of the highlights of the event was a lesson in La Conga, led by Rita herself.

➤ Rita visits Rockefeller Center Observatory in New York with a soldier, a sailor, a coastguardsman, and a marine—as well as a chaperone—as part of the promotion for *You'll Never Get Rich*. Judson accompanied her on the film's publicity tour, but they separated soon after. She always gave credit to Judson for making her a star; he also deserved equal credit for spending the money she earned. For his part, Judson never again succeeded in building a star's career, and he spent most of the rest of his life living under the label of "Rita Hayworth's ex-husband."

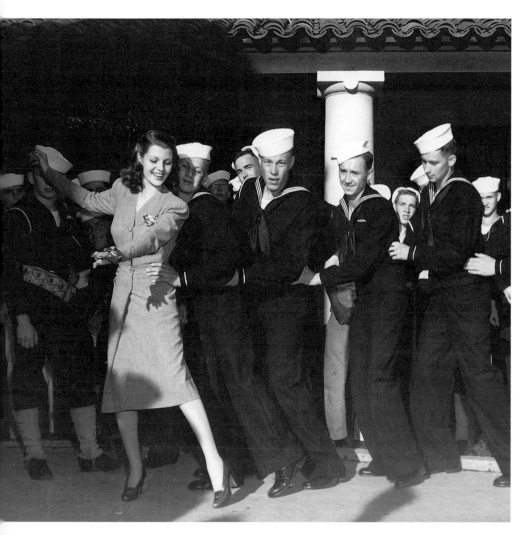

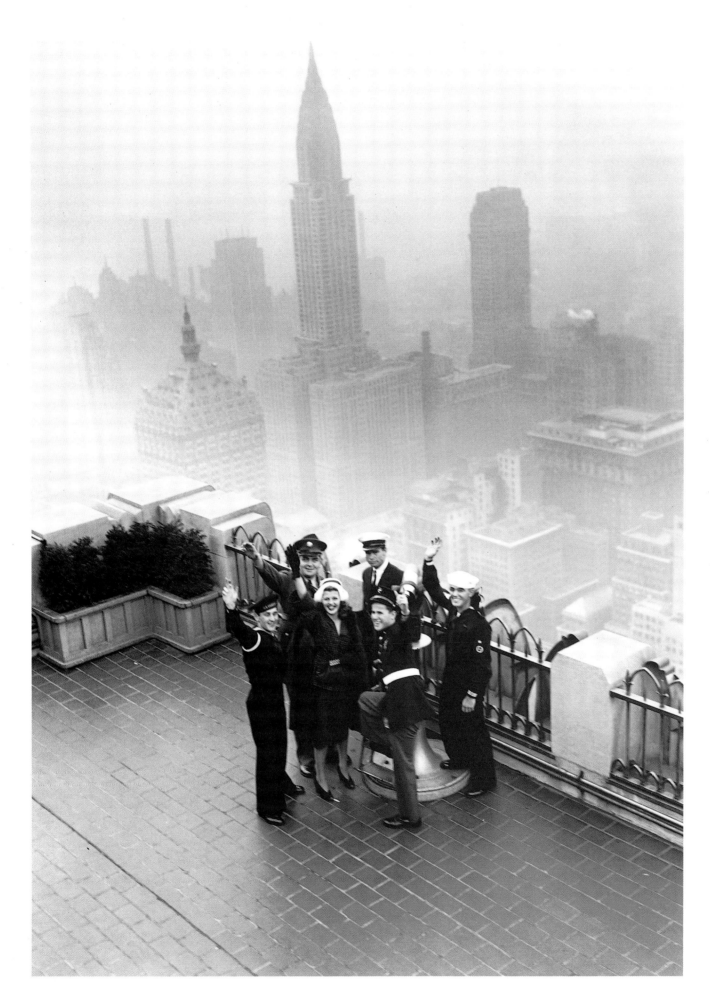

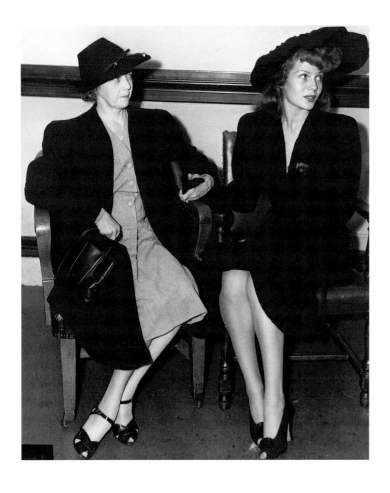

◄ In May 1942, Rita, wearing a somber black outfit and holding the hand of her mother, appeared in court to get her divorce from Judson. In front of the judge, Rita stated, "I never had any fun. I was never permitted to make any decisions. From the first, he told me I couldn't do anything for myself. My personality crawled deeper and deeper into a shell." Judson received a large settlement. Rita had little to say publicly about the demise of her marriage, but she was quite heartbroken. "I married him for love, but he married me for an investment," she revealed sadly. Rita was excited about the prospect of dating some of the many men who were now falling at her feet. Up until this time, Rita had never experienced true freedom, and she felt as though the world was suddenly available to her.

➤ A rare publicity portrait of Don Ameche and Rita for their upcoming film, *My Gal Sal* (1942). Ameche was eventually replaced by Victor Mature, a fateful decision that would change Rita's life. It's interesting to speculate what kind of chemistry the Ameche-Hayworth team would have generated, as Ameche was a popular leading man for the decade's other favorite sex symbol, Betty Grable.

➤ The stress associated with
the end of her marriage and the
looming career path she would
now tread alone can be seen in
Rita's face in this unretouched
publicity photograph for *My Gal
Sal.* Filmmaking seemed to
invigorate Rita, however, and she
was determined that her success
continue, despite the absence of
Judson's guiding hand. Rita seemed
a natural in the period costumes
of *My Gal Sal,* and her musical
numbers, dubbed by singer Nan
Wynn, were a colorful delight. A
special treat for Rita and filmgoers
alike was her onscreen dance to the
song "On the Gay White Way" with
her dear friend, choreographer
Hermes Pan, who was rarely seen
on film. Today the music of *My Gal
Sal* seems dated and forgettable,
but the film benefits from Rita's
spirited performance. Rita and her
new costar, Victor Mature, radiate
quite a bit of chemistry—which was
more than just good acting.

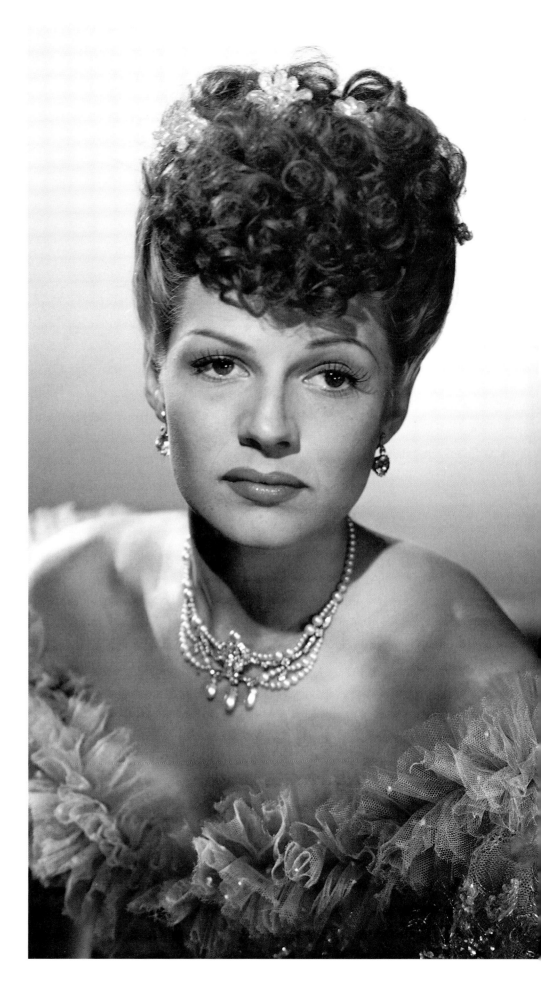

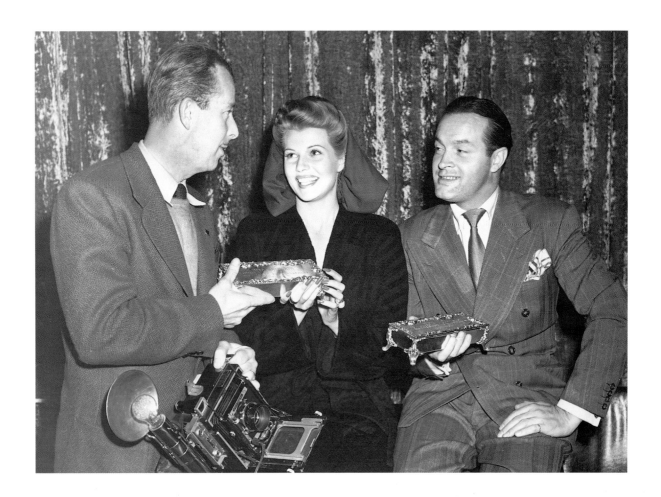

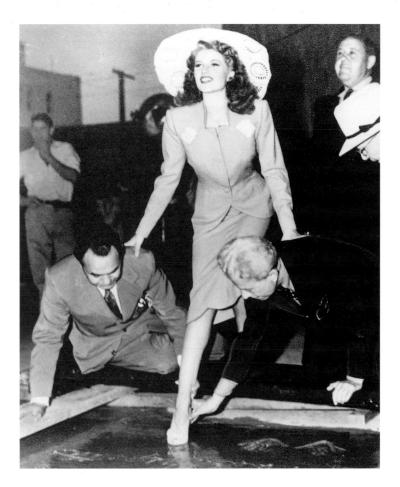

⋏ Rita and Bob Hope accept awards given to them by Hollywood photographers as the two most cooperative stars of 1941. The presentation was made over the *Lux Radio Theater* airwaves. Rita was so proud of the award that it graced the coffee table of her home for years to come.

➢ Rita's star continues to rise as she immortalizes her foot and hand prints in cement at Grauman's Chinese Theater in Hollywood on July 24, 1942. Helping out are her costars from *Tales of Manhattan* (1942), Edward G. Robinson and Charles Laughton (in background), and theater owner Sid Grauman.

∧ Rita with costar Charles Boyer
in *Tales of Manhattan*, which
featured several intertwined plots.
Manhattan was actually shot before
My Gal Sal but was released later.
Rita was thrilled to star with the
much older but accomplished
Boyer, and although her appearance
was brief, it once again put her in
the public eye and allowed audiences
to witness her blossoming talent
as an actress.

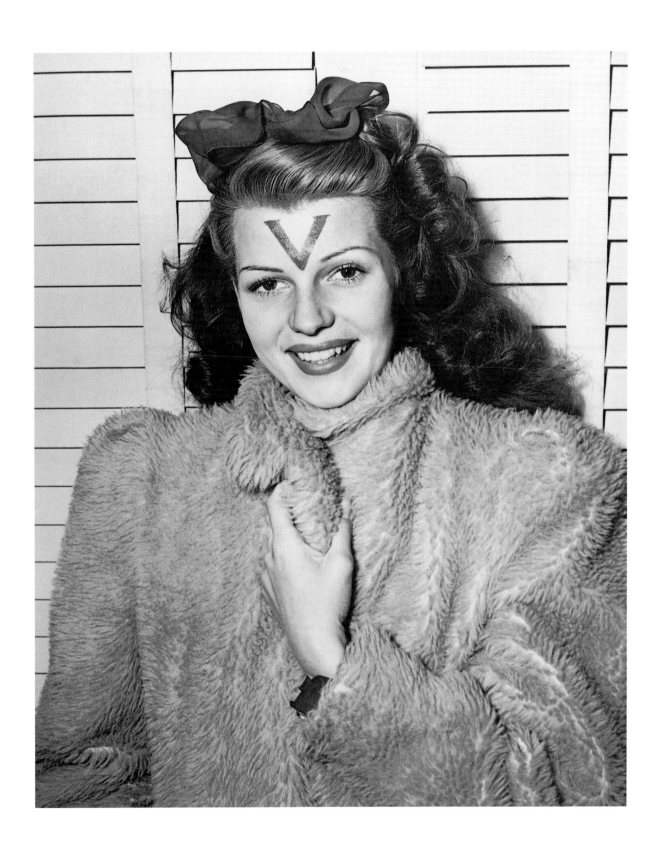

∧ Rita takes her World War II
patriotism to the extreme when
she sports a "V" for victory on
her forehead.

➤ Rita looks bursting with happiness as she attends the premiere of her film *Tales of Manhattan* with new beau, Victor Mature. On her finger is a ring given to her by Mature, which she insisted wasn't an engagement ring but which she proudly displayed to photographers. Louella Parsons, noted Hollywood columnist and busybody, detailed the many faults of Mature in her column and strongly suggested that Rita avoid a romance with the beefy actor. Mature, also known as "The Hunk," was able to make Rita laugh—a refreshing change from the dour-faced and strictly business Ed Judson.

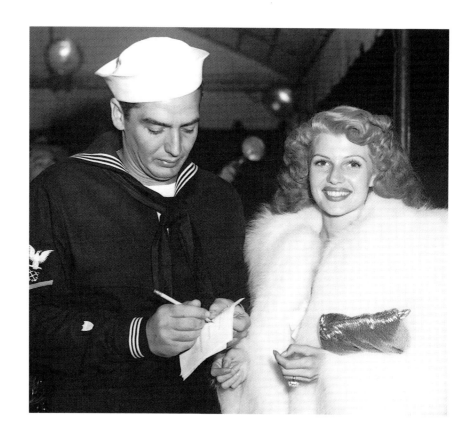

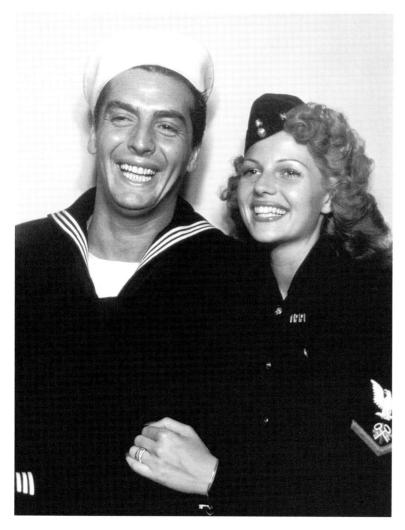

◀ Rita and Vic attend the premiere of *Pride of the Yankees* in August 1942. She is wearing the uniform of a Naval Aid Auxiliary, as well as sporting a trinity ring and lock-and-key heart bracelet given to her by Mature. The romance was getting serious, and Mature began the process of divorcing his wife. It seemed as though they were headed for matrimony when war intervened. Mature joined the Coast Guard and Rita, like many other women during the war, dutifully promised to wait for him.

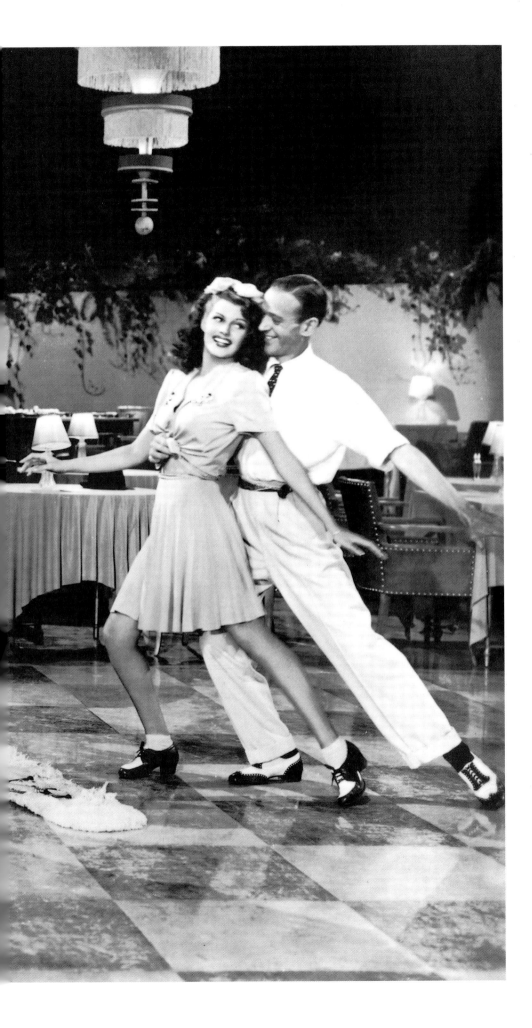

◄ *You Were Never Lovelier* (1942), directed by William Seiter (seated in chair, with hat), was the second and last film that Rita would make with Fred Astaire, and it too became a smash hit. Although Astaire, as usual, sings his own songs in the film, Rita was once again dubbed by singer Nan Wynn. Astaire would try to coax Rita out of her shyness by playing practical jokes on her during rehearsal. For one number, "The Shorty George" (pictured here during filming of the number), Rita's costume was a half-blouse that revealed a bare midriff. Astaire would dip his hands in ice-cold water and then slip them gently around her waist as he turned her around the dance floor, resulting in loud screams from Rita and much laughter on the set. In another, more serious, instance during rehearsals for this same number, Rita tripped and knocked herself out cold, an experience she later revealed as her most embarrassing career moment.

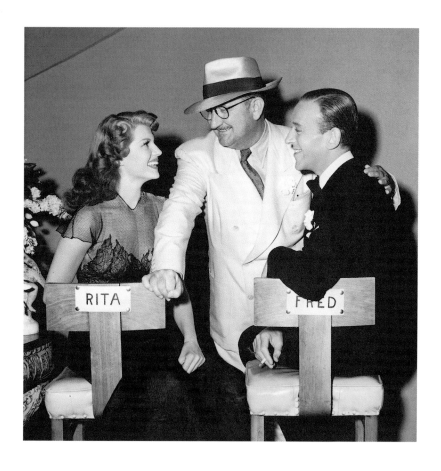

Rita and Fred Astaire chat with director William Seiter during the filming of *You Were Never Lovelier*. Astaire was very fond of Rita, and his admiration is evident on the screen. Rita always described herself as "a comedienne who could dance," and her films with Astaire highlighted these talents. It is a loss to the movie-going public that these two never made another film, but Astaire was not keen on being "teamed up" with another dance partner (a successful Broadway career with his sister Adele and nine films to date with Ginger Rogers were enough), even with someone as delightful as Rita.

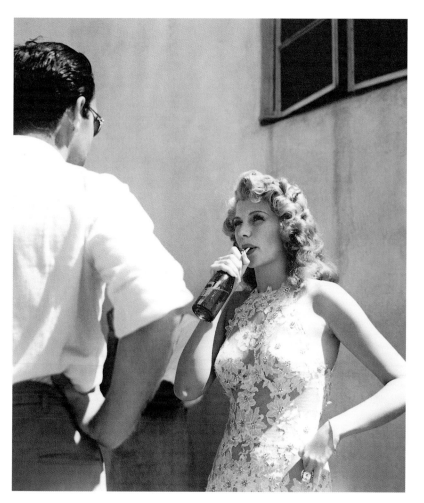

Rita sips a soda during a break in a photo session at Columbia Studios.

◄ ∨ Two photographs that perfectly express the two sides of Rita Hayworth. Offscreen she wore conservative and comfortable clothes (her favorite was a pair of rolled-up jeans) and no makeup; she was painfully shy, abhorred attention, and, unless with close friends or family, was quiet. Onscreen she was the sex goddess supreme with quick-witted banter that made men grovel. She was much more comfortable in the former mode.

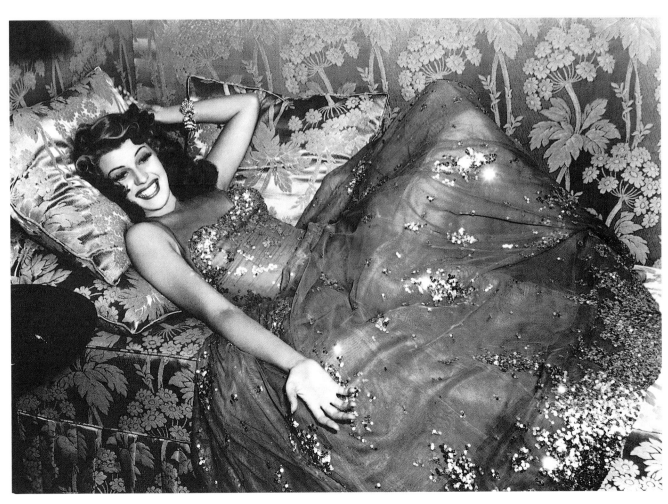

➤ Rita during an autograph session at the Hollywood Canteen. For the many men who had idolized her and kept her famous pinup with them at all times, meeting her was a dream come true. She would often help out at the Canteen after a long day of filming; no sacrifice was too great for "the boys." She was even known to have obliged several soldiers who asked for a lock of her hair.

During the months when Victor Mature was at sea, Rita continued to do her part for the war effort. She danced with soldiers at the Hollywood Canteen, toured with the USO, and visited servicemen in the hospital, signing autographs and giving chaste kisses on the cheek. In an overseas poll, American GIs named her the "Number One Back Home Glamour Girl." Along with Hedy Lamarr, Dorothy Lamour, Betty Grable, and other actresses of this era, Rita's contribution to keeping up the morale of America's fighting men was invaluable. The importance of these women during World War II cannot be overstated; to thousands of men, a simple pinup photo was a connection to home, a touchstone to that distant civilian life. For Rita, it was a privilege and a source of pride to have made such an impact.

➤ Rita was very active in work for the Naval Aid Auxiliary. Here she again wears their uniform as she makes her way to a radio performance. Rita's participation in many radio programs was yet another of her contributions to the war effort.

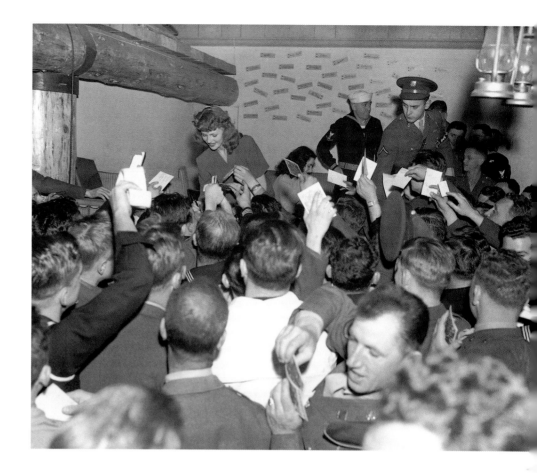

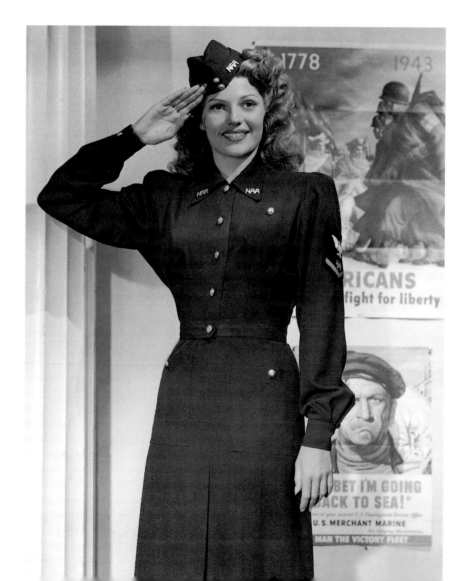

< A refreshingly natural photo of Rita taken by a fan after rehearsing at the studio.

> Columbia Studios often arranged and took full advantage of the stars' visits to the servicemen, staging photos and sending them out to all of the major magazines and newspapers. Likewise, the GIs were kept fully stocked on pinups and portraits of Rita. Here, in a visit to Camp Callan on Mother's Day, Rita darns the trousers of a very dramatic soldier.

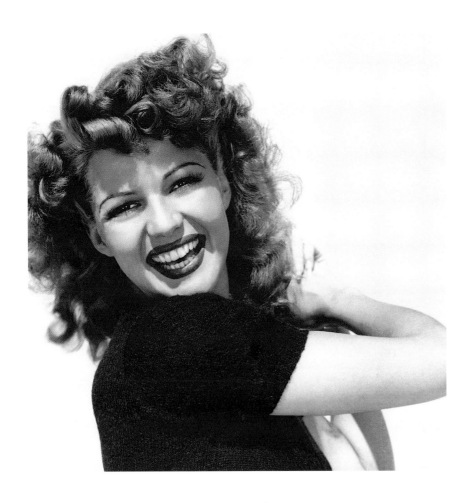

Rita's carefree expression belies her exhausting lifestyle. Her schedule of filming, performing on radio programs, helping out at the Hollywood Canteen, and posing for publicity photographs eventually took its toll. In September 1942 a tired Rita checked into Cedars of Lebanon Hospital. Her doctor stated that she suffered from a "complete nervous breakdown," but she was soon back at work.

Rita's hair became one of the most copied manes in Hollywood. At 24 years of age, Rita was already an idol for millions of women and a symbol of desire for millions of men.

Rita gets set up by her favorite portrait photographer and the man who was responsible for some of the most beautiful pictures ever taken of her, Robert Coburn (center). This photograph illustrates the labor needed and the effort extended for just a single portrait session; many of the players, such as hair and makeup artists, are not even pictured here.

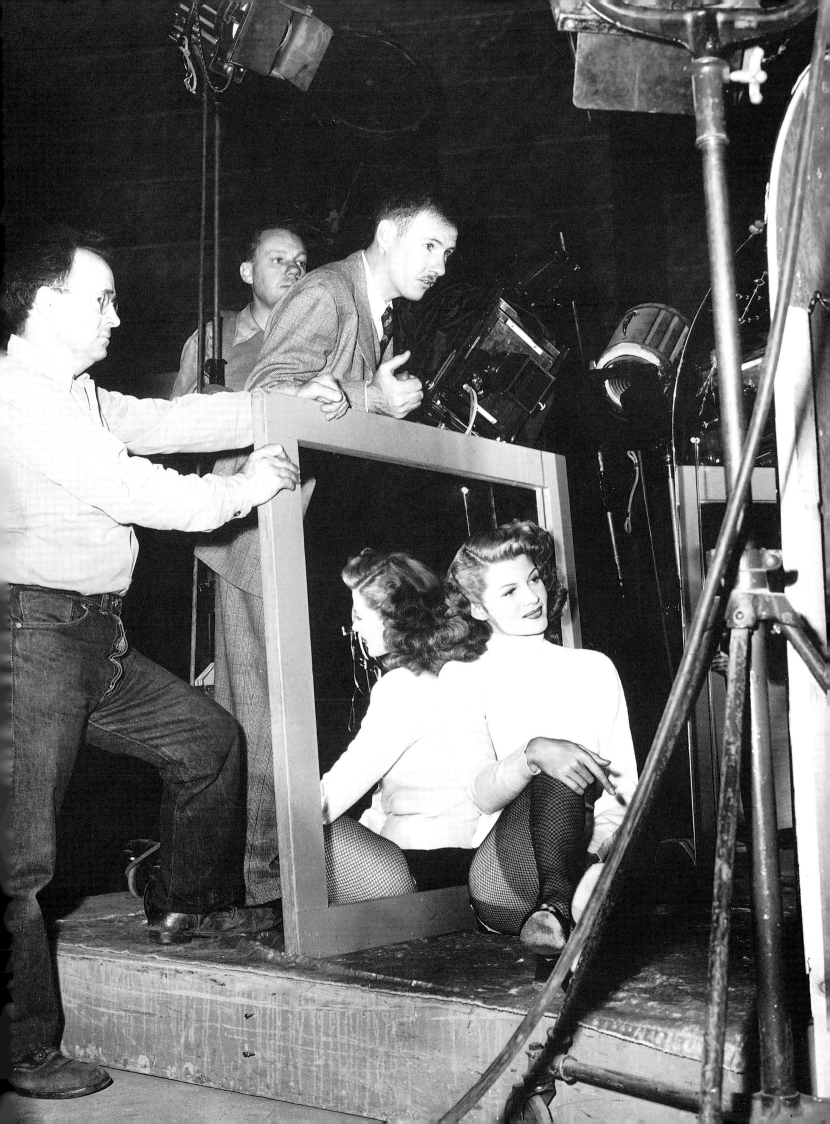

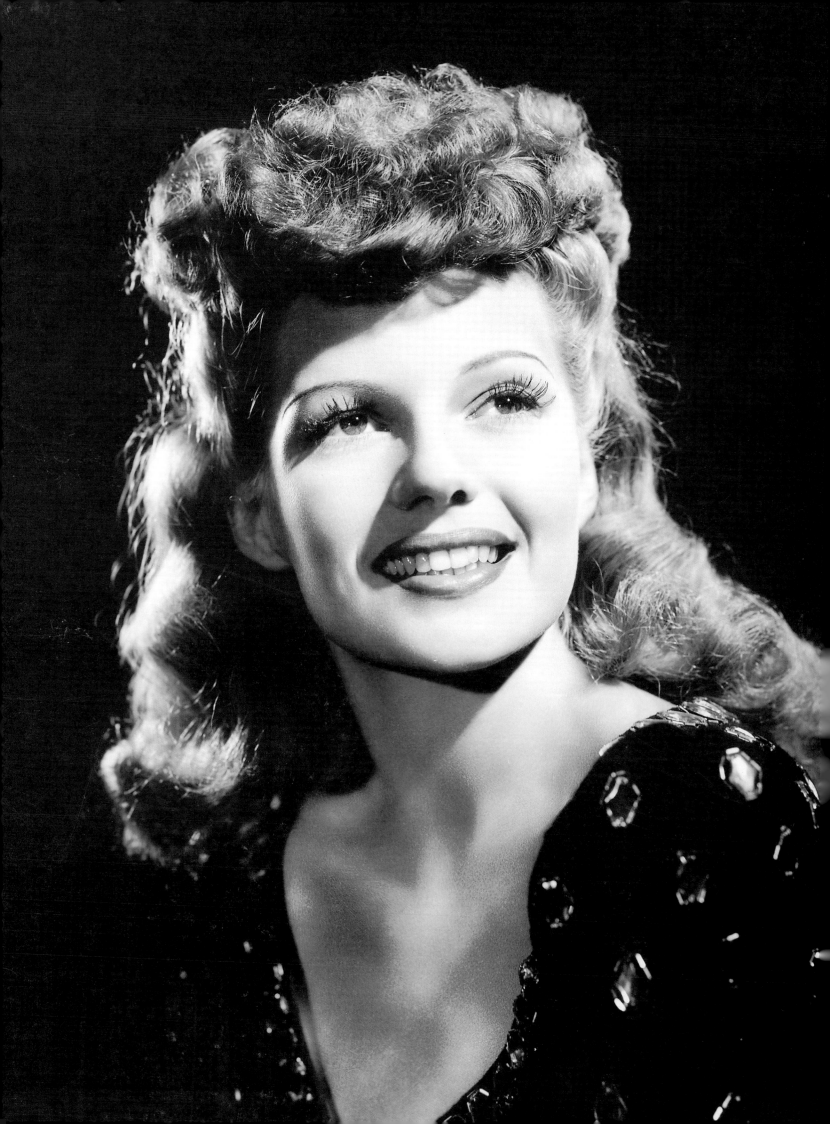

◄ On the cusp of superstardom, Rita
epitomizes the 1940s glamour girl
in this stunning portrait. Scheduled
to begin shooting a new film with
Gene Kelly, Rita kept up her corres-
pondence with Victor Mature, despite
the attentions of another appealing—
and persistent—suitor.

≺ Victor Mature's sense of humor may have captured Rita's heart, but it was Orson Welles's genius that stole it from under his nose. Welles, who soared to fame after his famous Mercury Theater "War of the Worlds" broadcast and his landmark film, *Citizen Kane*, became enamored of Rita shortly after he saw her picture in a magazine. When they appeared together on a radio broadcast, he was surprised to find that she was as sweet and gentle as she was beautiful. Rita, for her part, spurned his requests for dates in an effort to keep her promise to Victor Mature. She succumbed, however, to Orson's persuasive ways, as women often did. At the time, Welles was putting on a magic act for the GIs called *The Mercury Wonder Show*, which also starred his pal Joseph Cotten. He asked Rita to be his assistant, and she gamely subjected herself to various magic tricks. Years later and still carrying a torch for Rita, a bitter Victor Mature would complain, "I was really hung up on Rita, but she wanted to be *sawed in half!*"

∧ The fan magazines had a field day with this new romance of two of Hollywood's biggest, and most improbably matched, stars. Orson Welles had a medical deferment from military service, and the two saw each other often. Ever the showman, Orson barraged Rita with flowers and romantic evenings, and soon Rita was completely smitten. Rita, insecure about her lack of education, happily responded to Orson's willingness to share his knowledge. He encouraged her to read certain books and listen to music. "My growing up really started with Orson Welles," Rita would later say. "He was a brilliant man, a stimulating man, a man with whom I was deeply in love and who was in love with me." The press dubbed them "Beauty and the Brain," and as their relationship commenced, Rita found a comfort and security that she had not known before.

⌄ Rita's appearance with Fred MacMurray on a "Command Performance" radio broadcast is chronicled on celluloid. It later appeared in a 1943 short film called *Show Business at War*, part of *The March of Time* series produced by the editors of *Time* magazine. Actors Ginny Simms, Don Wilson, and Phil Baker round out the cast.

➤ Rita laughs gaily on the set of *Cover Girl* (1944), a Columbia musical with Gene Kelly, Phil Silvers, and Lee Bowman, which began shooting during Rita's romance with Orson Welles. Orson occasionally visited the set, and it was obvious to all that the couple were madly in love. Rita's happiness transferred onto the screen, and she was at her most spirited and lovely in this charming film.

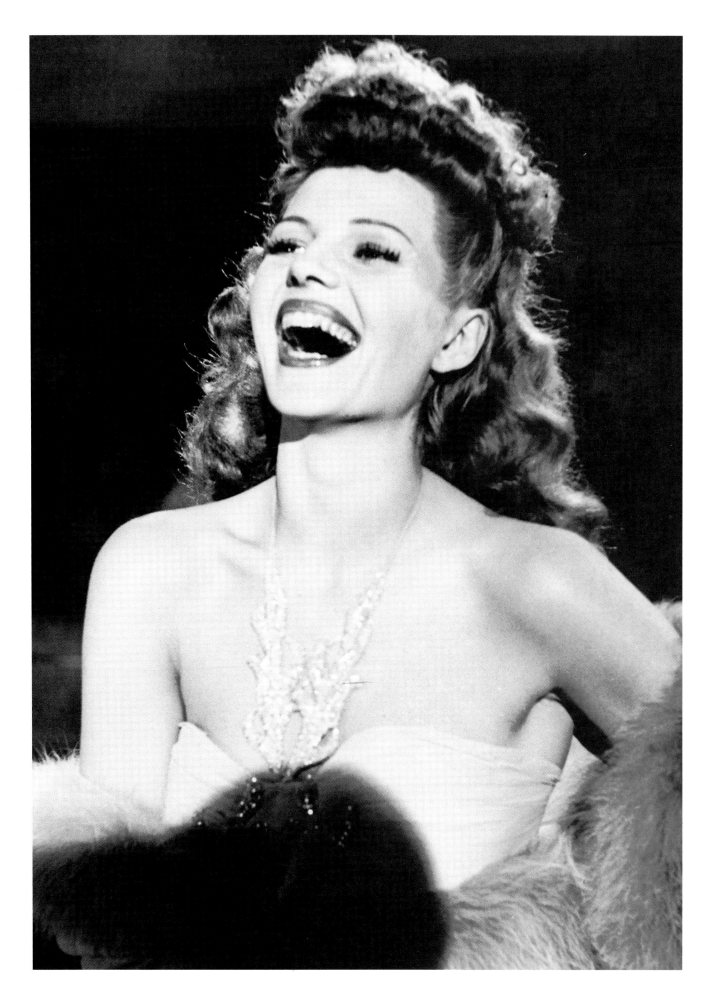

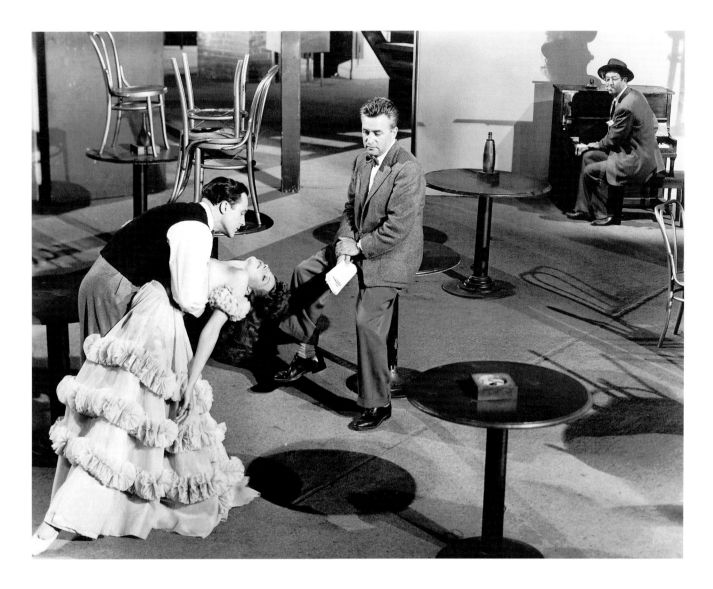

∧ Rita, Gene Kelly, and Phil Silvers are directed by Charles Vidor in the "Long Ago and Far Away" number. *Cover Girl* was the first and only picture that Rita would make with Gene Kelly, and along with the films she made with Astaire, it was one of her favorites. Finally, the world could see Rita in another color film, truly the medium for her spectacular beauty. But Columbia still would not allow her to sing her own songs, a situation that infuriated her. With a little training, her voice could be lovely, but the studio preferred to dub her songs using professional singers such as Nan Wynn, Anita Ellis, Jo Ann Greer, and—for *Cover Girl*—Martha Mears.

As in every other aspect of her work, Rita was a perfectionist when it came to dubbing her songs. During rehearsals, both Rita and the vocalist would study each other's movements and breathing so intently that when filming began, Rita's lip-synching was flawless. Her own voice can be heard briefly singing one line in *The Strawberry Blonde* and in several television specials in the 1970s, but the studio's lack of confidence in her ability, at a time when she was their biggest asset, was a sore point with Rita long after she had stopped making films.

In a scene from *Cover Girl,* Rita and the other showgirls (actress Leslie Brooks is second from left) perform "The Show Must Go On," in which they display their characters' less-than-perfect singing and dancing talents. One of *Cover Girl's* most entertaining numbers and a perfect example of Columbia's special brand of musical kitsch, the scene was an audience favorite.

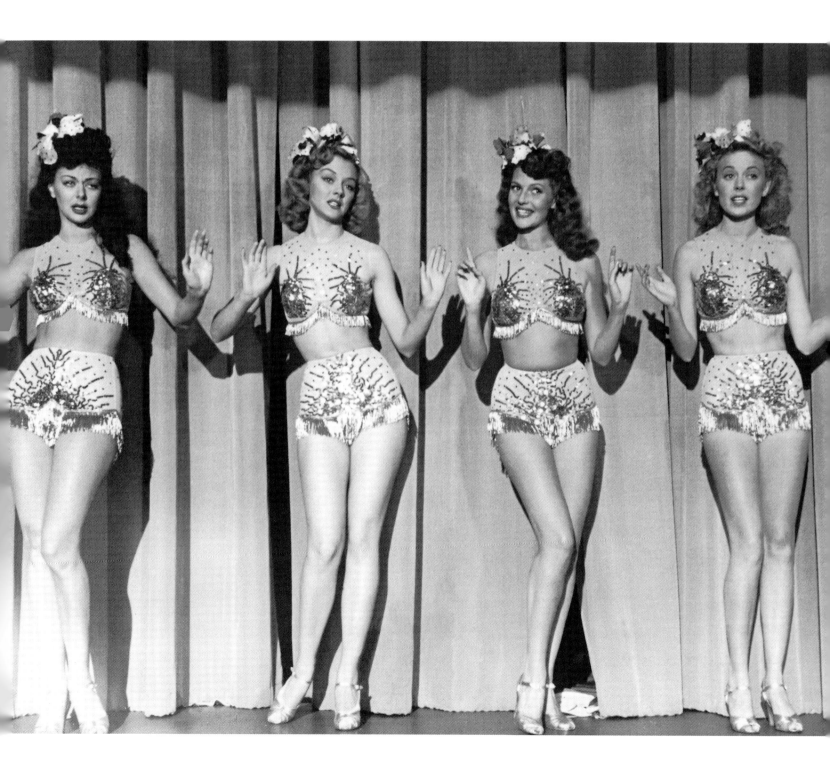

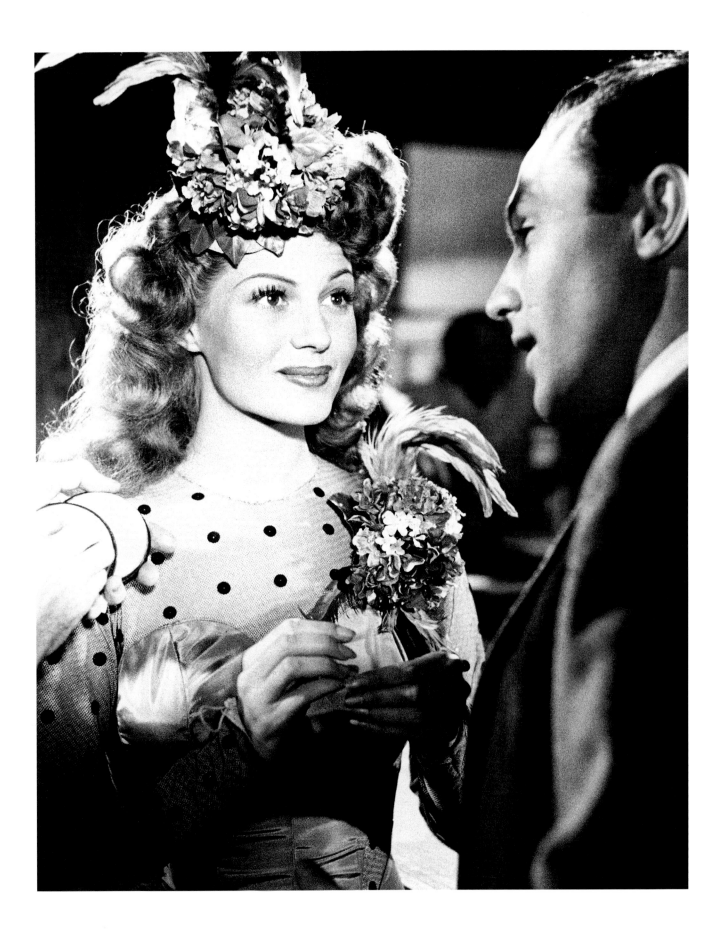

◄ Rita listens intently to the advice of costar Gene Kelly on the set of *Cover Girl*. To help promote the picture, she appeared on the cover of *Life* magazine for the third time on January 18, 1943. (Her fourth *Life* cover was for the November 10, 1947, issue; in 1971 Rita appeared on the cover with several other actresses from the 1930s and 1940s for *Life*'s February 19 issue saluting nostalgia.) *Look*, *Life*'s chief rival, got in on the action by naming Rita "Best Actress of 1944" for her performance in *Cover Girl*.

⌄ A light moment on the set of *Cover Girl* with costars Gene Kelly and Phil Silvers, director Charles Vidor (in bowtie), and composer Sammy Cahn at the piano. Not pictured but nevertheless an important new person in Rita's career during this time was the co-screenwriter of *Cover Girl*, Virginia Van Upp. *Cover Girl* would mark the beginning of their business relationship and personal friendship; Virginia would later produce *Gilda*.

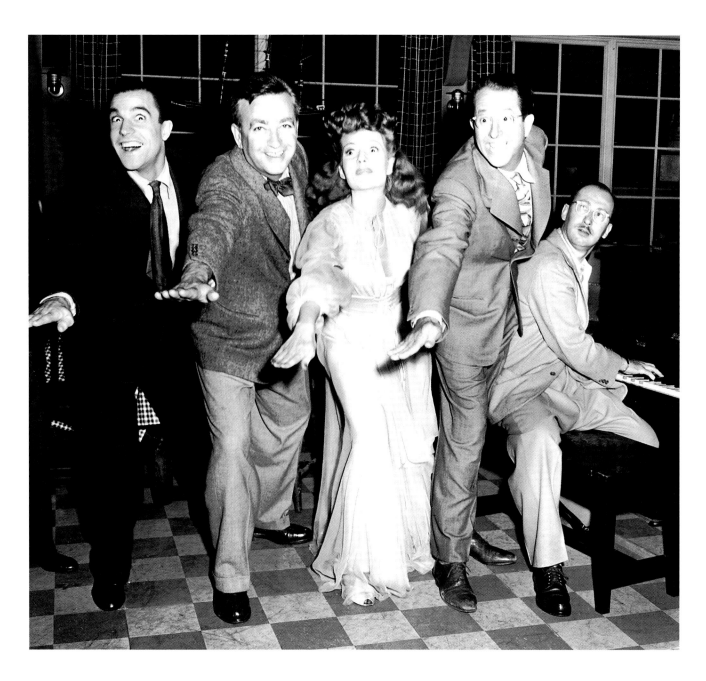

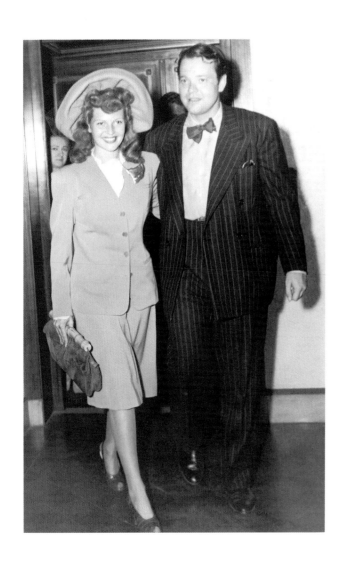

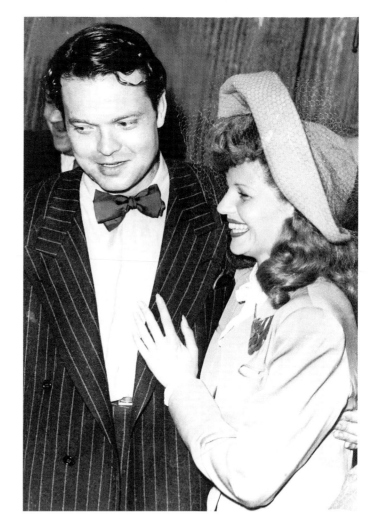

∧ ∧ ➤ To everyone's surprise,
Rita and Orson Welles were married
on September 7, 1943, in Santa
Monica. Joseph Cotten was the
best man. Rita, still wearing movie
makeup, secretly left the set of
Cover Girl for the brief civil
ceremony. In her brown suit with
matching hat and veil, she was
noticeably nervous, stumbling on
her words several times as a
roomful of reporters and photo-
graphers watched. As they left the
judge's chambers, Rita announced
she was happier than she had ever
been in her life. "When you're in
love, you're living," she once said.
"You matter."

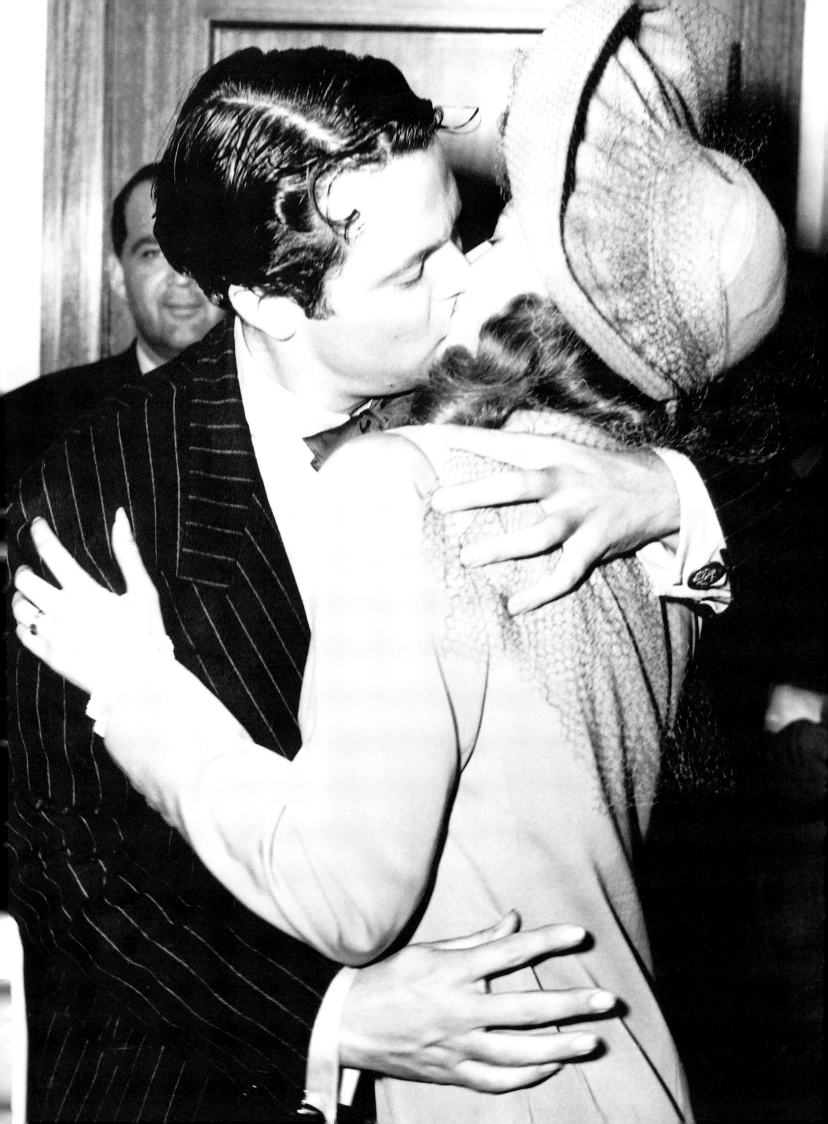

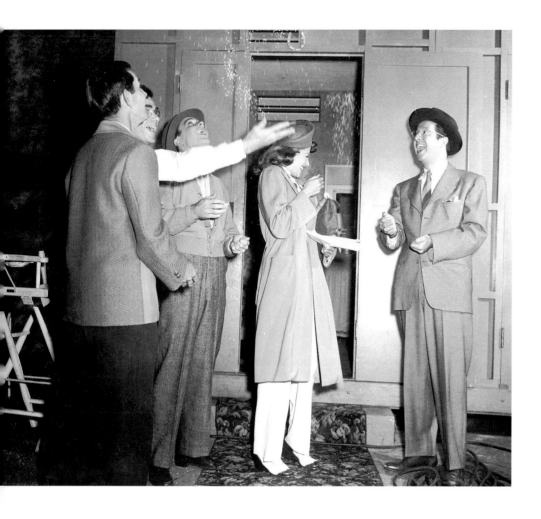

◀ On the set of *Cover Girl*, the cast and crew welcome the new bride with rice and congratulations upon her return after the wedding. It seemed as though everything was going Rita's way—she was happily married, and she was one of the top female stars in America. She still didn't realize her power as Columbia's biggest moneymaker, however, and Harry Cohn wasn't about to let her. Rita was too easygoing in her dealings with Cohn, who continued to monitor her every move, even going so far as to bug her dressing room. Cohn was livid about her marriage to Welles, perhaps more from jealousy than the fact that she hadn't informed him beforehand. He pulled her out of *The Mercury Wonder Show*, stating that it went against her contract.

◀ Rita is visited on the set of *Cover Girl* by her adored paternal grandfather, Antonio "Padre" Cansino. He had personally crafted Rita's first pair of castanets, which she kept by her bedside until her death. Padre was filled with pride at the accomplishments of his granddaughter, who was carrying on the family tradition. When he first saw his Margarita on the movie screen, he stood up in his chair and cheered.

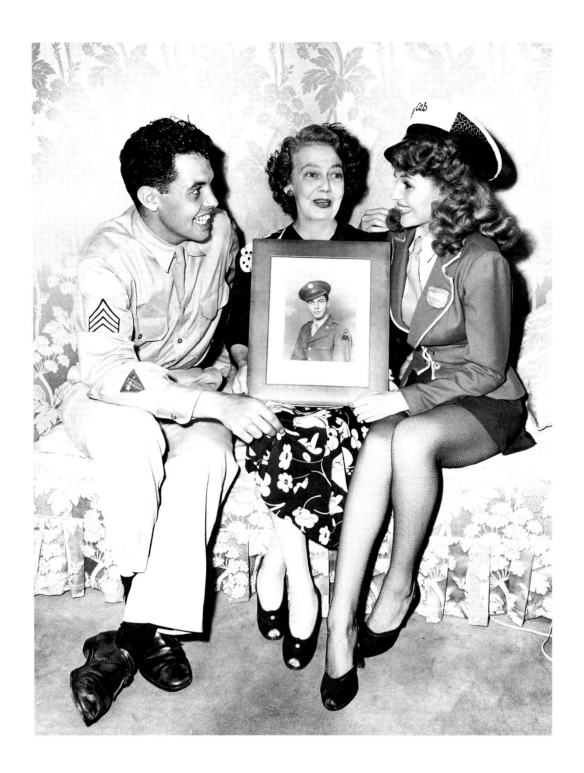

∧ Rita, her brother Eduardo, Jr.,
and their mother have a chat on
the set of *Cover Girl*. Volga holds a
photograph of Vernon, who was in
the service. Life back home in the
Cansino household was rough:
Eduardo, Jr., and Vernon were both
drafted, and Volga was gravely ill.
Rita was very supportive, and she
maintained a close relationship
with her mother.

In the meantime, Rita was finally
realizing what being married was
all about. Orson's gregarious
personality was bringing out a side
of Rita that few people had seen.
She seemed more at ease, more
herself, and happier than ever.
It was only natural then, that amid
all of this joy, Rita would find out
that she was pregnant.

◄ Makeup man Clay Campbell protects Rita from the sun's harmful rays during a photo shoot. Rita always implicitly trusted the crew members in charge of making her look good—many of the same people worked with Rita from film to film and became a family of sorts. All were fiercely loyal to Rita, even protective.

◄ Rita relaxes on the set between takes of *Tonight and Every Night* (1945). Rita is at her most beautiful in this film—cameraman Rudy Maté truly captured her "motherly glow" in several huge, breathtaking close-ups.

Rita longed for a baby, and she loved preparing for the baby's arrival. She toyed with the idea of quitting films, but her contract required that she make *Tonight and Every Night*, a musical that starred her with Lee Bowman, Janet Blair, and Marc Platt. Rita, whose vocals were dubbed by Martha Mears, performed the dance numbers in the early stages of her pregnancy, and in scenes filmed later she wore flowing gowns or coats to cover her expanding tummy. *Tonight and Every Night*, directed by Victor Saville, is one of Rita's forgotten gems, a truly delightful film that strays from the usual lighthearted musical theme and ends on a sad, realistic note.

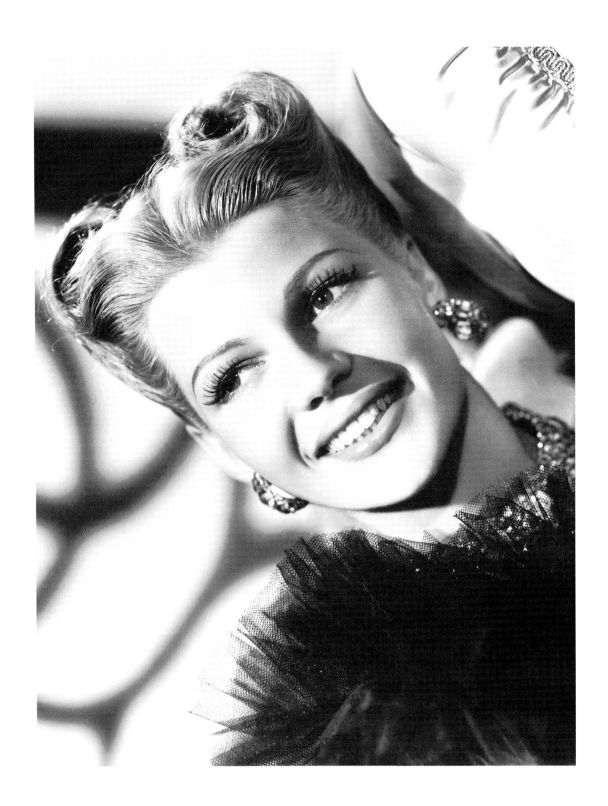

➤ Rita's anticipation over the impending arrival of her baby made her all the more anxious to leave the movie industry. She had worked her whole life, and she no longer found much joy in filmmaking. "I drove myself to the studio and they'd wash my hair to make it shiny bright," she recalled many years later. "Then I'd think, 'It's only 7 a.m. and I have the whole day to go.' But I stuck it out. I made zillions for Columbia and they didn't do anything for me. I made myself famous but they kept the money." The only thing that attracted Rita now was the security of love and family.

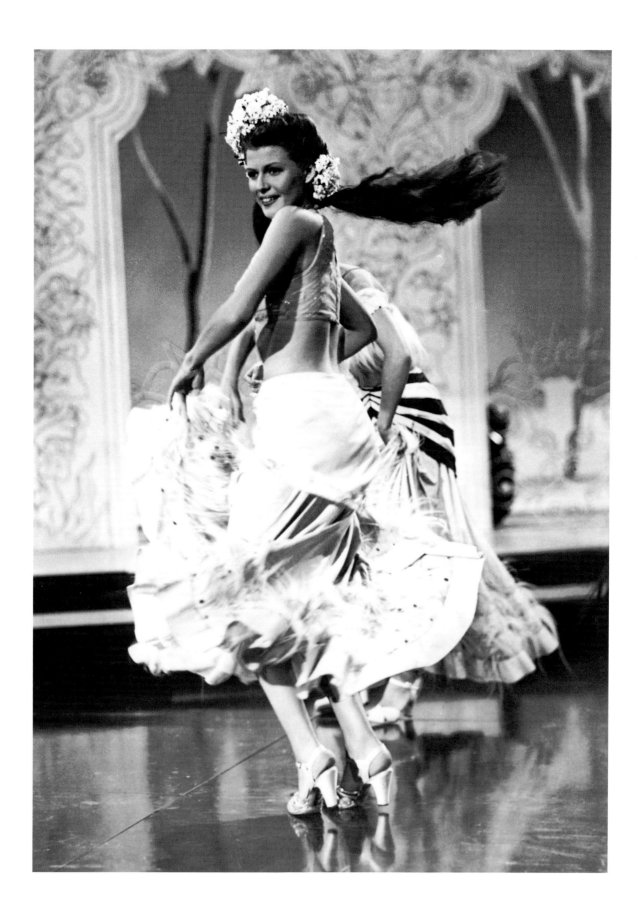

ᐱ Rita performs the number "You
Excite Me" in the film *Tonight and
Every Night*. She was approximately
three months pregnant at the time.

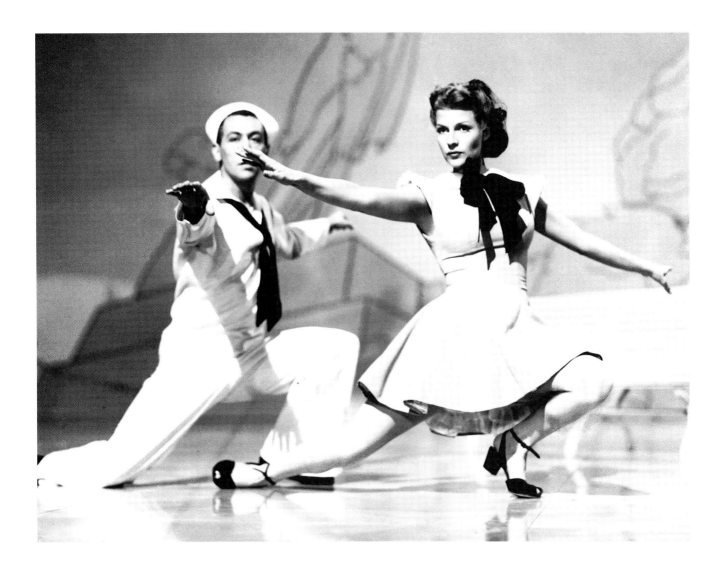

∧ Rita (wearing a hairnet to keep her hair in place) and choreographer Jack Cole rehearse the number "What Does an English Girl Think of a Yank?" in the film *Tonight and Every Night*—a rare film appearance by the renowned choreographer. Cole, who would subsequently work with Rita on other musicals, was amazed at Rita's lack of pretense. "Rita would just come in; she was absolutely always on time, you know," recalled Cole. "I can see her sitting there smoking a cigarette and drinking coffee, just like she was one of the dancers. It wasn't Rita Hayworth, Star; she was always very pleasant when she came in, always very nice to the kids. It wasn't a star bit at all." Cole would also notice something in Rita that many of her other dance partners had experienced: in rehearsals, Rita would sometimes appear to be simply going through the motions; but when the cameras rolled, Rita performed with such energy and vivacity that her costars were often caught off-guard. Rita came to rely on Jack Cole, who had a strong sense of her capabilities as a dancer. Nearly a decade later Cole would work closely with another sex goddess: Marilyn Monroe.

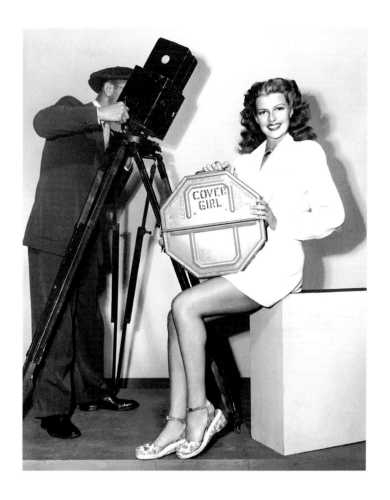

◄ Rita poses for a photograph taken by a vintage 1894 camera to commemorate the 50th anniversary of the first public showing of a motion picture. Columbia made sure to slip in some promotion for the newly released *Cover Girl* (note that the strategically placed film canister hides her pregnant figure).

➤ Rita and Orson go over the script of a radio broadcast for *Lux Radio Theater*. Rita was more settled than ever before, but insecurities about her relationship with Orson began to surface. Now that the wooing had ended, it seemed that Orson simply didn't have enough time for Rita. Orson's varied interests kept him busy, as did his constant entourage, and Rita was jealous. Nevertheless, she hoped that the new baby would provide family unity and solve the problems in their relationship.

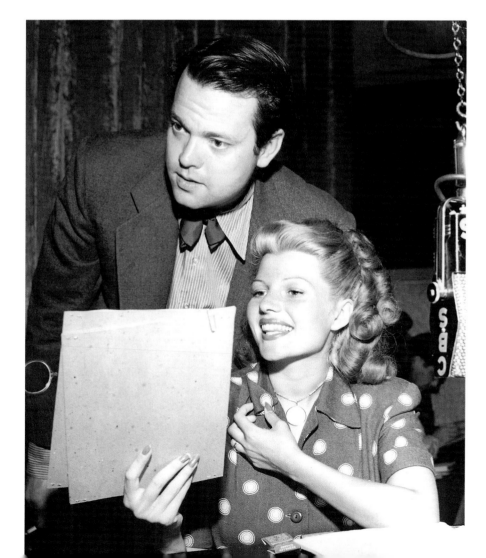

⌃ Rita relaxes at the home she and Orson Welles shared.

➤ A pregnant Rita at Elsa Maxwell's Paris Liberation Party, shortly before the arrival of her child. "When she was expecting her baby," said director and friend Charles Vidor, "she was like a goddess, walking far off the earth, touched with glory." During the final months of her pregnancy, Welles was on the campaign trail for Franklin Roosevelt and was often away from home. Orson was even entertaining the idea of running for president himself someday.

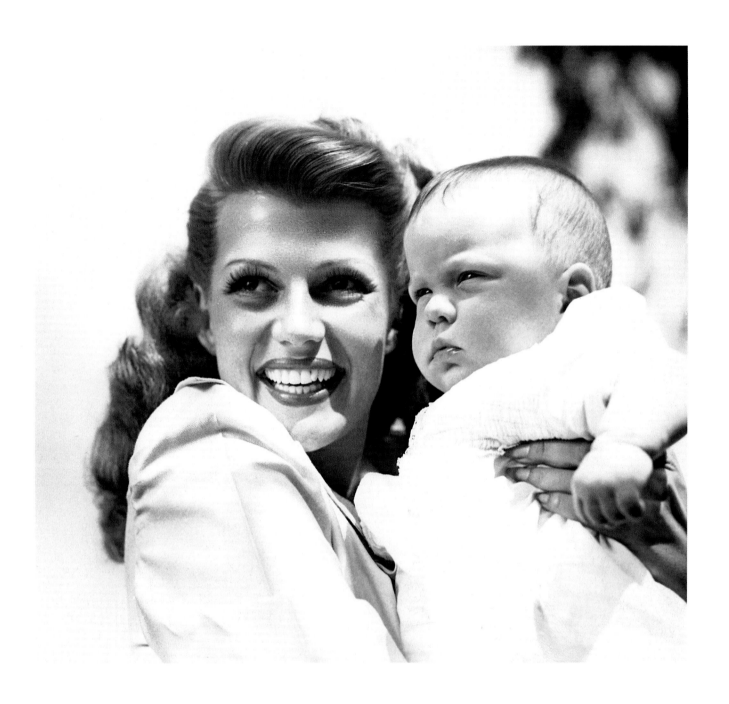

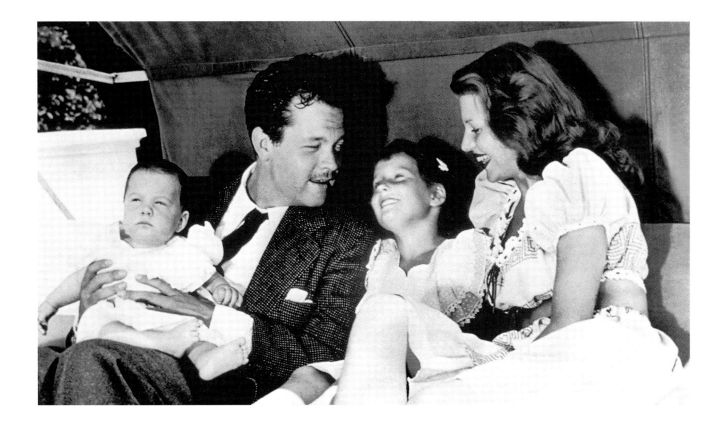

◄ ∧ On December 17, 1944, Rita
gave birth to an adorable little girl,
Rebecca Welles. Rita was overjoyed
and hoped that together with
Orson's daughter from a previous
marriage, Christopher, the four
would form an intimate family.

➤ Rita enjoys a quiet moment of
togetherness with baby Rebecca.
Her happiness was hampered by
the fact that her mother, Volga,
was in the hospital. Still weak from
having given birth, Rita flew to
Volga's side to care for her. Volga
soon died, and Rita was inconsol-
able; her mother had been her best
friend. "I have never seen her as
outwardly devastated as she was
when her mother died," revealed
Charles Vidor.

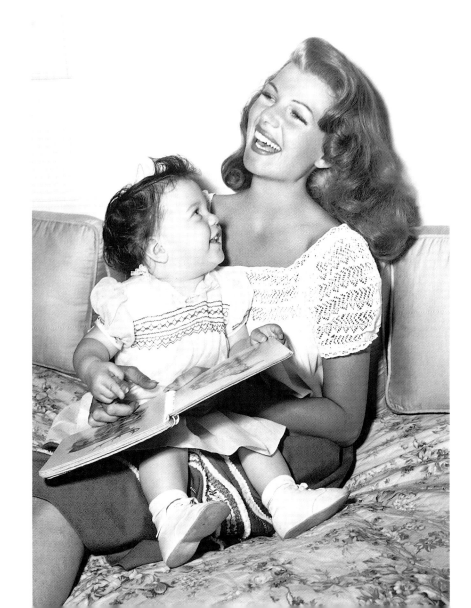

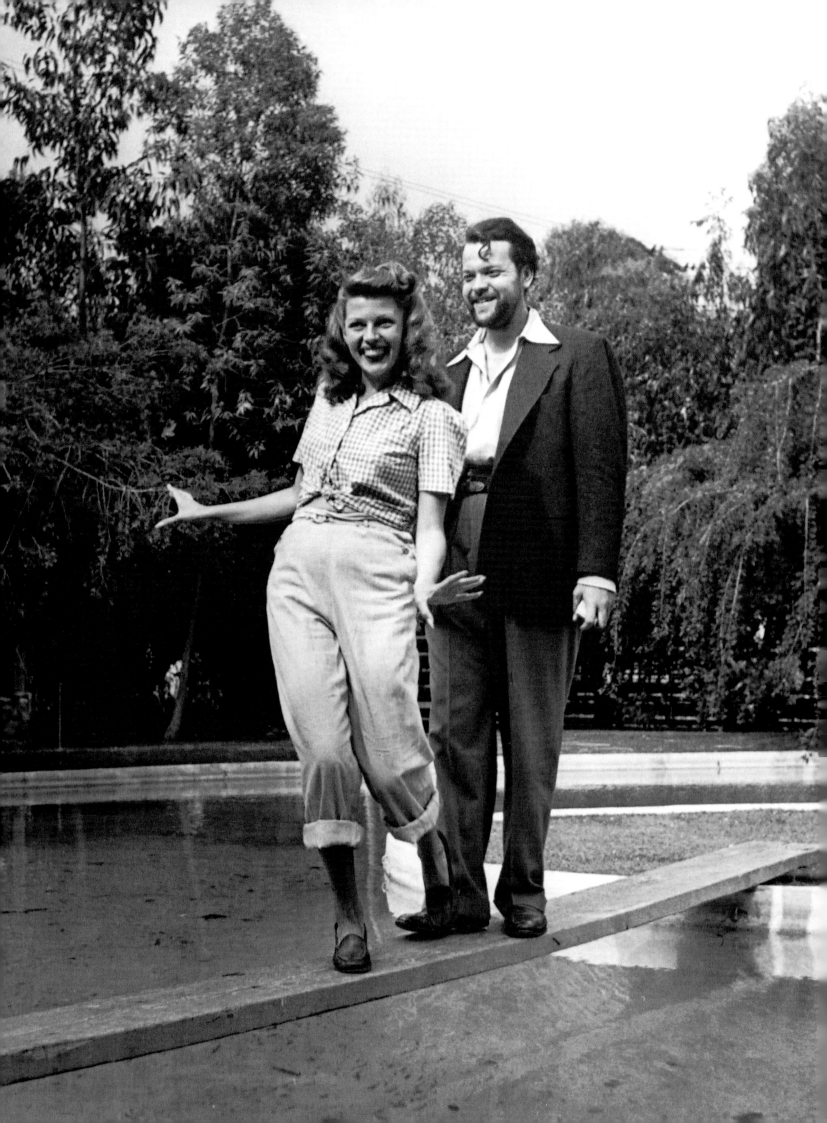

One of a series of photographs taken by Peter Stackpole for *Life* that captures the fun-loving side of Rita and Orson's relationship. The happy moments of their marriage were becoming fewer and farther between, much to Rita's distress. Rita's jealousies over Orson's indiscretions—some real and some imagined—were taking a toll on the relationship and were driving Orson away. Orson seemed in agony over the unhappiness he was causing Rita, yet he couldn't seem to change. The fact that Rita's contract would not allow her to travel with Orson on his various creative ventures only further exacerbated their difficulties. "We were jailed, both of us, by that contract. Victims of our success," she recalled years later.

Perhaps trying to recapture the allure of her 1941 World War II pinup, Rita poses again on her bed for a photograph that clearly rivals its predecessor. Marriage and motherhood had produced a mature sensuality in Rita that is evident in this striking study.

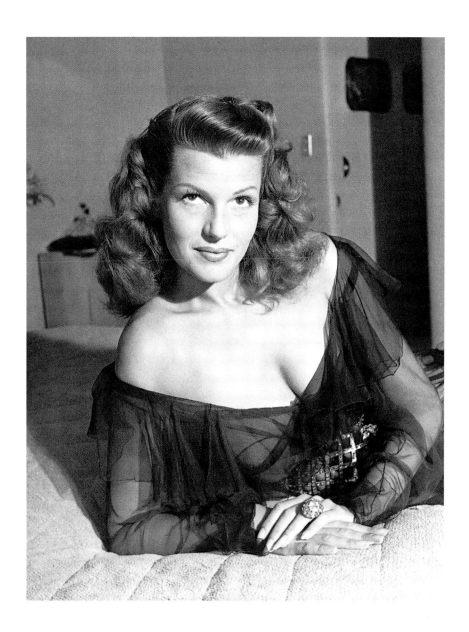

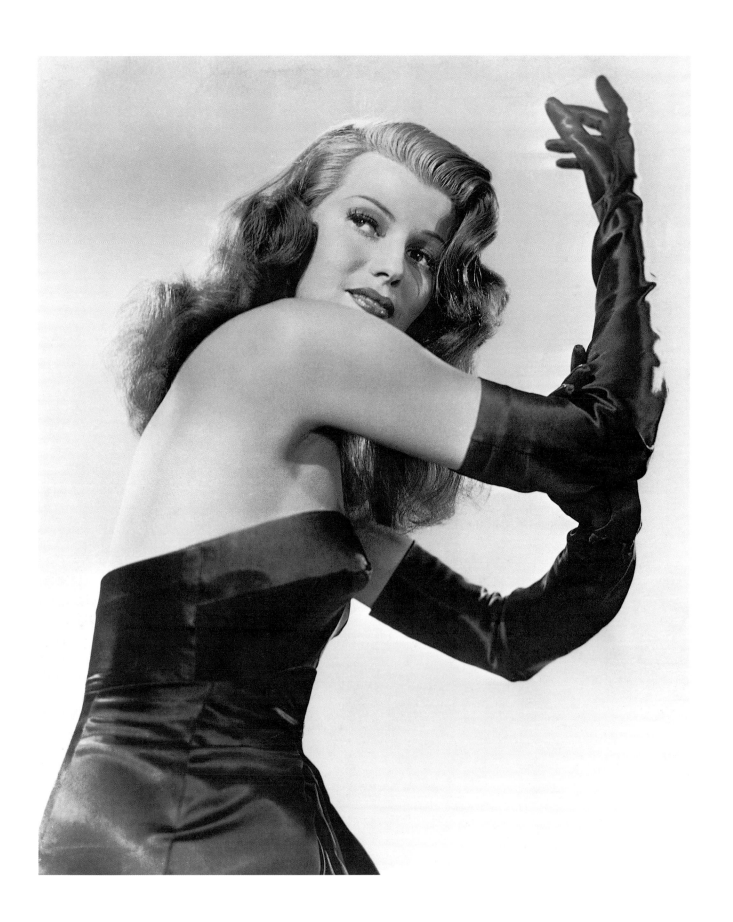

There Never Was a Woman Like Gilda

◄ This publicity portrait for *Gilda* (1946) captures the classic Hayworth look that the world still remembers best. Still coping with the loss of her mother and coming to terms with the unraveling of her marriage, Rita felt the need to return to work. *Gilda* was her second film with Glenn Ford, and it was destined to become her most celebrated picture. Never would she look more beautiful—or feel more miserable. *Gilda* was one of the first film noir pictures that became popular after the war. Rita's sultry rendition of "Put the Blame on Mame" became a classic movie moment, forever linking her with the character of Gilda. The number, which was filmed in only two takes, was a "limited" striptease in which she removed only her long black gloves, but it was enough to create controversy.

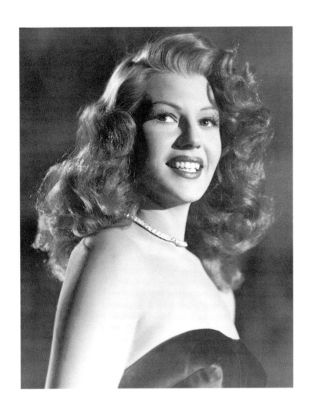

◀ ∨ "Put the Blame on Mame" was choreographed by Jack Cole, and Jean Louis designed the strapless black gown that became a fashion staple. Although it appears that Rita moves with ease in the famous black gown, she was actually tightly corseted (having recently given birth), and the dress was so stiff it felt like plastic.

The result, nevertheless, caused a sensation. Jack Cole would later say about this number, "Of all the things I ever did for movies, that's one of the few I can really look at on the screen right now and say: If you want to see a beautiful, erotic woman, this is it. It still remains first class." Of her identification with the role, Rita would quip, "No one can be Gilda twenty-four hours a day."

◄ Looking every inch the glamorous movie star, Rita has her famous mane touched up by hairdresser Flora Jaynes. She wears another of Jean Louis's fabulous creations, seen in the "Amado Mio" musical number.

➤ Rita relaxes on the set in costume for the carnival sequence of the film. The run in Rita's stocking was a crucial part of the plot development in the original script, but the scene eventually landed on the cutting room floor.

➤ "Gilda, are you decent?" Director Charles Vidor confers with Rita about one of the most famous movie entrances in history. When Rita flipped back her luxurious mane of hair and naughtily quipped, "Me? Sure, I'm decent," audiences went wild. The general public had never witnessed such a combination of raw sexuality and vulnerability, nor would they ever forget it.

➤ "There NEVER was a woman like Gilda!" read the tag line, and Rita's beauty captivated people all over the world. Years later, Orson Welles was still subject to the hysteria surrounding his famous ex-wife—on many occasions while nightclubbing in Europe, Welles would be greeted with an orchestra rendition of "Put the Blame on Mame" and mobbed by adoring fans shouting "Gilda! Gilda!"

◁ During the 1945 filming of *Gilda*, Rita and Orson Welles separated. Rita was distraught over the breakup, but her firm friendship with Glenn Ford helped her to cope with the separation. The chemistry between the two stars onscreen was extraordinary. "Rita and I were very fond of one another. We became very close friends and I guess it all came out on the screen," said Ford.

∨ Did she or didn't she? Rita confers with her favorite director, Charles Vidor, during the bar scene rendition of "Put the Blame on Mame." In a 1971 interview, Rita stated that she indeed used her own singing voice for this particular scene. According to a recent documentary on the history of Columbia Pictures, however, this persistent legend is untrue. Whatever the case, the rest of her vocals in *Gilda* were dubbed by Anita Ellis.

➤ Rita with Glenn Ford, in a rare and unusual publicity portrait for *Gilda* that depicts the happy ending. Most of the publicity photos showcased the love/hate relationship between Gilda and Johnny Farrell that made the film such a success. Rita and Glenn would go on to appear in three more films together, but none would eclipse the success of *Gilda*.

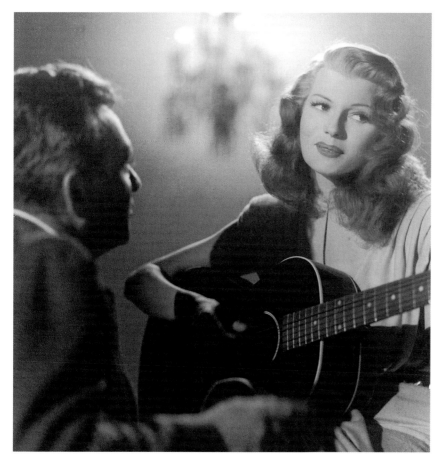

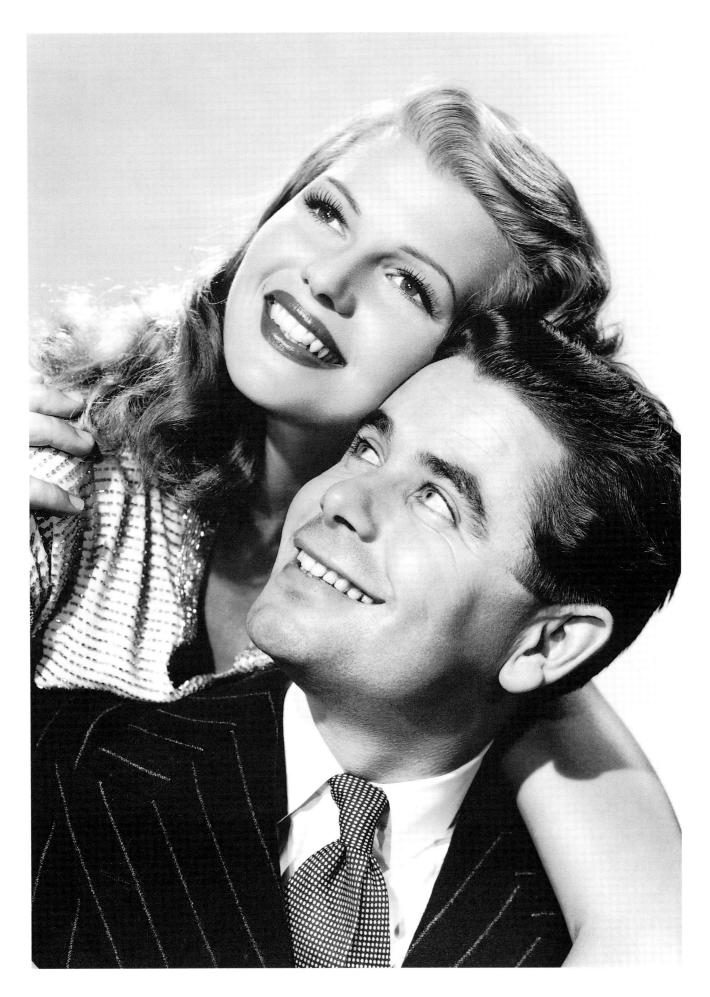

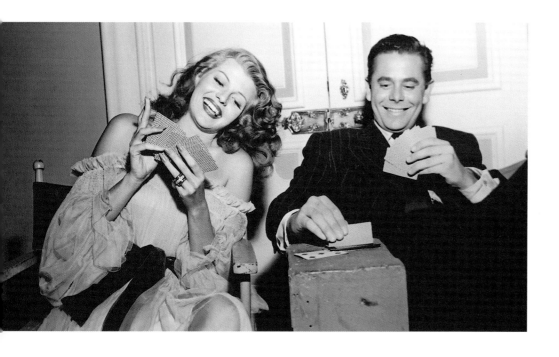

‹ Rita and Glenn enjoy a game of cards between takes (notice that the studio airbrushed Rita's cigarette from her right hand). "There were great scenes with Glenn Ford," Rita later recalled, "slapping each other and kissing each other. It was a marvelous big mess!" In one scene Rita had to strike Glenn across the face. As Charles Vidor explained, "She would no more do that in real life than she would commit murder."

⋁ Rita and costars George Macready and Glenn Ford study the script of *Gilda*.

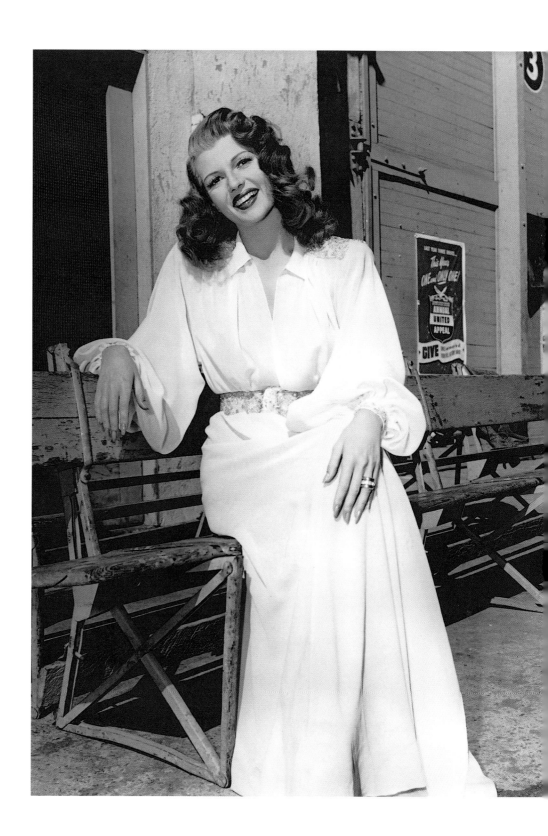

➤ Rita relaxing on the Columbia lot during filming of *Gilda*. After the film's success, many people expected Rita to walk and talk like the siren onscreen and were disappointed when they instead encountered a quiet, reserved woman. She once jokingly blamed *Gilda* producer Virginia Van Upp for creating a character that she could never live up to. "Most men fell in love with Gilda and wakened with me," she complained in a now famous remark.

Y Rita tickles the toes of her daughter, Rebecca, at their home in Los Angeles. Rita loved being a mother and proclaimed it her greatest achievement.

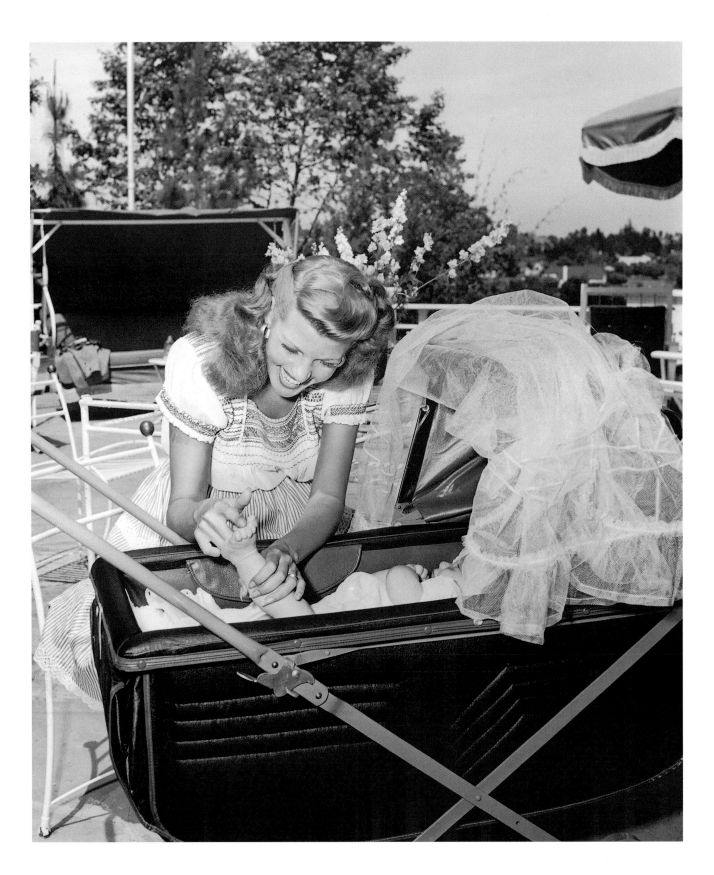

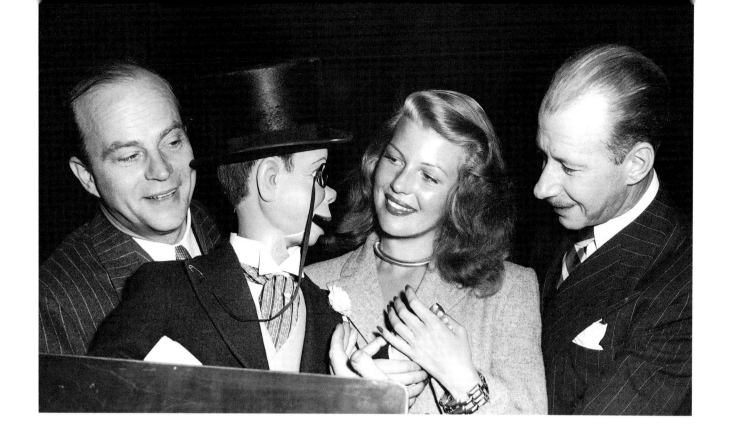

∧ Charlie McCarthy makes a play for Rita during her appearance on the Edgar Bergen and Charlie McCarthy radio show. Orchestra leader Ray Noble is at right.

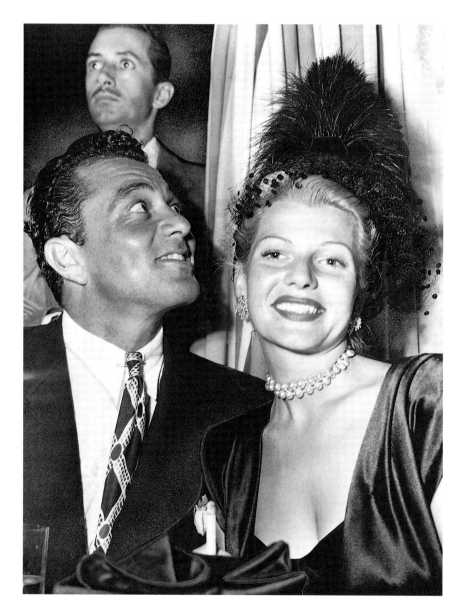

< By New Year's Eve of 1946, Rita was seen about town with singer and former costar (*Music in My Heart*) Tony Martin, who seems to be amused by Rita's stylish chapeau. *Newsweek* called Rita "the most publicized woman in America." Indeed, *Gilda* was one of the top box-office successes of the year. In the midst of this triumph, Rita was trying to enjoy her life as a single woman. Of course, she would have preferred to be with Orson, but on the rare occasions when they were together during the separation, reconciliation seemed a remote possibility. Orson later said that he had never wanted a divorce but instead had hoped that Rita would accept him as he was, flaws and all. The thought of life without Orson was devastating to Rita, but she was strong enough to know it was time to get out of an unhappy situation.

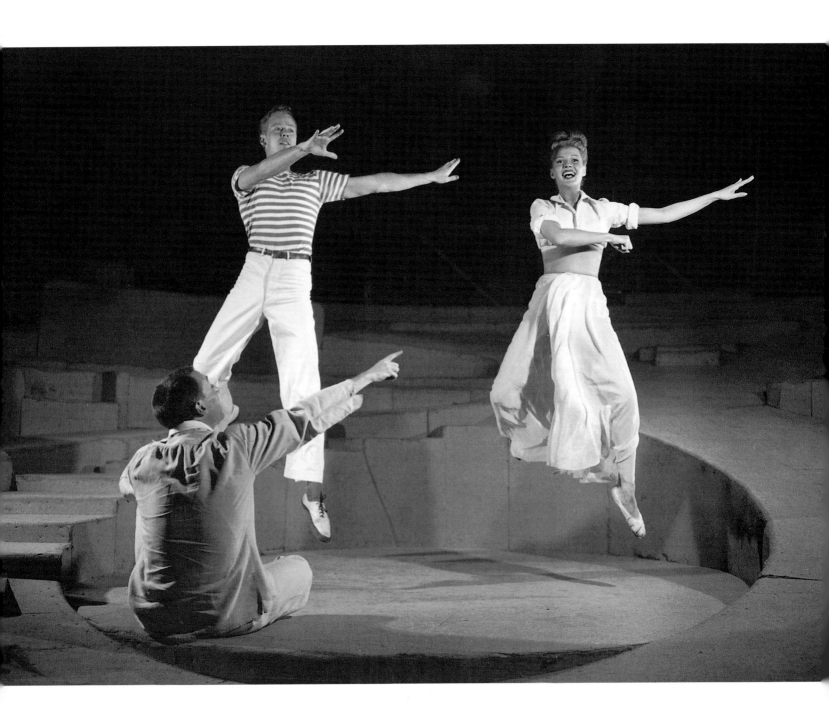

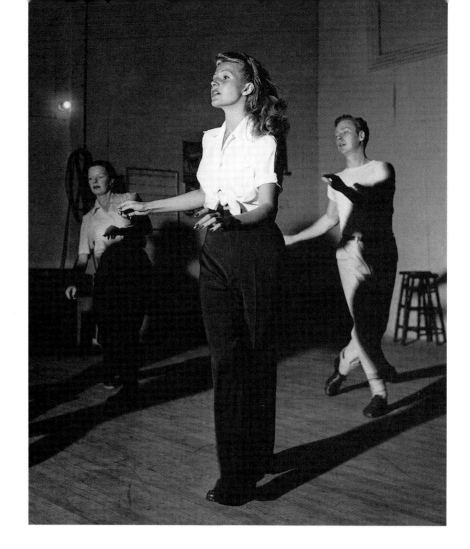

◄ ➤ Few people realize the immense effort that Rita put into her musical numbers. Weeks of rehearsals, bleeding feet, sore muscles, and hours upon hours of constant dancing were all part of the "magic" on the screen that most moviegoers took for granted. In 1946 choreographer Jack Cole (seen at left as he sits and directs Rita and dancer Marc Platt) was assigned to Rita's next film, *Down to Earth* (1947). The film, with its forgettable songs and silly plot, was a poor choice to follow *Gilda*'s phenomenal success. Rita played the character of Terpsichore, the muse of dance. She lived up to that name, but her vocals were again dubbed by Anita Ellis. Costar Larry Parks, best known for his work in *The Jolson Story*, failed to establish any chemistry with Rita, despite the fact that the two of them had been Columbia's biggest stars the previous year. The film, directed by Alexander Hall, has one redeeming quality: it preserves Rita Hayworth at her most breathtakingly beautiful, in lush Technicolor.

➤ A triumphant Rita returns to the set of *Down to Earth* after negotiating a new contract with Columbia. In the process of filming, Rita decided to hold out for more money from the studio. She had been Columbia's top moneymaker for several years, and yet she was still making paltry sums compared to others of her stature in the film industry. Together with Columbia, Rita formed Beckworth Corporation, a company that would allow her twenty-five percent of the profits from every one of her pictures after *Down to Earth* and her next film. In light of the money her pictures were making, Rita was likely to become a very rich woman.

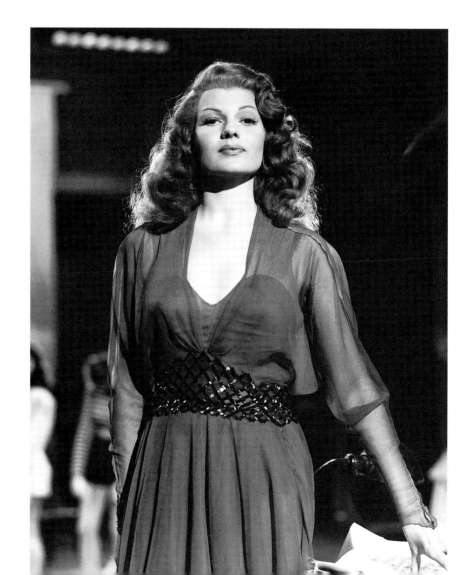

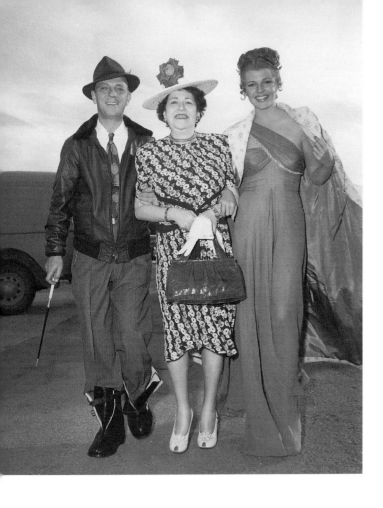

➤ Rita's career as a glamour girl was in full swing, and she was grateful for the adulation. Many years later when she was asked the secret of her success, Rita said, "Maybe it's because I've always kept my clothes on for the camera. I think all women have a certain elegance about them which is destroyed when they take off their clothes."

⋎ Rita relaxes in her dressing room during the filming of *Down to Earth.*

⋏ Hollywood columnist Louella Parsons (seen here on the Columbia lot with the director of *Down to Earth*, Al Hall, and Rita) may not have detected any "star quality" in Rita when she watched her dance at Agua Caliente in the early 1930s, but she became a serious ally when Rita became a superstar. Louella was a very powerful woman in Hollywood, and together with her rival, Hedda Hopper, she was catered to—in varying degrees—by most of the show business elite. Orson Welles was one of the rare few who did not feel the need to kowtow to these two women, and Louella often blasted him in her columns as a result. Rita was always cordial but never very forthcoming in her interviews with Louella. However, much to Orson's annoyance when they were married, Rita read Parsons's column first thing in the morning when she woke up!

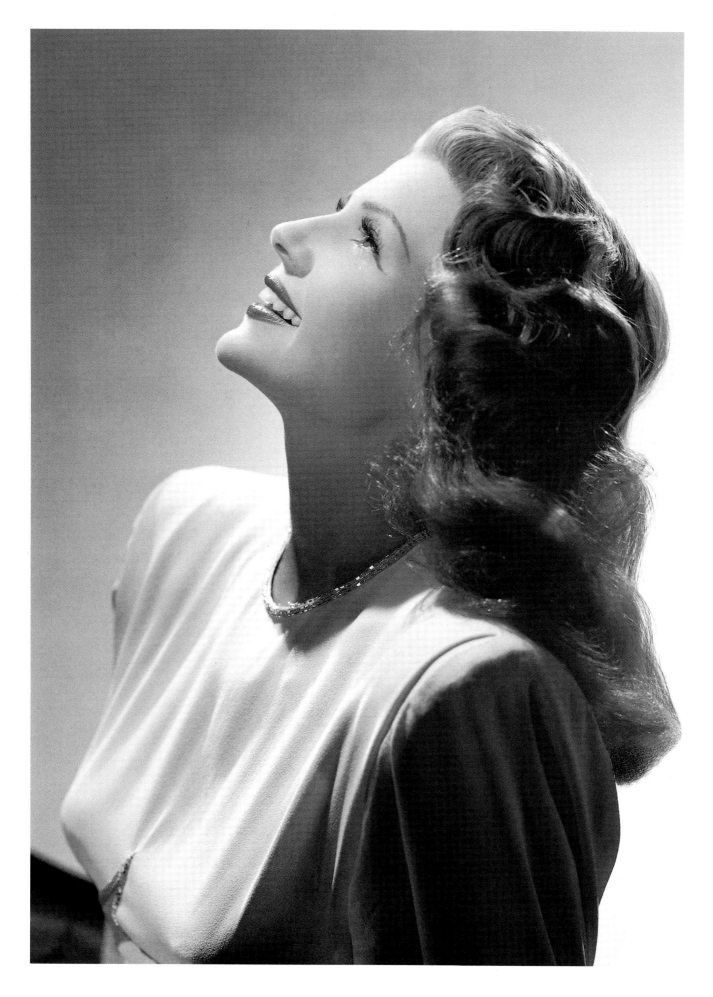

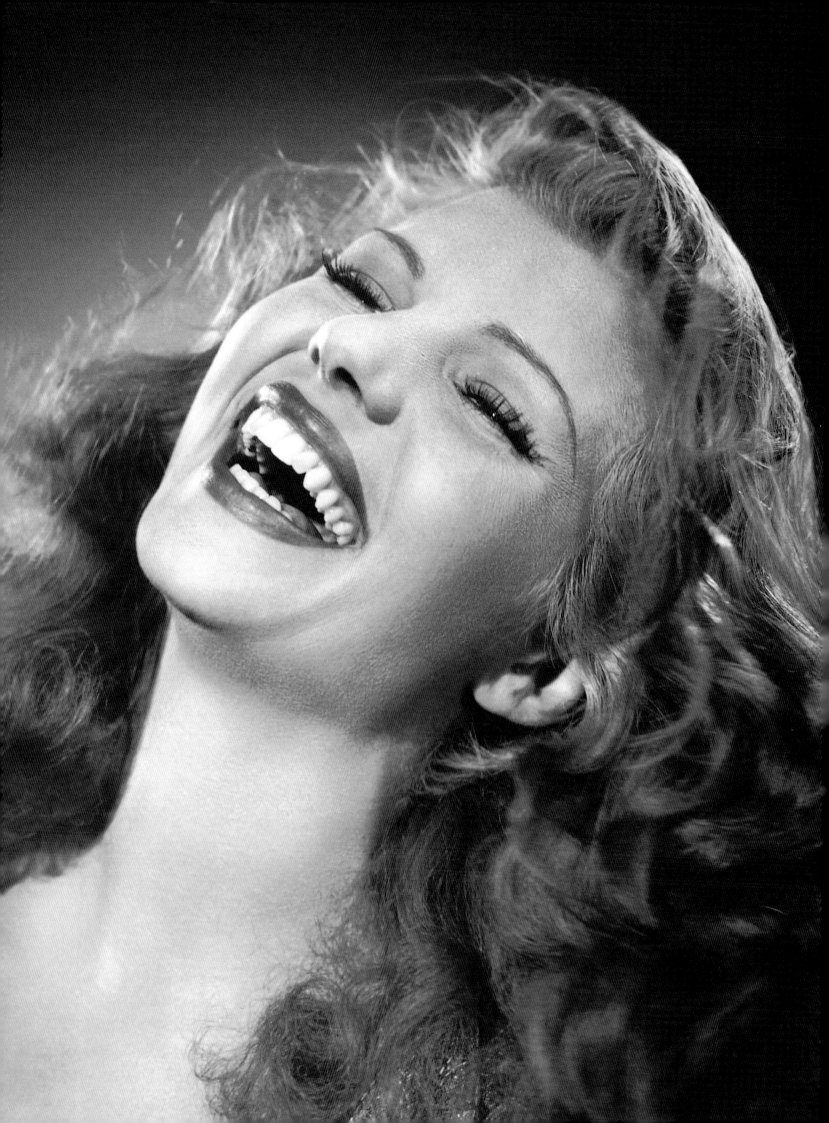

< The publicity portraits taken to promote *Down to Earth* are some of the most beautiful ever taken of Rita. "I like having my picture taken and being a glamorous person," she reasoned. "Sometimes when I find myself getting impatient I just remember the times I cried my eyes out because nobody wanted to take my picture at the Trocadero."

➤ Rita was awarded a "GI Oscar" by soldiers in eight theaters of operation around the world. At ceremonies at Walter Reed Hospital in Washington, D.C., Rita was given her GI Oscar for "best glamour girl." Here she is seated with Jennifer Jones, "best actress"; Josephine Houston, soloist at the ceremonies; and standing, from left, Leo McCarey, "best director"; Eddie Bracken, "best comedian"; Milton Berle, master of ceremonies; Major General Norman T. Kirk, award presenter; and Bing Crosby, "best actor."

➤ Rita tapes a performance of *Suspense* for CBS Radio with costar Hans Conried in 1946. Her newly blonde hair was a portent of things to come.

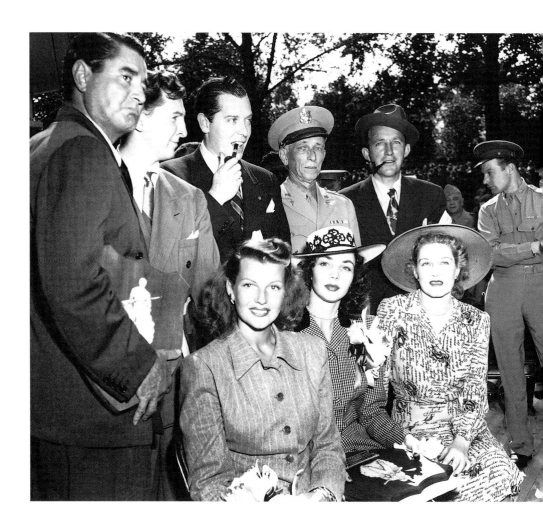

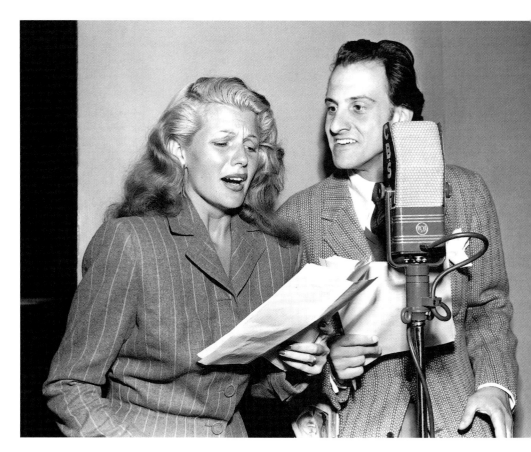

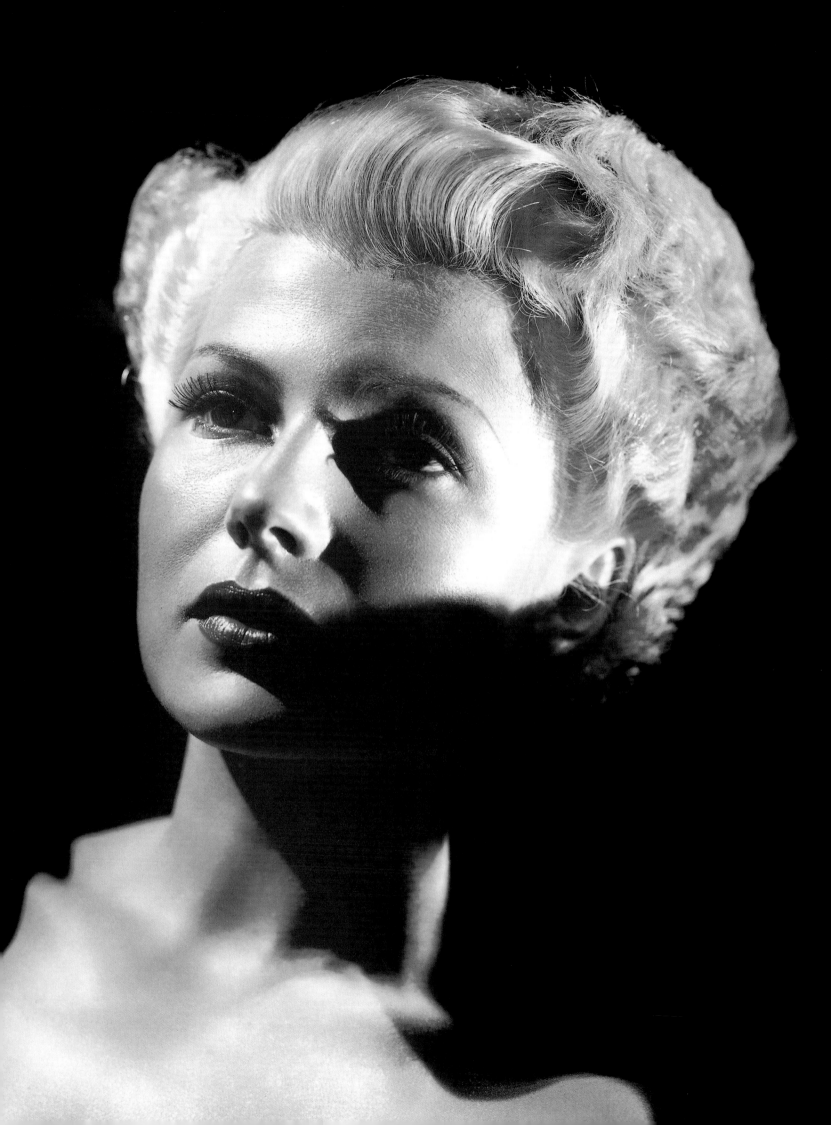

The Love Goddess

◄ A spectacular portrait of a blonde Rita taken by her favorite portrait photographer, Robert Coburn. "I'd usually talk to her all the time when I was photographing her, getting her in the mood," Coburn recalled later. "Then, I'd catch her at her peak. I don't think she ever cared how she looked in a picture . . . she didn't bother checking or approving them. That's rare for women." Although Coburn photographed hundreds of actors and actresses over the years, the only movie-star portrait he had framed and hanging in his home after his retirement was of Rita.

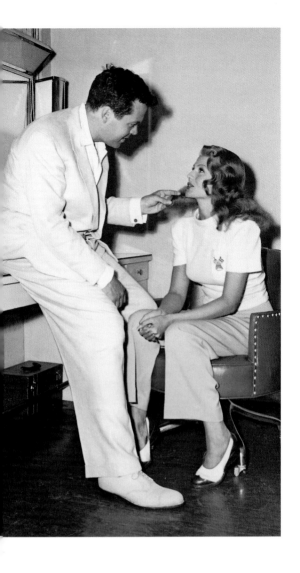

◄ ∨ ► "Topaz Blonde" was the name of the new color of Rita's hair, and in late 1946, with every reporter and photographer in Hollywood watching and snapping pictures, her long, lovely locks were shorn off. It is a testament to Orson Welles's creative persuasion that Harry Cohn allowed his biggest star to completely change her "look," for a role that would be quite a departure from her previous films.

Although her divorce papers from Orson Welles had already been drawn up, Rita was slow in signing them. Orson, meanwhile, had been working on a Broadway version of *Around the World in Eighty Days* and was badly in need of funds to complete the project. He asked Harry Cohn for a loan; in exchange he would make one film for Columbia. He returned to Hollywood (after *Around the World in Eighty Days* failed) and began filming *The Lady from Shanghai* (1948), with Rita as costar. Even though they were separated, Rita was excited at the prospect of working with and being directed by her husband, whose talent she greatly admired.

The cutting of Rita's hair was quite a publicity stunt, with Orson Welles supervising and chanting, "More! More!" while Rita's

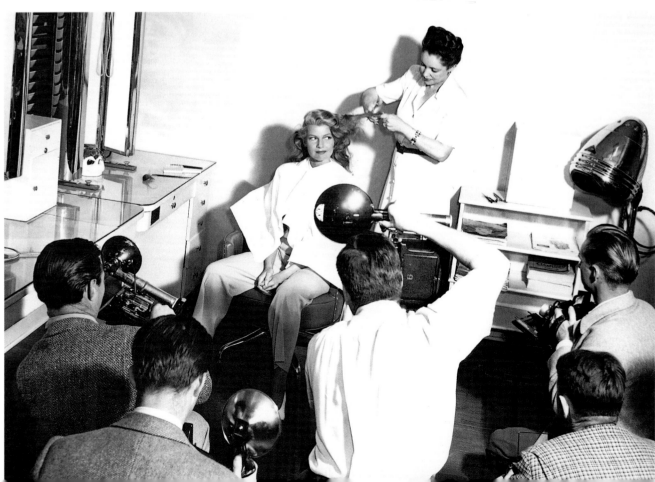

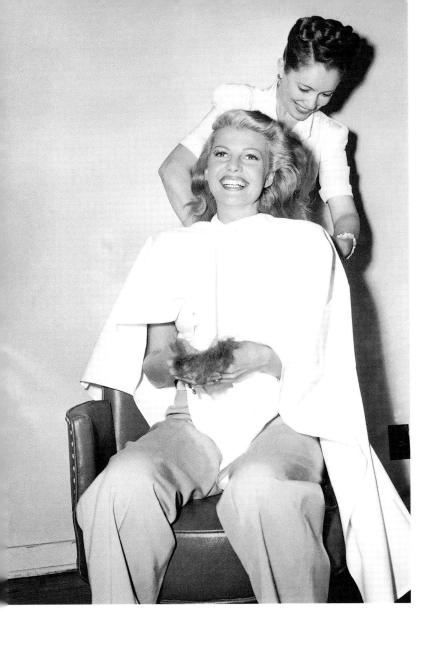

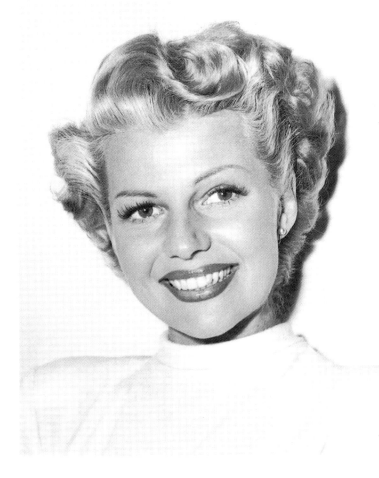

longtime studio hairdresser, Helen Hunt, did the cutting and styling. Rita was ecstatic about her new look, which was as far from Gilda as one could get. The fact that Orson was back in her life only increased her happiness, and the two seemed to be getting along wonderfully. The location shots filmed in Acapulco provided Rita and Orson with some fun in the sun, together with their friend Errol Flynn, whose yacht was used in the film. For the first time since their courtship days, Rita had Orson's full attention. Later Rita would say that she and Orson were separated but still friends during the filming of *Shanghai*, but others sensed that she was hoping for a reconciliation.

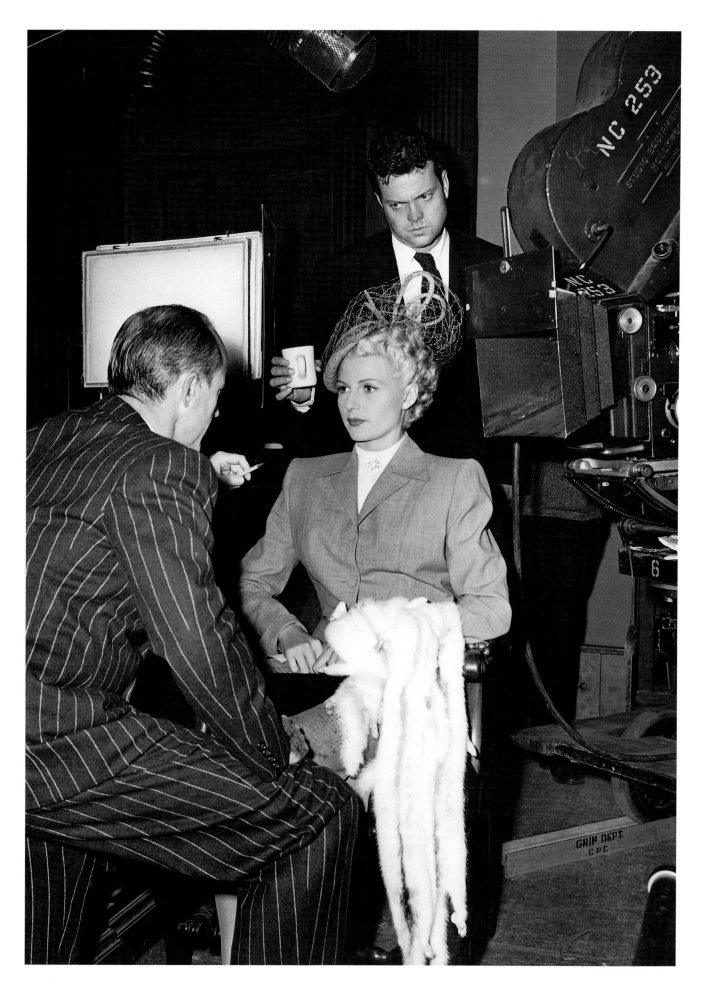

◄ Welles directs Rita and actor Carl Frank. Although *The Lady from Shanghai* was not well received when it was released, it is now considered one of Orson Welles's *and* Rita Hayworth's best films. Orson himself was never happy with the film; the studio edited it haphazardly, and his original vision was gone. Despite the change in hairdo (which audiences found hard to get used to), Rita was truly beautiful in the film, and her acting under the direction of her husband was superb. Harry Cohn, for his part, couldn't understand the plot of the rough cut of the film and offered a thousand dollars to anyone who could explain it to him. Cohn never got over the cutting of Rita's hair. "Orson was trying something new with me," Rita said, "but Harry Cohn wanted 'The Image'—The Image he was gonna make me 'til I was 90!"

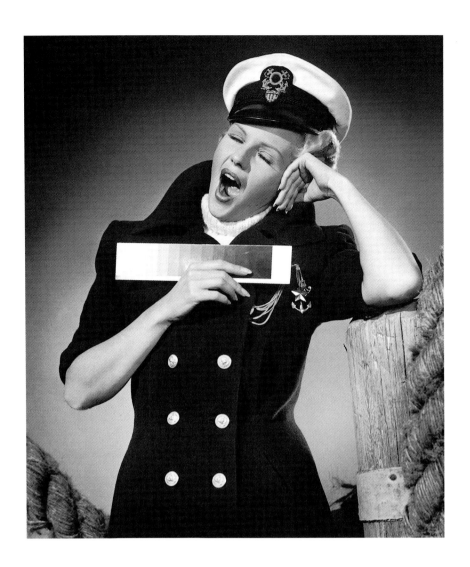

⋏ The side of stardom seldom shown to the public: a tired, yawning Rita Hayworth shows that being a superstar was ten percent glamour and ninety percent hard work.

➤ A rarely seen publicity shot of Rita and Orson Welles for *The Lady from Shanghai.*

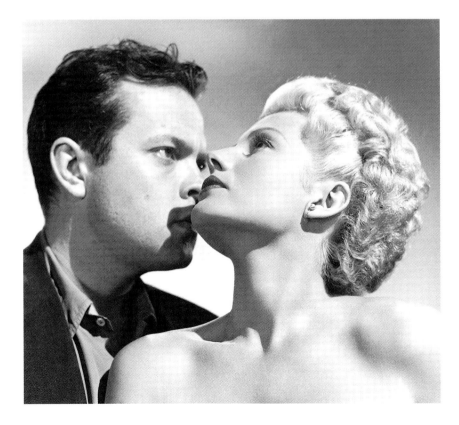

◄ Perhaps contemplating her future, Rita wanders along a tropical Pacific beach during a break from filming *The Lady from Shanghai*. For Rita, the end of filming would also mark the end of one of the happiest periods of her life. Although Rita and Orson got along well during the filming, the marriage didn't survive. Rita collapsed on the Columbia lot soon after shooting ended and was diagnosed as having a severe cold bordering on influenza. Clearly, the stress of the last few months was taking its toll. The realization that her marriage was finally over was difficult to acknowledge. Nevertheless she would later credit Orson Welles with giving her "my first personal adult happiness."

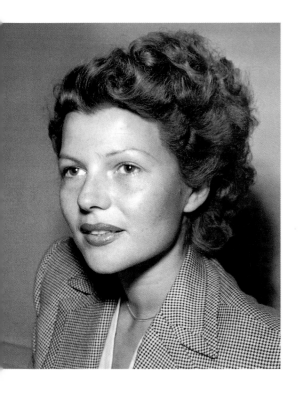

◀ ∨ In April 1947 Rita sailed on the Holland–America liner, the *S.S. Veendam*, for a four-month, eight-country European goodwill tour that would culminate in the London premiere of *Down to Earth*. Much to Harry Cohn's rage, Rita often appeared in front of the press and public without makeup, something that most major stars were loath to do. This semi-rebellious behavior reflected her desire to separate the screen goddess image from the real woman.

Rita had never been to Europe before, and she was looking forward to some rest and relaxation—none of which she was allowed because of her busy schedule. Harry Cohn felt that the long trip would allow her hair to grow out, a concern first and foremost in his mind. Rita was mobbed upon arrival, and as all eyes and cameras were trained upon her, she would find few quiet moments.

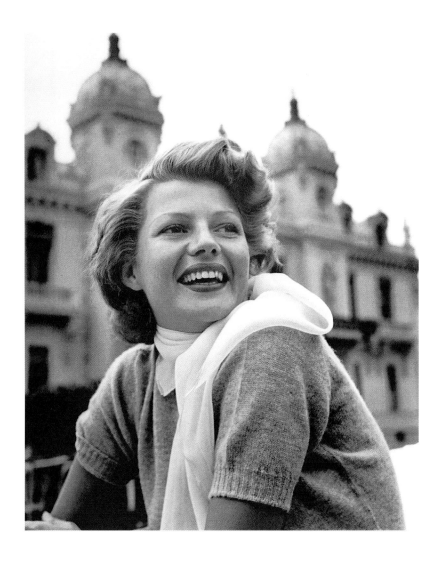

◄ As part of her European tour, Rita makes a stop in Monte Carlo.

➤ Rita enjoys world-class treatment while visiting Paris. Rita's quiet manner confused the European press; they expected snappy dialogue and witticisms à la Gilda. Consequently, the tour was not as successful as hoped. Rita returned from her trip on the *Queen Elizabeth* in September 1947. It was the first of many trips she would take to Europe, but the last she would ever take for the sake of publicity.

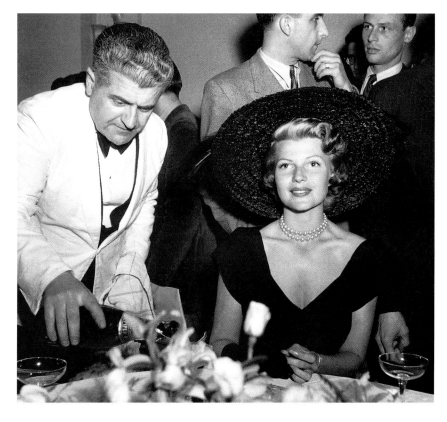

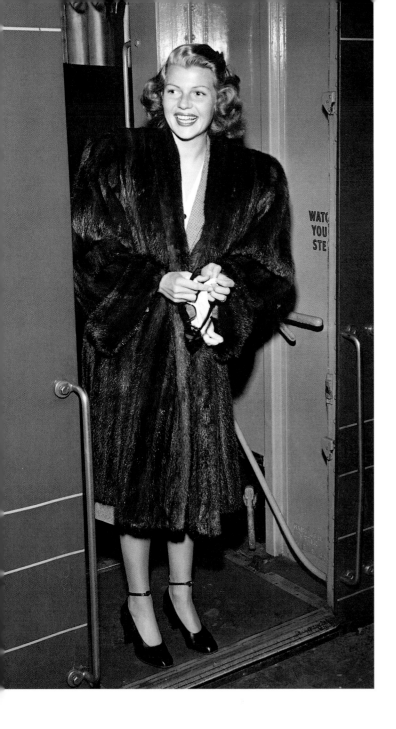

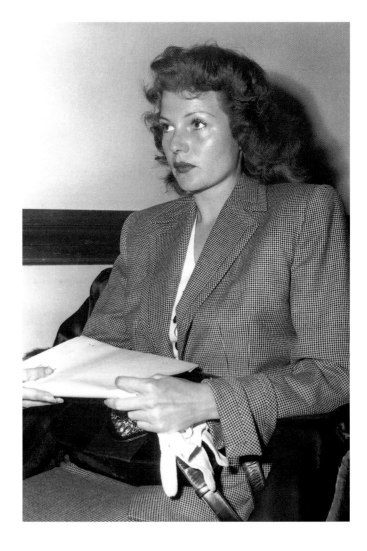

⋀ In October Rita arrived in New York to attend several performances of Broadway's *Born Yesterday*, for which Harry Cohn had purchased the film rights with the idea that Rita would play the lead. Although Rita was a talented comedienne, it is hard to imagine her in the role for which Judy Holliday would later win an Academy Award. Given the chance, however, Rita probably would have succeeded in making the role her own. Unfortunately, by the time the film was made, Rita was embroiled in worldwide headlines.

⋀ Rita appeared in court in November 1947 to obtain her divorce from Orson Welles. Rita did not ask for alimony, and she obtained custody of Rebecca; Orson was allowed to visit Rebecca on alternate weekends. "I have great respect for this man and we've always continued friends," Rita said later. "It would seem to me infinitely selfish of parents not to be, if only for their child's sake. A child shouldn't be tossed back and forth from one 'stranger' to another; there must be friendship and understanding between

parents." Rita and Orson always remained on amicable terms.

During this time, Rita was named by the International Beauty Show as "the woman most closely possessing the 'down to earth' beauty qualifications which have made the Venus de Milo symbolic of feminine pulchritude throughout the ages and the world." Clearly, this award was the work of the Columbia publicity department to promote Rita's latest film, *Down to Earth*.

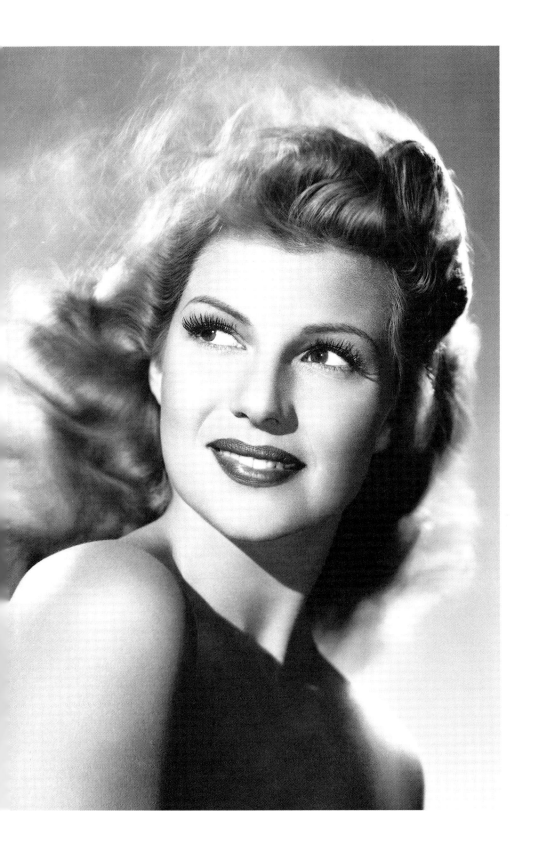

◀ Rita's place in the Hollywood firmament was forever changed by a November 10, 1947, *Life* article by Winthrop Sargeant. The author described Rita as "The Love Goddess in America," and she lived in the shadow of that label for the rest of her life. Along with the "Gilda" image, the "Love Goddess" hype made it increasingly difficult for the real Rita to emerge. "They created the image," she later recalled, "and sometimes you found it hard to live with yourself knowing that what was being sold to the public wasn't you." The article noted that Rita's life was a "history of masculine effort exerted in her behalf by husbands, directors, producers, publicity men and managers. Rita, at her end, has done what she has been told to do, worn what she has been told to wear, learned what she has been told to learn and said what she has been told to say with infinite patience and good nature. The fundamental trait of Rita's character is simply the desire to please people." The article failed to mention that Rita had renegotiated her own contract and achieved greater control in the direction of her career. Her next film, *The Loves of Carmen*, would be the first under her new Beckworth Corporation contract.

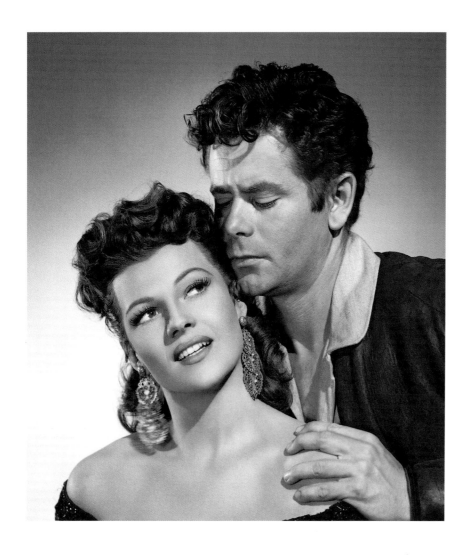

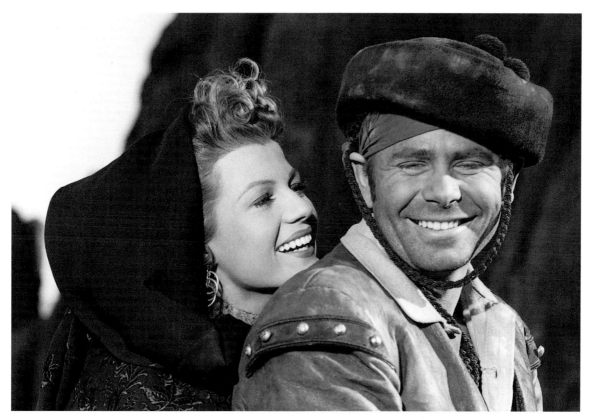

◄ *The Loves of Carmen* (1948), based on the novel by Prosper Mérimée, teamed Rita again with her old friend Glenn Ford. Charles Vidor again directed the team, and although the success of the film couldn't match that of *Gilda*, the combination of Ford and Hayworth in a love-hate relationship once again succeeded in attracting audiences.

⋎ Rita cuddles up and shares a joke with her favorite leading man, Glenn Ford.

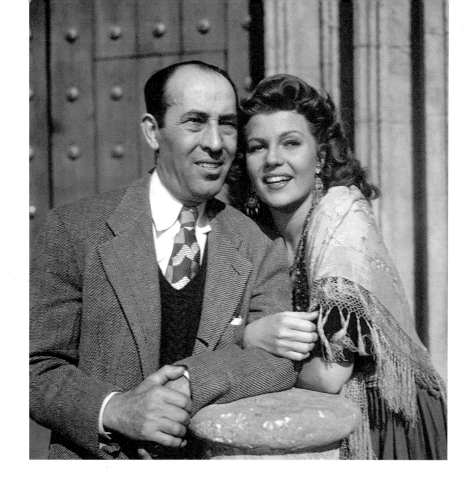

➤ In *The Loves of Carmen* Eduardo Cansino choreographed the Spanish dance numbers for his daughter. This situation made Rita slightly uncomfortable, and she asked for an additional, more experienced instructor to help with the flamenco numbers. The film was a family affair—Rita's brother Vernon had a bit part, and her Uncle Jose had a small dancing role. *The Loves of Carmen* would mark the end of Rita's most successful moviemaking decade and her reign as one of the nation's top box-office attractions.

➤ Looking like a regular 1940s housewife, Rita strolls with costar and friend Glenn Ford during location filming of *The Loves of Carmen* in Lone Pine, California. The film was supposed to take place in sultry Spain, but the weather in Lone Pine was actually quite cold. The crew bundled themselves up in heavy clothing while Glenn, Rita, and the rest of the cast froze in front of the camera.

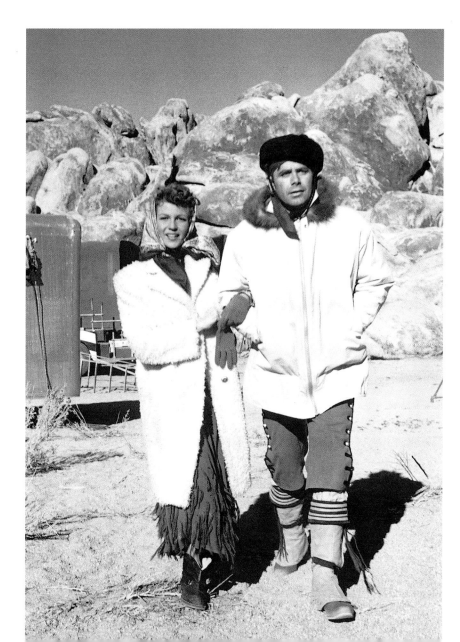

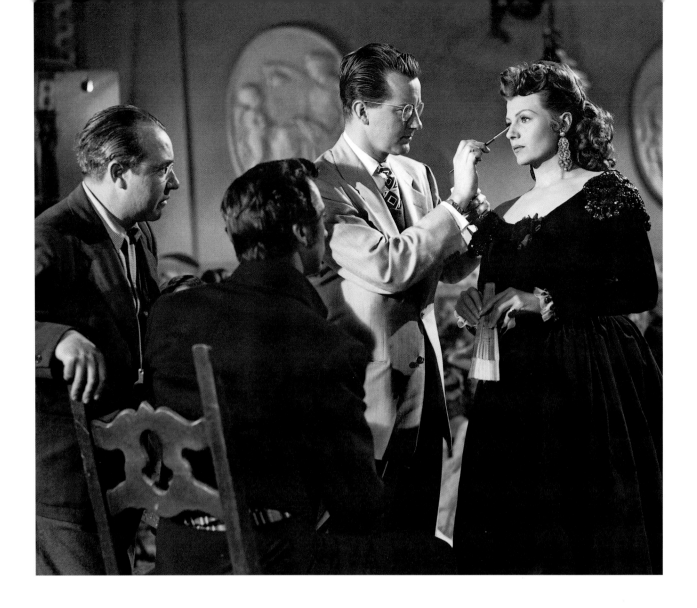

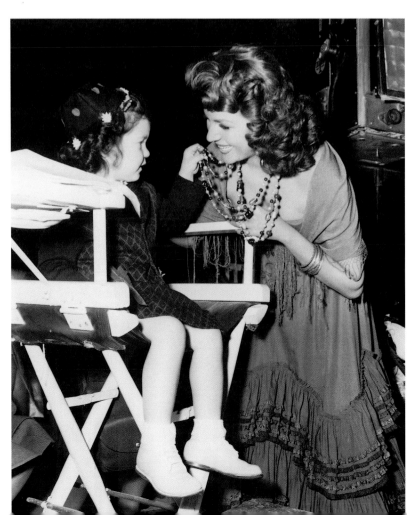

Rita's favorite makeup man and good friend, Robert Schiffer, touches up Rita's face on the set of *The Loves of Carmen*. Schiffer was a key member of Rita's studio "entourage" who worked with her on almost all of her major films at Columbia.

Rebecca admires her mother's beads as she visits the set of *The Loves of Carmen*. During this time, Rita was rumored to be involved with billionaire (and later recluse) Howard Hughes. Nothing was to come of the romance, however.

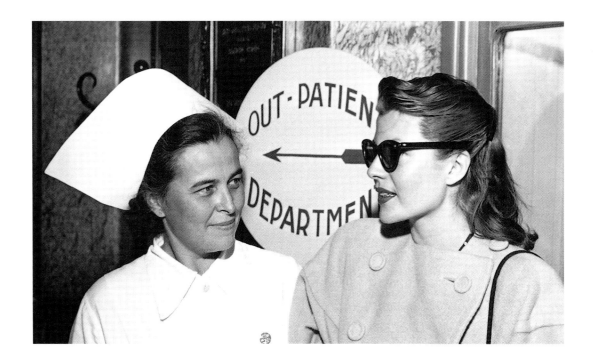

↗ After filming for *Carmen* was over, Rita embarked on a four-month European vacation. In Paris she was admitted to the hospital, reportedly suffering from anemia. Despite her illness, she was happy to be in Europe, where she could enjoy some privacy and much needed relaxation.

➤ Rita on the *Queen Elizabeth* with her secretary, Shifra Haran. There was no man in Rita's life, and she was still depressed over the end of her marriage to Orson Welles. Many thought that Rita's trip to Europe was an attempt to reconcile with Welles, who was scheduled to film in Rome during this time. Indeed, Rita stopped in Cannes and arranged to meet Welles there. They spent some time together, but it was evident to Rita that she was the only one seriously interested in getting back together. What she didn't realize was that she was about to embark on an adventure that would splash her name across newspapers the world over—and more important, bring love into her life again.

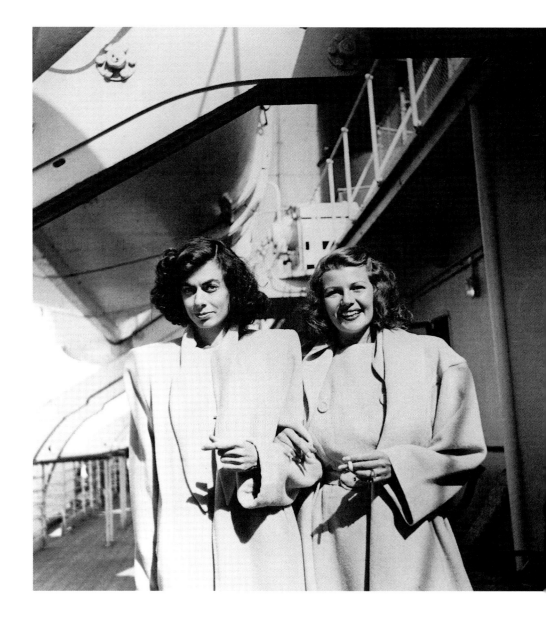

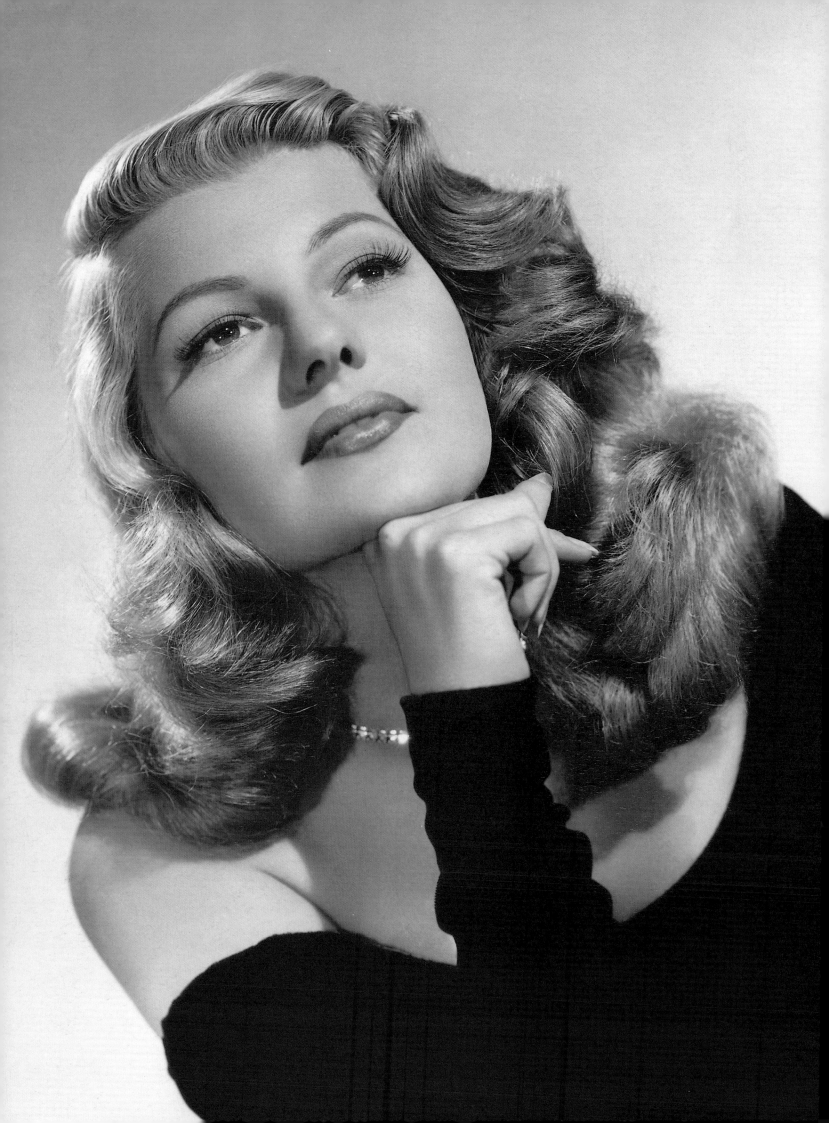

From Movie Star to Princess

<One of the last portraits of Rita before she left Hollywood for Europe in 1948. She would not return to the studio for three years.

After her stint in the Paris hospital, Rita spent some time in the south of France, soaking up sun and being pursued by every playboy and eligible bachelor that the glamorous Riviera had to offer. She stayed at the Hôtel du Cap, and she declined most invitations; she wanted only to be left alone in order to regain her strength.

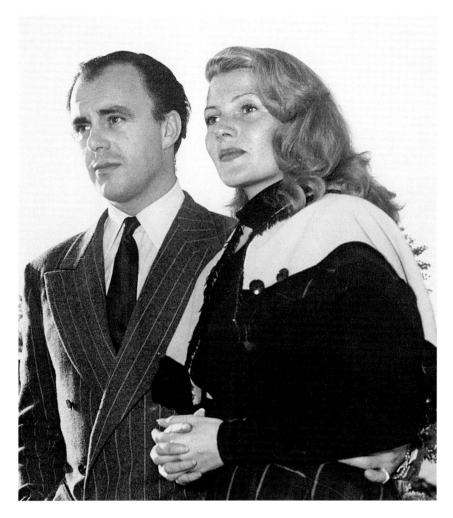

◄ Elsa Maxwell (right), the society hostess, invited Rita to a party at the Palm Beach Casino in Cannes to help lift her spirits. A reluctant Rita, looking ravishing in a white dress, agreed to attend the party, but only as a favor to Maxwell—her thoughts were still with Orson. Elsa Maxwell had other plans, however, and seated Rita next to a dark, handsome stranger who captivated Rita within minutes of their meeting.

➤ Rita had no idea who he was, but she would soon find that no other man could compare to Prince Aly Khan, a suave and charming horse breeder who was the son of the Aga Khan, spiritual leader of the Ismaili Moslem sect. Aly was considered quite a catch, and he would prove to be the great love of Rita's life. After meeting Rita, Aly pursued her with a vengeance, and she quickly fell under the spell of this charismatic man. Her somber mood quickly turned to fascination. Rita later wistfully reminisced about the night they met and the subsequent time they spent together: "We danced and we danced and we danced! I like to think we never stopped."

➤ Ever the gentleman, Aly Khan lights Rita's cigarette. The two began seeing each other regularly. Rita had never received such attention from a man, especially one as sought after as Aly. She was trying to stay on her guard, but she felt herself succumbing to the charms of this amazing man, in whose company she felt like the most special woman in the world. It wasn't long, however, before the press began to smell headlines. After all, even though Rita was divorcing Orson Welles and the Prince had an "in name only" marriage to Joan Yarde-Buller, the fact remained that they were both married.

∨ Rita and Aly stroll publicly at the St. Cloud Race Track near Paris. In order to avoid the prying eyes of the press and spend some time alone together, Aly and Rita decided to take a vacation in Madrid, then travel on to Seville and Portugal. The pair was constantly followed by fans who recognized "Señorita Gilda," and the press was in hot pursuit during most of the trip. To one reporter who managed to corner him, Aly replied, "Look here, old boy, I'd like to answer your questions, but how can I when they are so embarrassing?" The couple was, however, able to visit some of Rita's relatives, including her grandfather, Padre. In the atmosphere of simple people and simple things, Rita flourished. Aly fell more in love with Rita when he saw her with her family, and he was determined to marry her.

Even though the two seemed to be quite smitten with each other, Rita decided to return to Hollywood. The fear of scandal was one reason for her return, but she also needed time to think. "The world was magic when you were with him," she later said, but she was well aware that they were two very different people in style and temperament. Her contractual obligation to Harry Cohn and Columbia gave her an excuse, and for the time being, she was happy to be in Hollywood again.

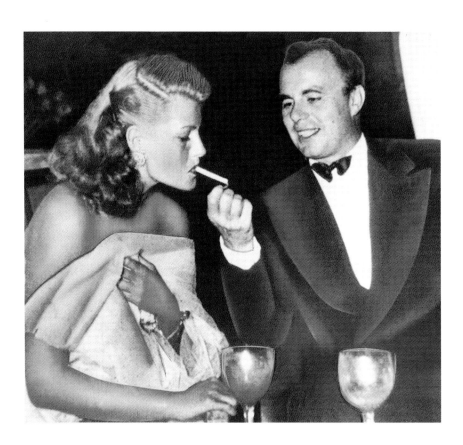

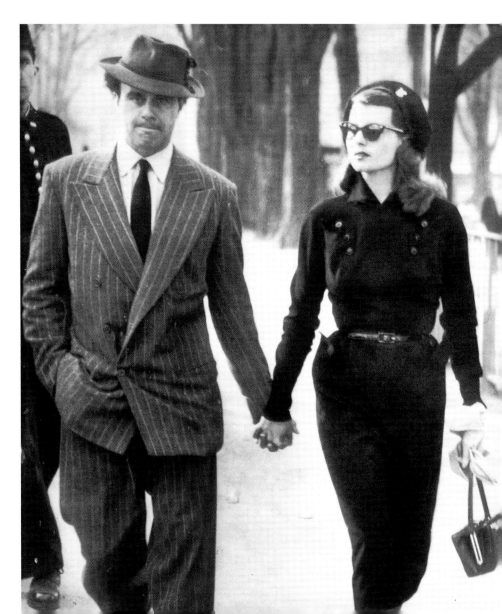

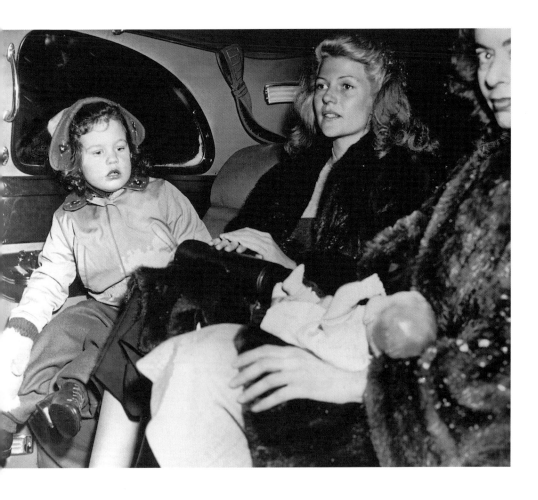

◄ If Rita thought she could forget about Aly while in Hollywood, she was wrong. She was miserable without him, and it seemed that Aly couldn't live without Rita, either. He soon arrived in California. They were seen about town together, but they soon left on a trip to Mexico City, Acapulco, and Havana. When back in Hollywood, Rita informed Harry Cohn that she would not be returning to work on the film she was currently assigned, a western called *Lona Hanson*, in which she was to costar with William Holden (a pairing that probably would have produced spectacular results). Rita's agent, Johnny Hyde of the William Morris Agency, reported that Rita refused the picture because "she doesn't consider Lona Hanson a characterization and role best suited to her talents." Harry Cohn knew better, and he suspended her contract, even though she had script approval under the terms she had negotiated for Beckworth Corporation. Unfortunately for Rita, every time her contract was suspended it delayed its end and kept her under contract to Columbia for a longer period of time. Nevertheless, in December 1948, Rita obtained her final divorce decree from Orson Welles and didn't look back, as she and Becky (who seems only interested in retrieving her doll from secretary Shifra Haran) prepared to sail for Europe on the *Britannic*.

◄ Rita throws snowballs in Switzerland, where reporters followed her and Aly to a hotel in Murren. The constant headlines deeply disturbed Prince Aly Khan's father, the Aga Khan, and he requested a meeting with the prince and Rita. He found Rita a "charming, modest, sweet, lovely, and exceptional girl," and he quickly gave his consent to a marriage between the movie star and his son. Obtaining a divorce from his wife was a simple task for the prince. In their verbal "open marriage" agreement, they had agreed to divorce if Aly decided to marry again. And so the process began. On January 17, 1949, the new couple announced their wedding plans. In their statement Aly added that he hoped the press would now leave them alone.

∧ Rita and Aly look over the field at Epsom Downs, England, as they attend the English Derby. This photo, taken shortly after their wedding, shows them handsomely attired in Derby fashion. Rita was unprepared for the lavish and constantly active lifestyle of Prince Aly Khan. She was an introvert who preferred to stay home and enjoy a night with the family; the prince was an outgoing fellow who enjoyed social activity. "We were together but not together," Rita would say later of her relationship with Aly. "We seldom had a minute alone." Aly loved Rita, but he was a gregarious person, and nothing was going to change that.

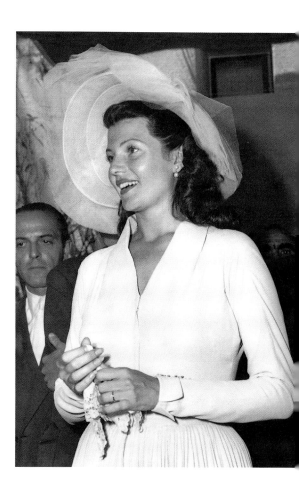

On May 27, 1949, Rita Hayworth and Prince Aly Khan wed. Louella Parsons would call the union "the most colorful and really fabulous Cinderella story ever to come out of Hollywood." Many people forget that Rita Hayworth, not Grace Kelly, was the first movie star to become a princess. Rita and Aly's hope for a private ceremony was denied, as was their desire to be married in the prince's home, the Château de l'Horizon. Much to the distress of Aly and Rita, the French government ruled that the wedding would take place at the city hall in Vallauris. The body of a dead man found washed up on the rocks earlier in the day garnered scant attention compared to the hoopla surrounding the wedding. Three hundred notable guests attended, and a special cocktail called the "Ritaly" was created just for the occasion. The press was in full force to see Rita's wedding dress of light blue crêpe (designed by Jacques Fath) and to witness the guests consume 600 bottles of champagne. In the pool, thousands of floating white carnations formed the letters "A" and "M" (for Margarita). Despite her nervousness, Rita was excited. "I can hardly think. I'm sort of lost in a dream world," she said.

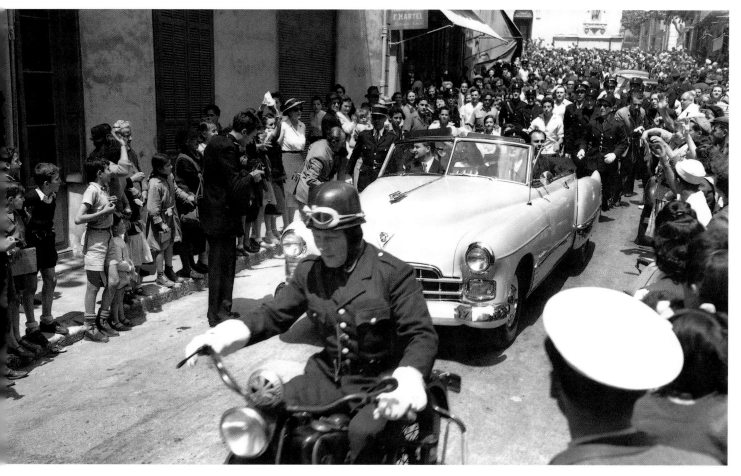

< Aly genuinely loved Rita, but he had lived a certain way all of his life, and he expected his new wife to respect this. The couple rarely remained in one of Aly's many homes for any length of time, and Rita found it difficult to become comfortable and familiar with her surroundings. Rita did her best to play the part of princess at various functions such as the races and dinner parties. On at least two occasions, Rita publicly fainted, causing speculation that she was pregnant—the speculation turned out to be correct.

∨ Rita and Aly enjoy a tea break in December, after Rita checked into the Montchoisi Clinic in Lausanne to await the birth of their child.

> A radiant Rita is photographed as she enters a waiting car during the final months of her pregnancy.

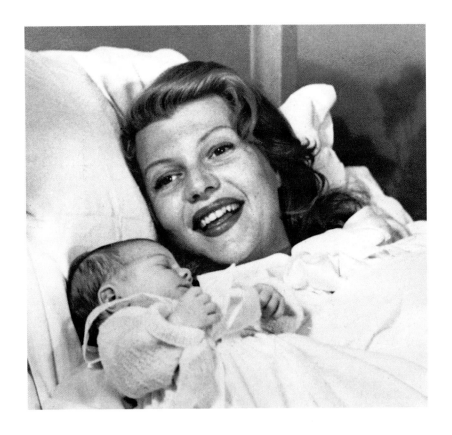

Princess Yasmin Aga Khan was born on December 28, 1949. More than twenty journalists and photographers waited outside the hospital for eight hours to report the news. The proud parents were thrilled with their little daughter, and after Rita regained her strength, they left for Gstaad and an extended vacation at Aly's fifteen-room chalet. For Rita, the few months in Gstaad consisted of glorious contentment. Aly was a devoted father, and he lavished Rita, Yasmin, and little Becky with attention. "It was the happiest time I've ever known," Rita would later recall. "This was the quiet interlude when we were a family; there was a sense of continuity, of calm and belonging, which is terribly important to me."

Little Princess Yasmin gazes lovingly into the eyes of her mother.

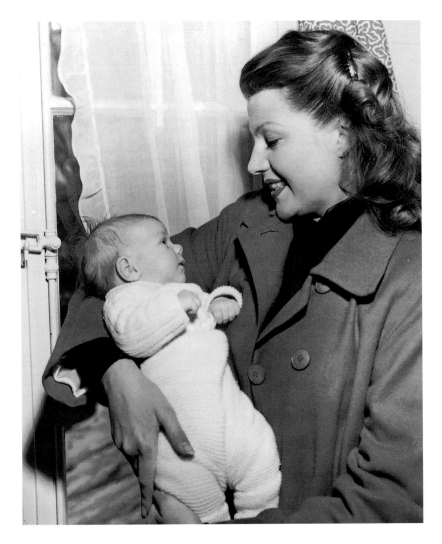

◀ Rita on vacation on the isle of Capri in 1950—where she was surrounded by photographers and reporters wherever she went. The idyllic existence she had experienced with Aly and the girls in Gstaad was not to last. Life had returned to normal, and Rita was trying to cope with the painful reality. Her hopes for a normal family life of privacy and togetherness seemed an impossible dream.

▼ In Deauville, France, Rita indulges in her favorite pastime, golf.

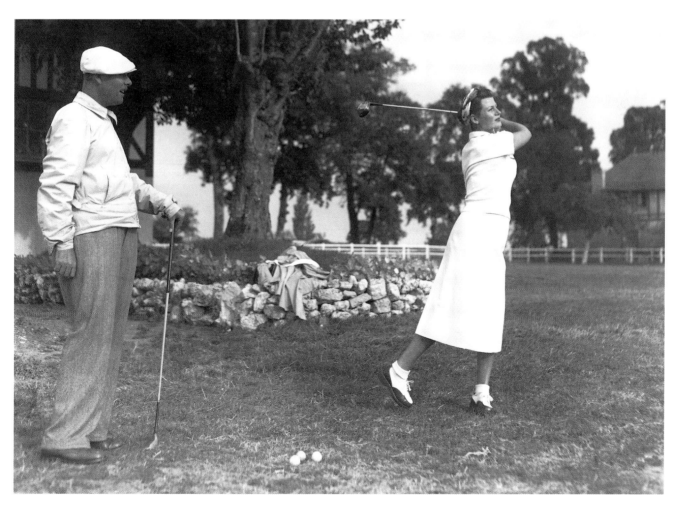

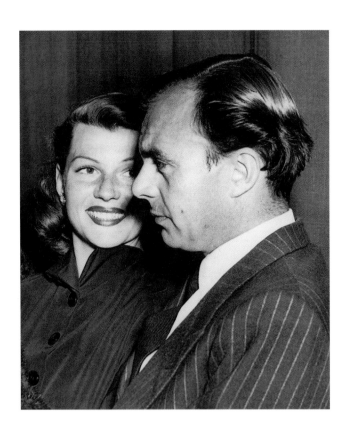

◀ One of the world's great Cinderella stories was about to come to a sad end. Rita and Aly prepared to go on a second honeymoon, an African safari to be filmed for a documentary by Rita's friend, producer Jackson Leighter. Ironically, the film, entitled *Champagne Safari*, didn't play in theaters until 1952, after Rita had split with Aly. When Rita and Aly were not receiving dignitaries or fulfilling social obligations (as many as four a day), Rita was alone—which didn't make for a successful second honeymoon. She missed her daughters after four months' absence, and she returned to Cannes earlier than the prince. She packed up the children and fled to Paris and then Le Havre, where they set sail for New York. She had decided to leave Prince Aly Khan.

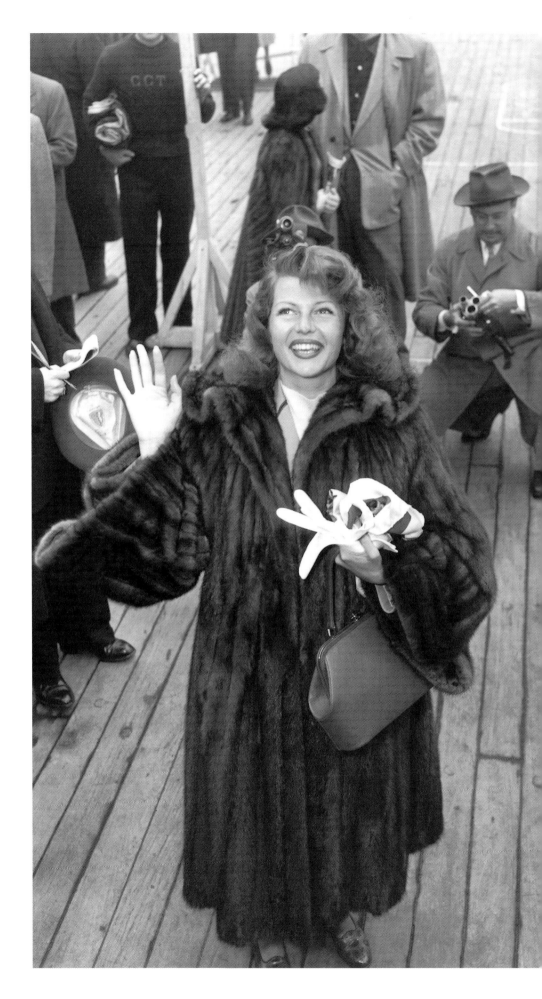

◄ Upon arriving in New York on April 2, 1951, Rebecca and Yasmin are whisked off the liner *de Grasse* in order to avoid the prying eyes of the press. Traumatic moments such as these, with crowds closing in and flashbulbs popping, deeply affected both daughters and increased their own desire for privacy.

➤ Rita was greeted by a barrage of reporters who grilled her about whether or not she and the prince were divorcing, but she refused to discuss it—she would only volunteer the fact that she was craving a hot dog. She was putting on a good front, but inside she was miserable. As she told a friend, "I had loved Aly so much that leaving him was almost unbearable. It was so easy to love him. It was very hard to get him out of my heart. But it was a step I knew I had to take." Soon after arriving in New York, Rita took the steps toward divorce by establishing residency in Reno, Nevada.

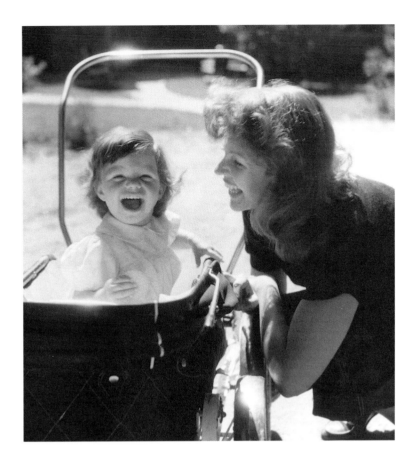

In May 1951 a fresh-faced Rita and Yasmin stroll on the shores of Lake Tahoe as Rita completes the six-week residence requirement prior to asking for a divorce from Prince Aly Khan. It seemed inconceivable that their marriage was over; it had all gone so fast and, for a time, been so magical. Six weeks in Nevada, however, provided Rita with some much needed time to take stock of her future. The realization that she now had two daughters to raise and support—single-handedly—spurred her into action and sent her back to Harry Cohn.

Out of necessity, Rita returned to Columbia. She had not asked Aly for any money and most of her own savings had been spent, and thus she needed to return to work. Harry Cohn was more than happy to welcome her back to Columbia, with one stipulation—he was calling the shots. After working so hard to gain her independence and her right to direct her own career, Rita now lost her power of script approval. Her first film upon her return was *Affair in Trinidad* (1952), and it was nothing but a poor imitation of *Gilda*. Rita later admitted that after she first read the script, she threw it across the room in anger. Glenn Ford played the leading man, but even their onscreen chemistry couldn't overcome a terrible screenplay. Still, Harry Cohn directed the publicity department to build up Rita's "comeback" picture to such a degree that one would have thought it was the next *Gone With the Wind*.

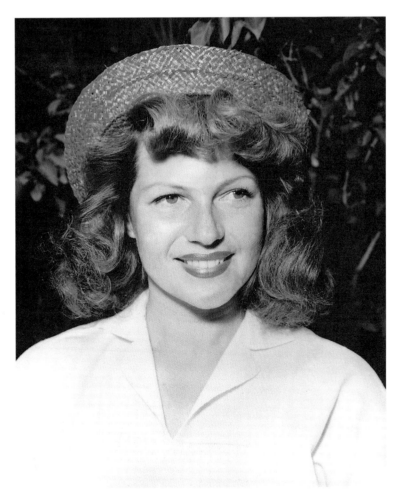

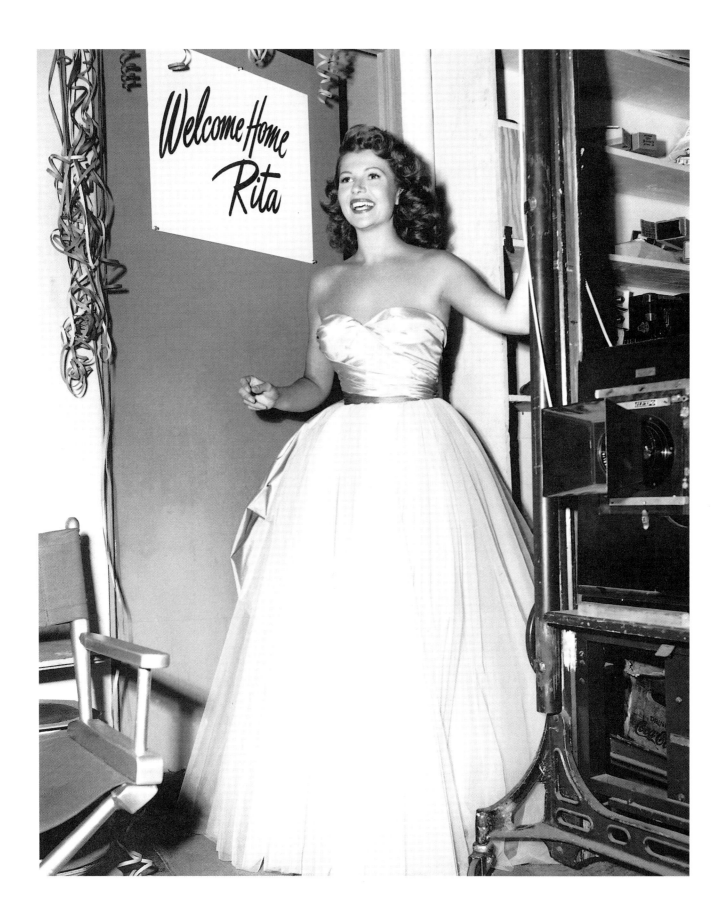

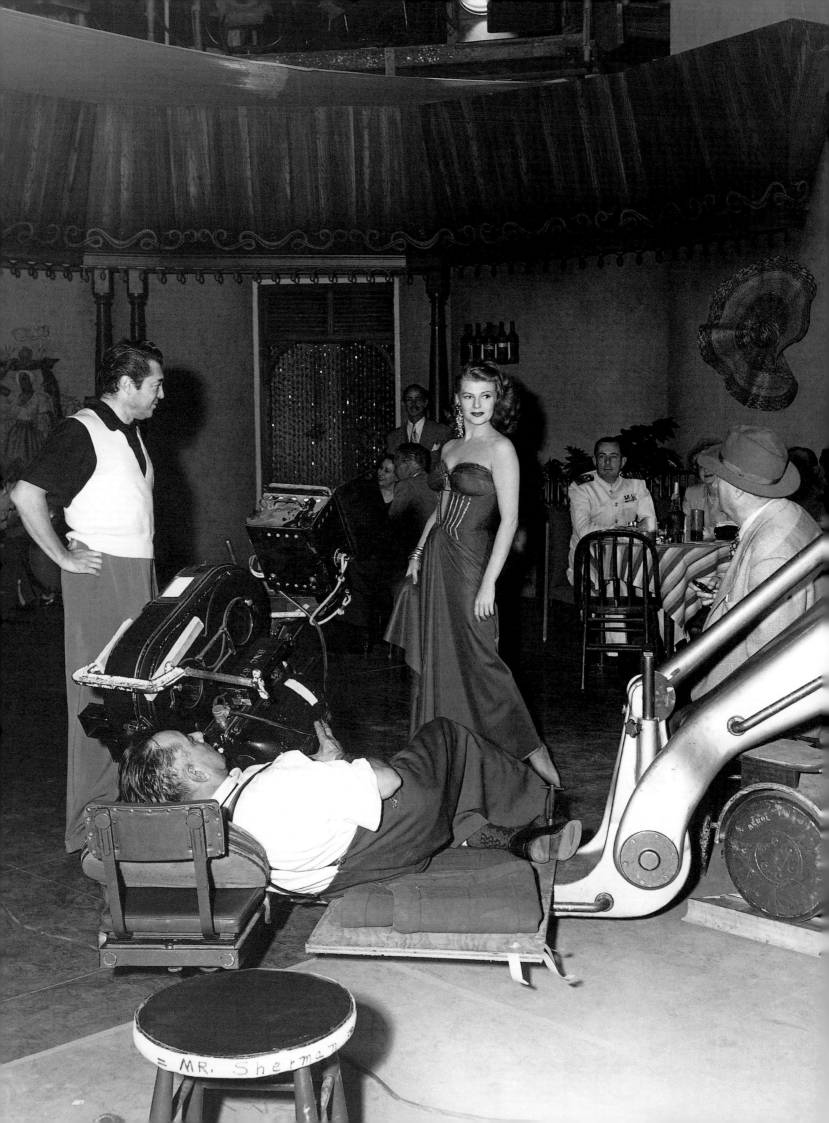

◄ Rita on her first day back in front of the cameras, shooting the "Trinidad Lady" number under the direction of Vincent Sherman (far left). Rita, although appreciative of the outpouring of affection she received from old friends, cast, and crew, found it difficult to go back to work. She had been away from moviemaking for three years, and a melancholy could be seen in her eyes that had not been there before. She still danced and looked gorgeous, and her acting had a sensitivity not previously seen, but she was not the same Rita Hayworth the public had come to know and love. She would later refer to these years as "rugged, rugged times." She mused, "Who wouldn't prefer having breakfast in bed to getting up at the crack of dawn and having a cup of coffee in a studio makeup department?"

➤ *Salome* (1953), Rita's next film, sought to cash in on the current popularity of biblical films. Her costars included the formidable Judith Anderson, Stewart Granger, and Charles Laughton. A superb cast does not a classic film make, however, and Rita was less than enthusiastic about the project. What did excite Rita was a recent message from Prince Aly Khan—he was coming to Hollywood to see her.

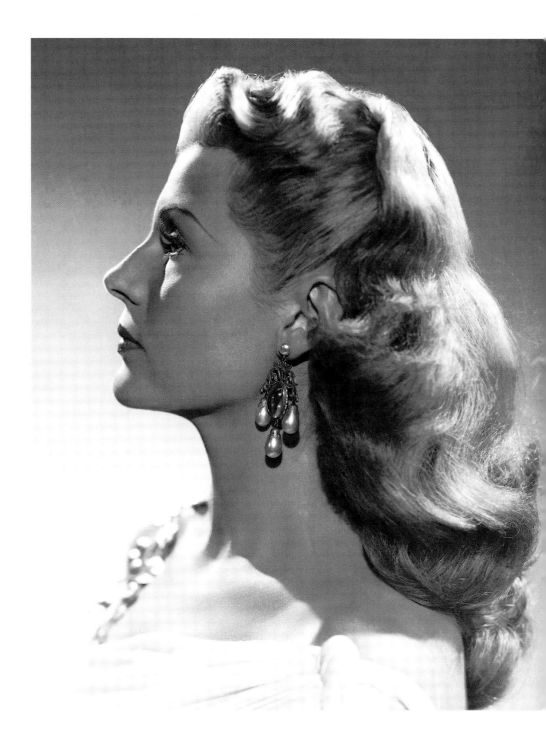

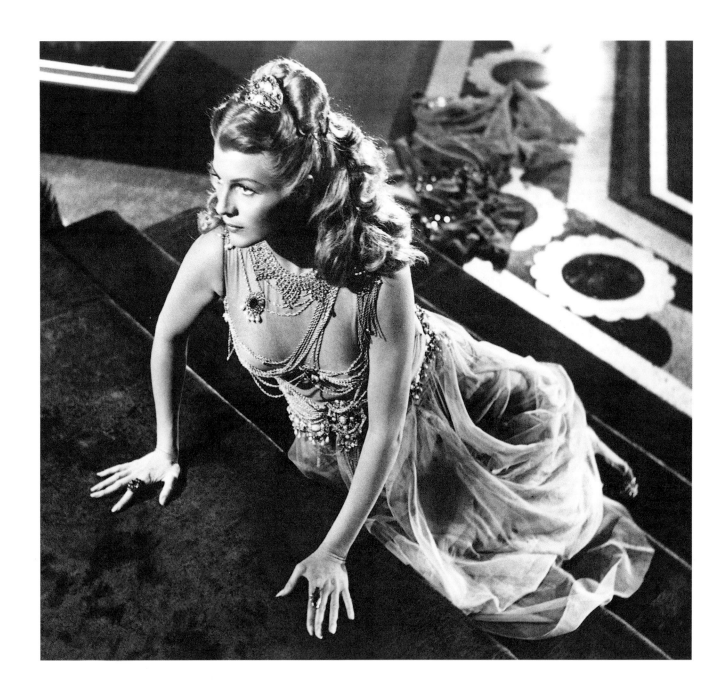

⋏ Rita's sensuous "Dance of the Seven Veils," in which she slowly discards several veils to reveal an extraordinarily risqué costume of nude material, still radiates sexuality, as the scenery-chewing Charles Laughton eyes her lecherously. Columbia felt it was important that Rita play positive characters, and thus they took liberties with the Bible to make Salome more sympathetic: instead of asking for the head of John the Baptist, this Salome tries to *save* his life.

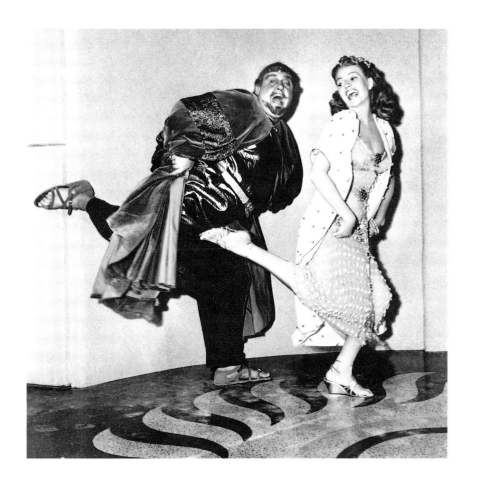

< Rita jitterbugs with costar Charles Laughton on the set of *Salome*. William Dieterle, director of the film, later said of Rita, "At first she talks in monosyllables. As she gains confidence in you she talks freely—not articulately, not with complete self-expression, but warmly." He felt she had much more potential as an actress than her roles had allowed her to express.

> Rita, once again before the still cameras, manages to laugh despite her personal troubles. It seemed to her that she was right back where she had started, under the despotic hand of Harry Cohn. At this point in her life, sitting in the portrait gallery for hours on end was beyond tedium. The past few years had put everything in a different perspective, and the hundreds of photographs taken to help promote *Salome* seemed incredibly insignificant. She faced it all with natural dignity, however, and kept her thoughts to herself.

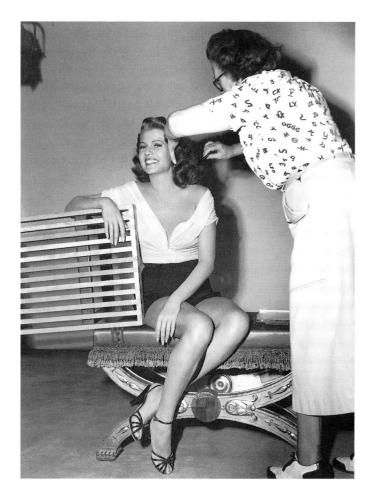

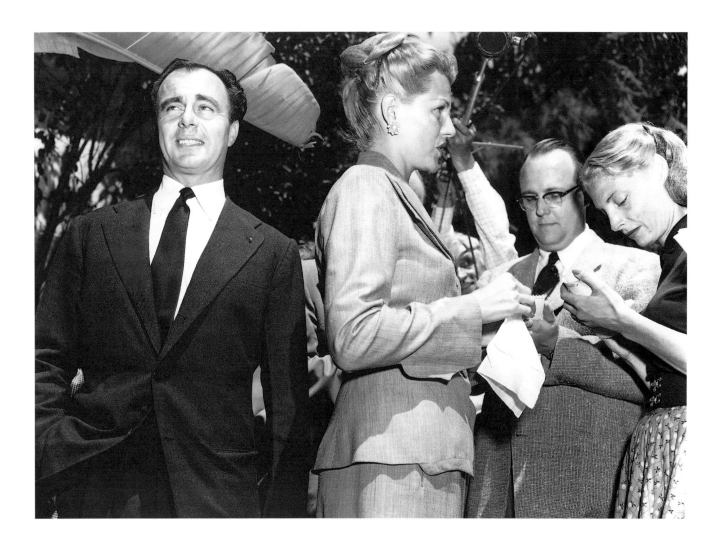

∧⟩ Although Prince Aly Khan's lifestyle had not changed since the separation, he asked to meet with Rita and talk about a reconciliation; they also had little Yasmin's future to consider. Still trying to come to terms with her feelings for Aly, Rita agreed, and the prince arrived in Los Angeles in August 1952 amid much publicity. During a meeting she and Aly scheduled with the press outside of her home, Rita seemed nervous and unwilling to talk, and she would not comment on the state of their relationship. She and Aly agreed to meet again the following month in Paris. It was all too much to comprehend, and the tension in Rita's life could be seen in her face.

➤ In September 1952, after completing *Salome*, Rita sailed for Paris to meet with Aly and discuss a possible reconciliation. Here Rita and Aly pose for photographers on the balcony of Aly's home in Paris, and inside they answered questions. After their talks the two decided to part ways, and in January 1953 the divorce was finalized. Despite the couple's differences, many people considered Aly the true love of Rita's life. When Prince Aly Khan died in a car accident in 1960, Rita was devastated.

⌄ Rita's first date after her initial split with Aly Khan was actor Kirk Douglas. He later stated that he saw in Rita a "loneliness, sadness —something that would pull me down." Of course, this was also a particularly difficult time for her. Rita was seen about town with various men, and each time, the press declared her current suitor "her next husband." In reality, Rita cared very little for the Hollywood nightclub scene, but she felt she needed to go out to keep up appearances.

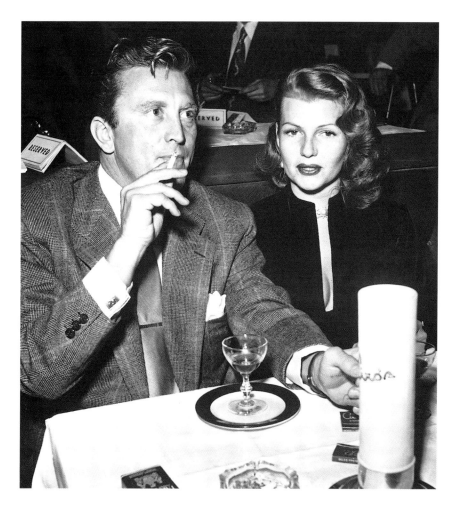

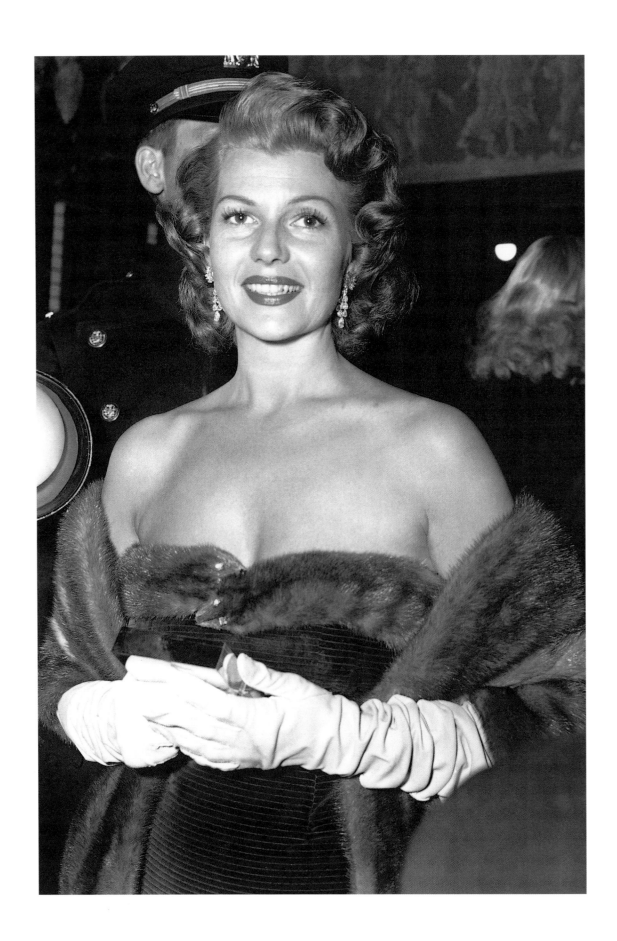

Bewitched, Bothered, and Bewildered

‹ Looking stunning in a mink-trimmed evening gown, Rita attends the New York premiere of *Salome* in March 1953. Her appearance caused such a stir that mobs of people had to be held back so that she could enter the theater. Rita was sought after for interviews by all of the major magazines and newspapers, and the constant publicity puzzled her. "I'm a Spanish peasant," she said modestly, which in her heart she was. The fact that this "Spanish peasant" had transformed herself into the world's reigning movie queen, unflinchingly given up her spectacular career for love and life as a royal princess, then returned on a cloud of even greater celebrity, was too sensational a story for people to ignore.

◄ Onstage during a live appearance on *The Ed Sullivan Show*, in March 1953, Rita nervously chats with Sullivan about her new film, *Salome*. Rita's television debut helped garner the popular show some of its highest ratings ever.

∨ Singer Dick Haymes was considered by many to be the big mistake of Rita Hayworth's life, a rebound romance from which she later had difficulty extricating herself. They met during the filming of *Salome*, and at that time the relationship was not serious. When she returned from Paris, however, Rita needed attention, and Haymes, whose career was on the downswing, was more than happy to give it. Haymes had a reputation for being irresponsible with money, women, and life in general. He had been married three times, was being sued by his ex-wives for back alimony, and was being pursued by the IRS. Rita's friends did not understand her attraction to this man, who had none of the charisma of her former husbands. "I wasn't crazy about him," Yasmin said later about Haymes. "He didn't have a caring quality about him. I tried to stay away as much as possible, and not get involved with him."

➤ A familiar sight on the set: Rita sits quietly in the background. Rita always felt more comfortable with the crew than around the other stars or studio executives. Here she rests her sore feet and relaxes with a cigarette on the set of *Miss Sadie Thompson* (1953).

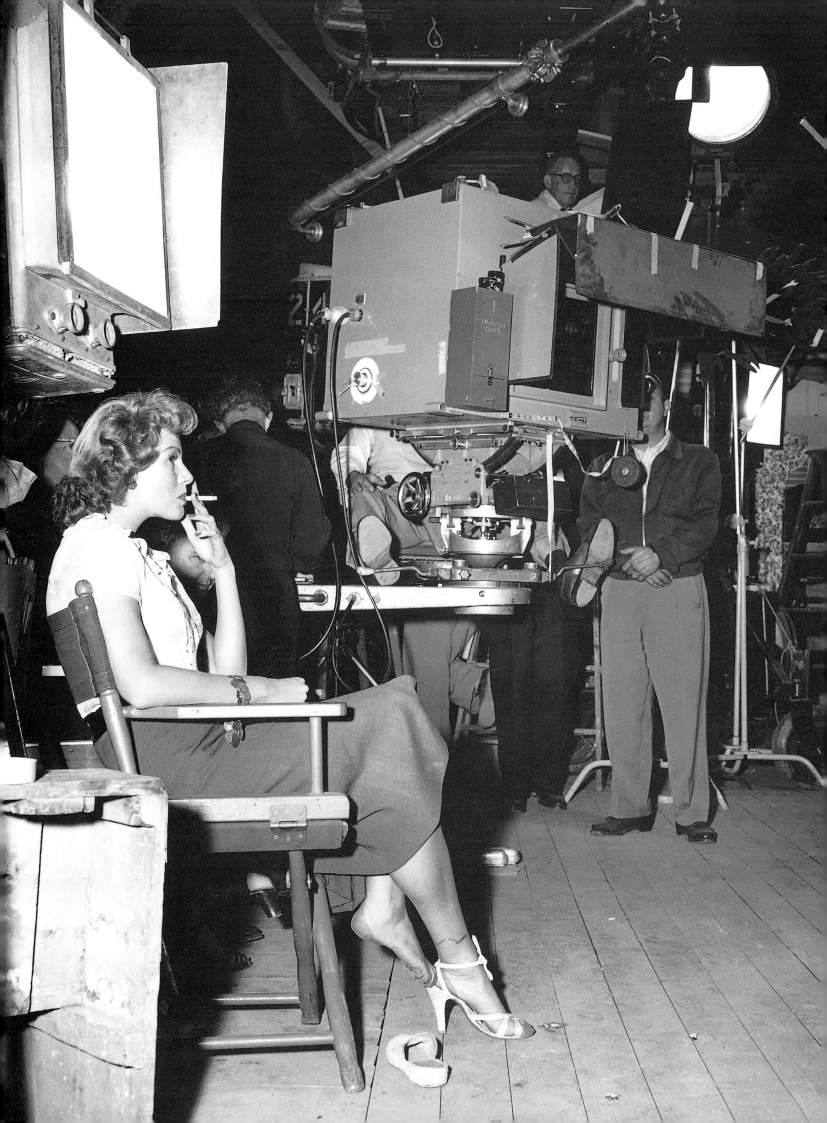

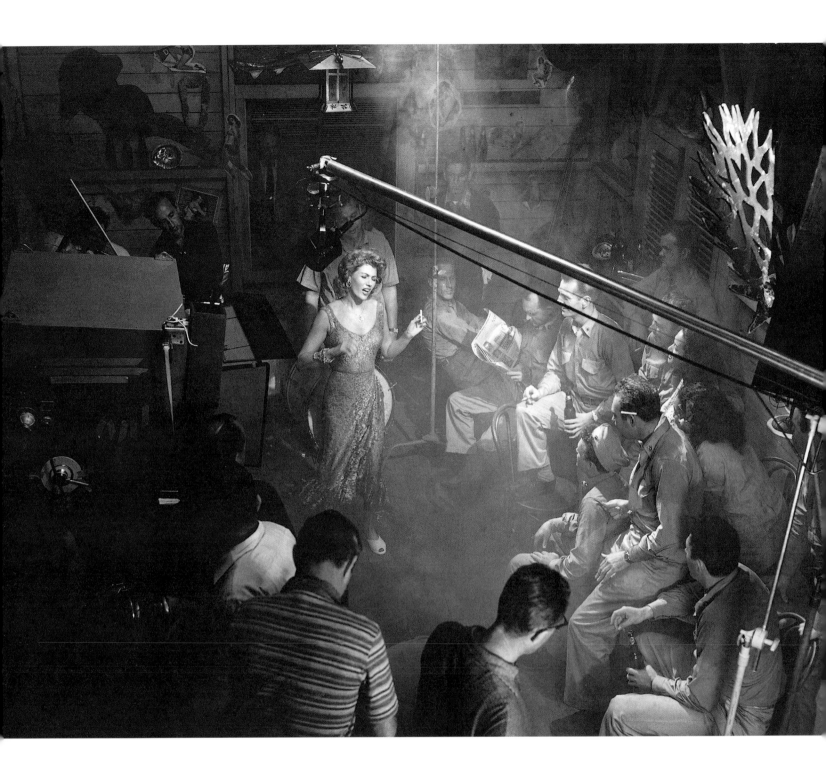

∧ Rita rehearses "The Heat Is On" number in her slippers for *Miss Sadie Thompson*. For the first time in a while, she had a role that truly showcased her acting ability, and Rita hoped that the film would open doors to more interesting roles. During the location shooting in Hawaii, a spontaneous visit by Dick Haymes helped to buoy Rita's spirits. Rita's performance was grittier and gutsier than anything she had previously done; unfortunately, audiences didn't respond. Although Rita received good reviews for *Miss Sadie Thompson* (which was shot in 3-D), and the musical numbers (dubbed by Jo Ann Greer) were much lustier than those in the average light-hearted musical, the film was not a great success.

▼ Rita and Dick pose for photographs after applying for a marriage license. The strain on their faces can be seen during this unguarded moment. By now, Haymes was exerting an unhealthy control over Rita, reminiscent of her relationship with Ed Judson—except that Haymes had none of Judson's business savvy. But Rita felt that she needed to remain loyal to him, after his visit to the set of *Miss Sadie Thompson* in Hawaii landed him in legal hot water. Haymes, who was born in Argentina, had declared himself a citizen of that country in order to avoid U.S. military service. Hawaii, which at that time was not an American state, was considered out of bounds to aliens, and Haymes had not obtained permission to enter the islands. Hence, he was in trouble with the U.S. Department of Immigration. Rita felt somewhat responsible, and in later years she stated that she only married Haymes to prevent him from being deported.

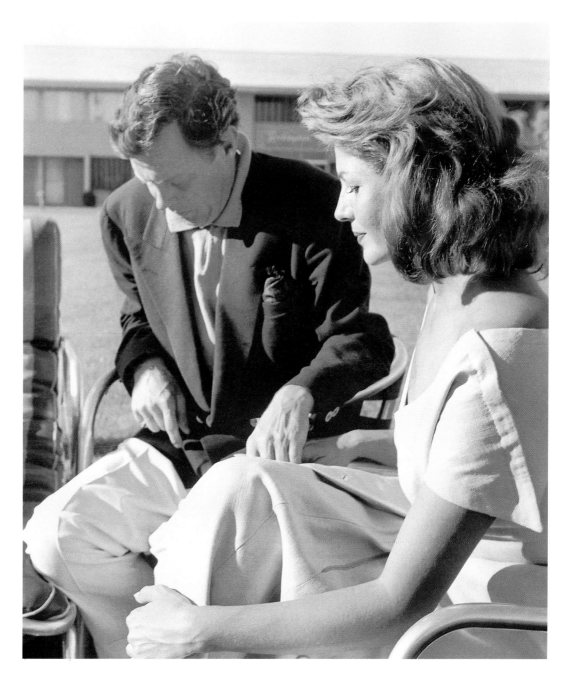

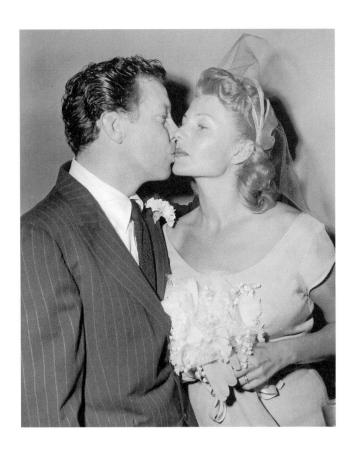

◄ ∨ ► The Sands Hotel in Las Vegas was a far cry from the Château de l'Horizon in Cannes (one news article described it as "a skid into the rhinestones"), but here Rita celebrated her fourth wedding. With Rebecca and Yasmin in attendance, Rita and Dick Haymes were married on September 24, 1953, in a ceremony that took only three minutes. Unlike the 120-pound wedding cake at her third marriage, this four-tiered wedding cake's bottom layers were made of wood, and the Sands Hotel gave itself top billing over the bride and groom. A roomful of photographers and reporters showed up, but Haymes seemed the only truly happy person in the room (his recent booking as a headliner at the Sands may have been an additional reason for his happiness). Rita appeared subdued and nervous, quietly whispering "I love you" to Haymes before they kissed for the small crowd. When asked if Rita had ever cooked for him, Haymes snapped, "Don't be silly. Who would marry Rita for her cooking?" Haymes's problems followed the couple on their honeymoon in New York, where police literally beat at the door of their hotel room to arrest him on charges of not paying alimony to one of his ex-wives. The problem was eventually cleared up, but it was just the beginning of the difficulties Rita would endure in her marriage to the crooner.

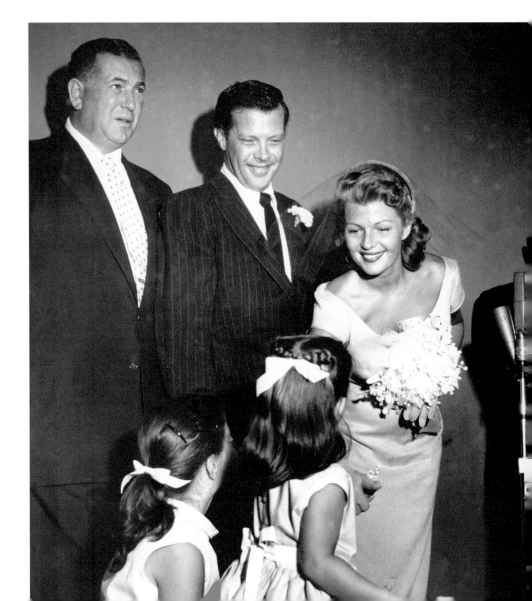

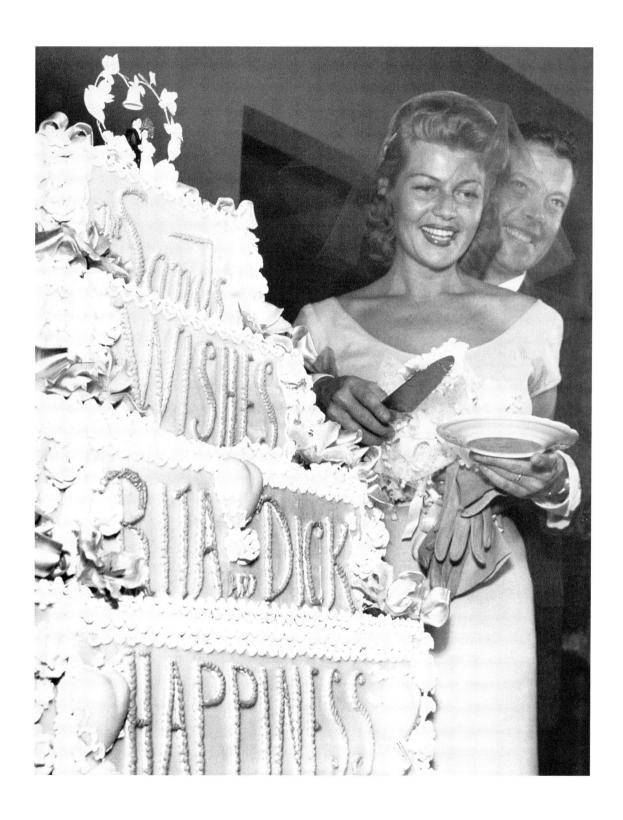

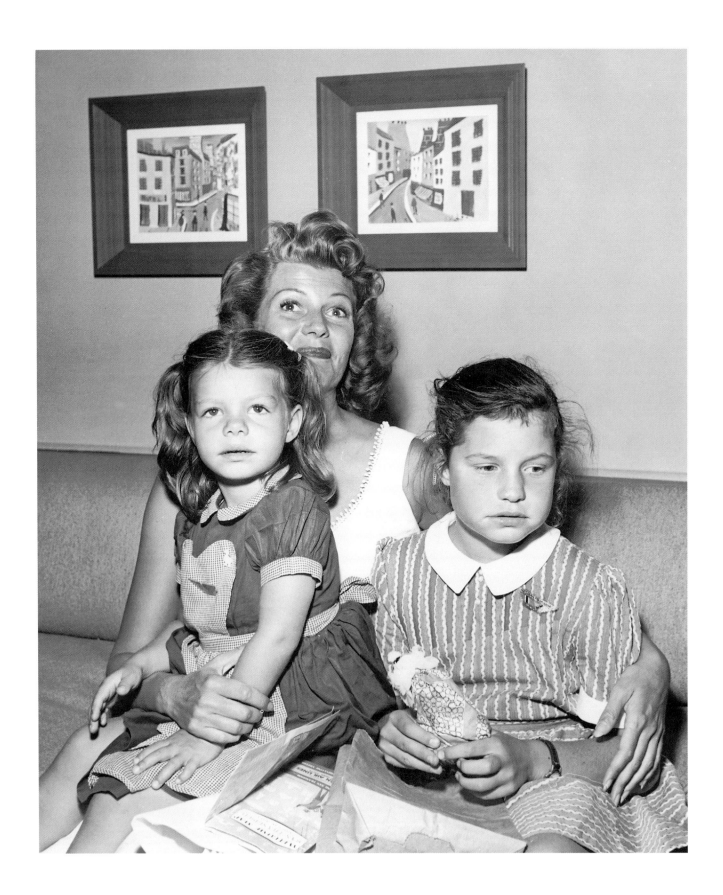

∧ In the midst of the wedding hoopla, Rita received death threats against herself and Princess Yasmin (left), requiring special security for the movie star and her two daughters. Nothing was to come of the threats, but the frightening letters forced Rita, Rebecca, and Yasmin to stay under heavy guard in Rita's Las Vegas hotel room.

Rita and Dick (and little Yasmin) are mobbed by friendly fans shortly after their marriage. Because of the financial problems she and Haymes were experiencing, Rita decided to break her Beckworth Corporation contract with Columbia—she received an immediate payment from the studio by giving up her percentage of her films' profits, but it would eventually cost her hundreds of thousands of dollars in lost revenue. The transaction marked a low point in Rita's career. The creation of the Beckworth Corporation had been a shrewd business move as well as a symbol of her power as a show business superstar. Single-handedly Dick Haymes seemed to be sapping Rita of all of her assets, and she later greatly regretted the decision.

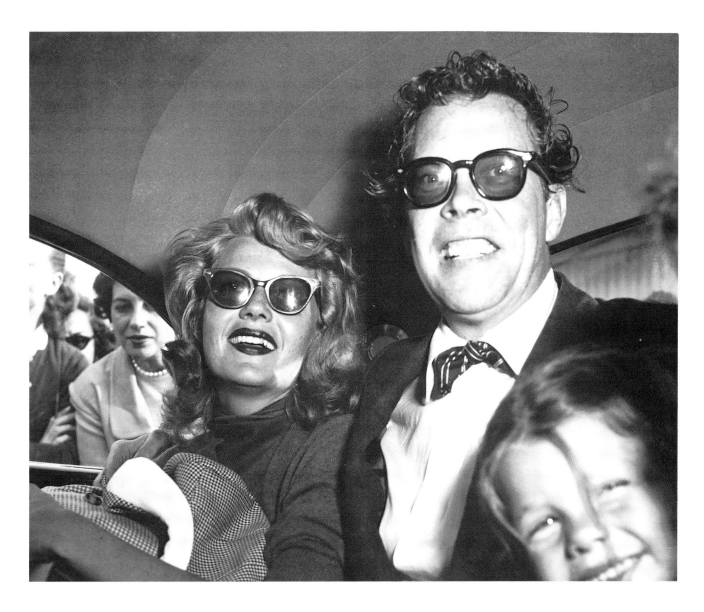

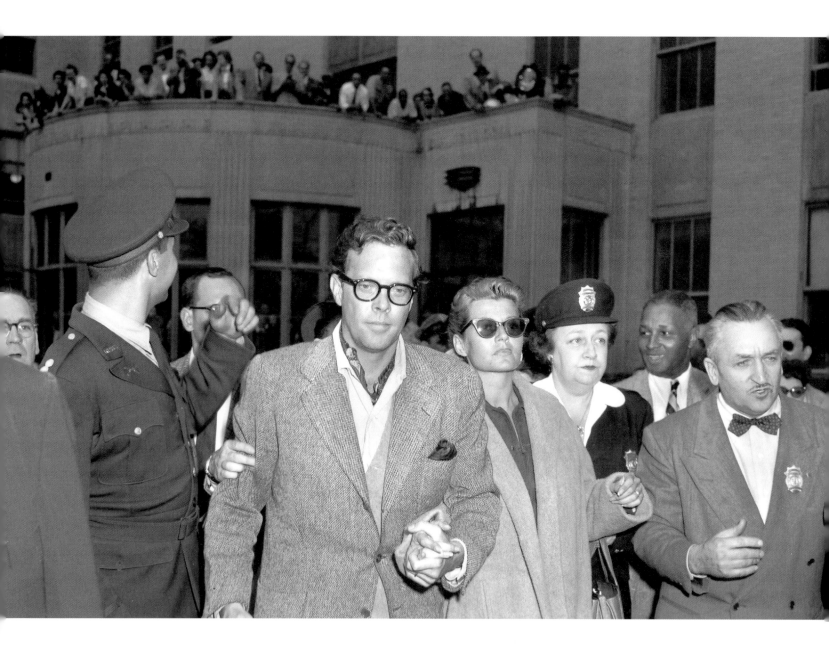

⋀ While in Florida for one of Dick's singing engagements in 1954, Rita left the children in White Plains, New York, in the care of a friend of Haymes's mother, a woman named Dorothy Chambers. Rita assumed she was an adequate governess based on the recommendation of her mother-in-law. Yet no sooner had Dick and Rita reached Florida than Rita was charged with child neglect. Someone in the White Plains neighborhood had seen Yasmin and Rebecca playing unchaperoned outside of Chambers's house in what

appeared to be unsafe surroundings. The Westchester County Society for the Prevention of Cruelty to Children was called in, and Yasmin and Rebecca were taken from the Chambers home. To make matters worse, *Confidential* magazine, the tabloid newspaper of the 1950s, had managed to take and print photographs of the girls playing alone outside. The article stated that Rebecca longed to be in school and that Yasmin was a happy little girl who followed the reporter (who was disguising himself as a would-be tenant) around like a friendly puppy. The article went on

to describe the children's complete freedom and lack of supervision. Rita was devastated. She and Haymes returned to New York immediately to reclaim the girls, but not without a hearing in which both Orson Welles and Prince Aly Khan testified that Rita was a "fit and loving mother." Photographs of Rita coming out of the courthouse showed her distraught with grief, tightly gripping Haymes's hand. Rita had always been extremely devoted to her children, and the episode clearly indicated how much she had allowed the problems of Dick Haymes to consume her.

➤ Upon returning to Hollywood, Rita was scheduled to begin filming a new picture called *Joseph and His Brethren.* She dutifully began the process of costume fittings and hair tests. Haymes, who was becoming increasingly pushy with regard to Rita's career decisions, insisted on playing the part of Joseph, an idea Harry Cohn considered laughable. Because the studio couldn't find a leading man for the role of Joseph, Rita successfully sued Columbia for failing to live up to their contract. The film was never made. Columbia countersued Rita, stating that she had not shown up for work on the film. Only after Haymes was out of Rita's life would she make amends with Columbia.

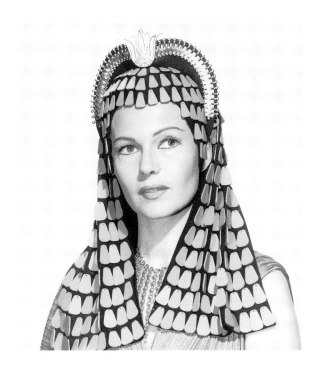

➤ Dick, Rebecca, Rita, and Yasmin frolic at the beach, playing the part of one big happy family. In reality, the children had as little contact as possible with Haymes and in no way considered him a father figure. Rita would leave Haymes shortly after this photograph was taken.

In the aftermath of the child neglect charges—and rumors of physical abuse—Rita took action. She separated from Haymes in August 1955 and fled to New York with Rebecca and Yasmin. The U.S. Immigration Office finally let Haymes off the hook, and she no longer had to feel guilty or responsible for his deportation troubles. Harry Cohn had provided a loan of $50,000 for Haymes's legal fees and debts, a loan which Rita was forced to pay back herself. She would later have little to say about this period in her life, for understandable reasons. In one rare moment of admission, however, she categorized her marriage to Haymes as "the one and only impetuous move I ever made." In the meantime, she signed a custody agreement for Yasmin with Prince Aly Khan that satisfied both her and the prince and would allow Yasmin to see her father more often.

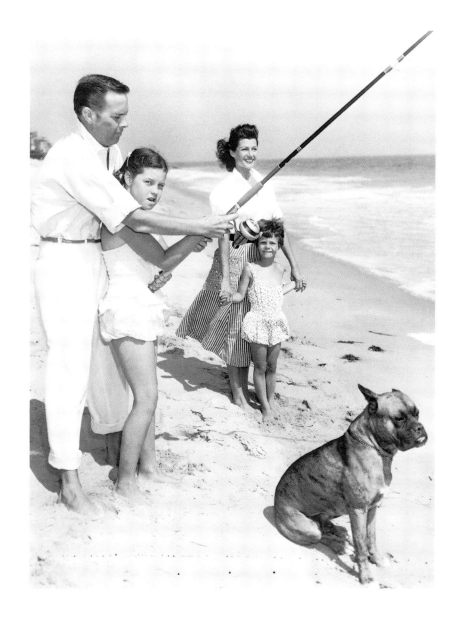

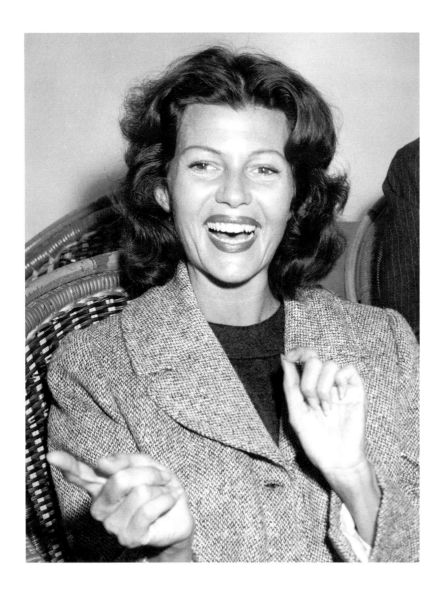

◄ Aboard the *Queen Elizabeth* in September 1955, a clearly relieved and happy Rita fields questions from visiting reporters. She and her two daughters sailed to Europe, and after long separations both Yasmin and Rebecca were going to see their fathers. During her stay, Rita spent some time with Prince Aly Khan, and as usual, the press declared a reconciliation. The truth was that the two had come to be trusting friends. "There were always good feelings between them," Yasmin later recalled, "and although their marriage didn't work, theirs was a truly good relationship." When Rita was called back to Hollywood to negotiate a deal with Columbia, Yasmin and Rebecca stayed with Aly.

∨ Rita spends an evening with a close friend, choreographer Hermes Pan. Pan and Rita's other close friends would often remark on how instinctively Rita would respond to music. Within minutes, the usually reserved Rita would be out of her seat and dancing gaily around the room. With her beloved castanets in hand, Rita would briefly forget her troubles and lose herself in the freedom of dance.

➤ Rita and Princess Yasmin enjoy a snowball fight during a holiday at Megeve in the French Alps.

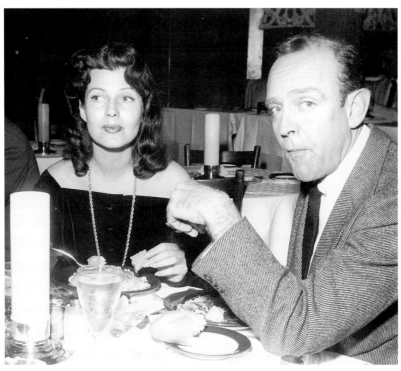

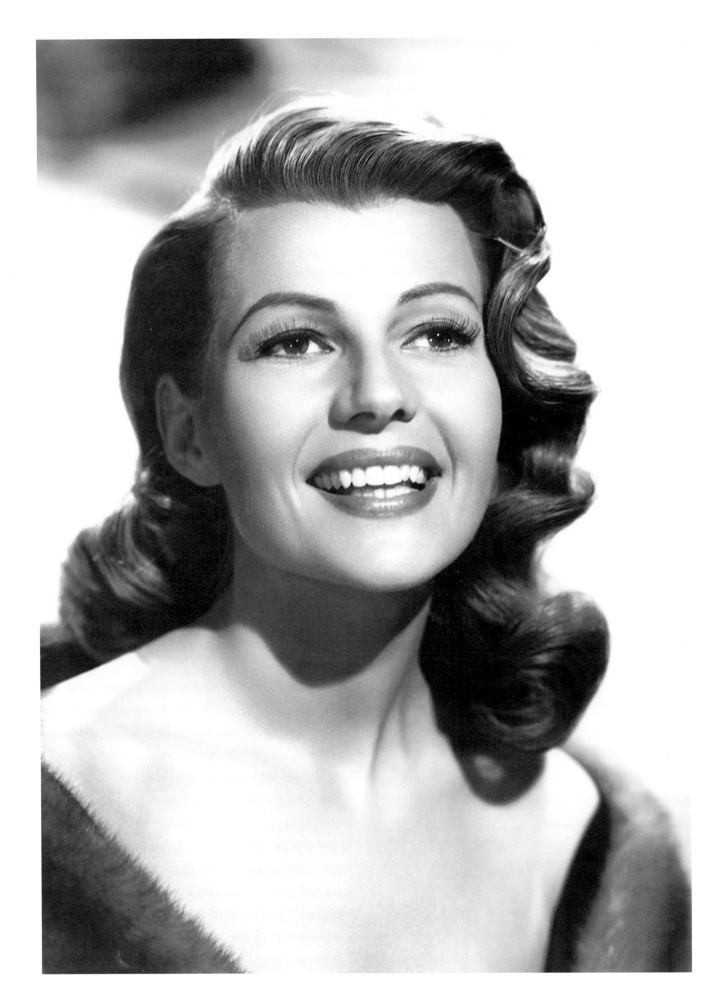

◄ Rita looks as stunning and beautiful as ever in these portraits originally intended to promote *Joseph and His Brethren*; they were later dug out by Columbia and used to publicize her 1957 film *Fire Down Below*.

➤ December 1955 brought Rita back to Hollywood and federal court to finally negotiate a two-picture deal with Columbia. She stated that "many personal pressures" had prevented her from working on *Joseph and His Brethren*, not the least of which was Dick Haymes. During her explanation, she began to cry. Harry Cohn took advantage of Rita's vulnerable position, and she received much less money than she had in the past. For her part, Rita was happy to have only two pictures left before she could turn her back on Columbia forever. After four years of being off the screen, the Love Goddess was back.

At this time Rita also met with Raymond Hakim, an Egyptian movie producer who was interested in starring Rita in one of his films. Hakim's hopes for a film about Isadora Duncan (which would star Rita), possibly with a script by Ben Hecht, dissolved after Rita negotiated her new Columbia contract. Instead, Cohn arranged for Rita to star in a new film called *Fire Down Below* (1957).

➤ Rita is the center of attention as she walks on the deck of the liner *Queen Elizabeth* en route to Trinidad for the filming of *Fire Down Below* in May 1956.

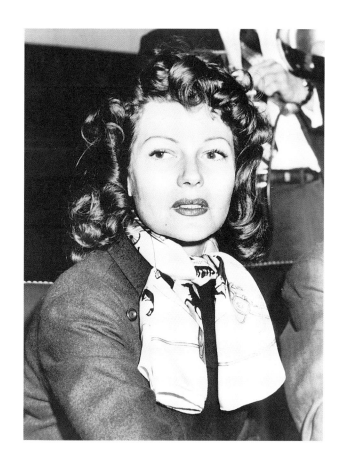

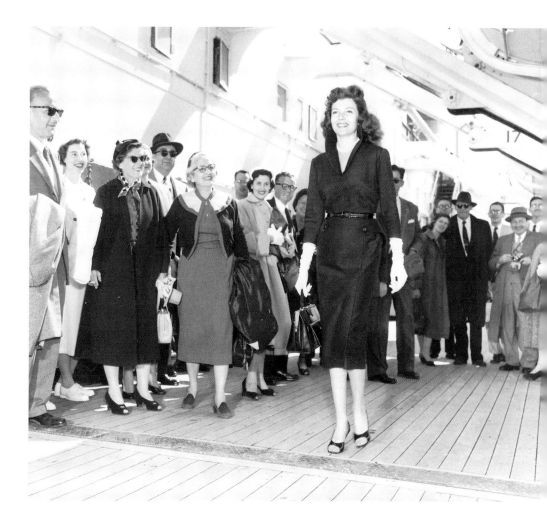

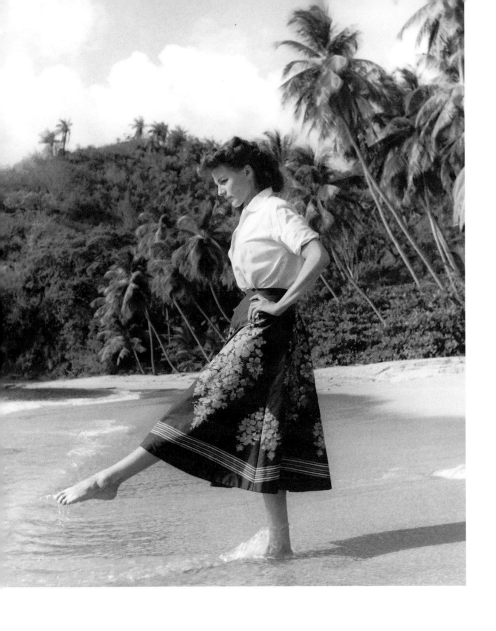

A remote island in Trinidad was just what Rita needed. Starring with professionals such as Jack Lemmon and Robert Mitchum was another attraction, and Rita appreciated their friendship. The fact that Rita had not been in front of the camera for years was not lost on anyone, particularly the producers of the film. One visiting producer who thought the lighting on one of Rita's scenes was taking too long exclaimed, "No matter how long you take, Hayworth ain't gonna look any younger." Rita, who was sitting nearby, burst into tears.

Rita relaxes on the set of *Fire Down Below* with her costar Robert Mitchum. The film was not a commercial success (Rita herself referred to the film as "a pile of junk"), and Rita's one dance number in the film was nothing like the sultry numbers for which she was known. It seemed that Columbia couldn't make a Rita Hayworth film without including the requisite Rita Hayworth *dance*. "I come from a dancing family and enjoy appearing in musicals," she said, "but you have no idea how much I always look forward to roles in which I do not have to rehearse and limber up for months prior to going before the cameras." She hoped that the end of her Columbia contract would allow her to find roles in which she could concentrate on her acting.

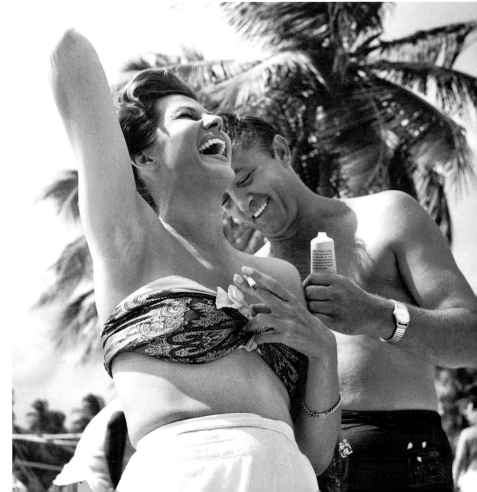

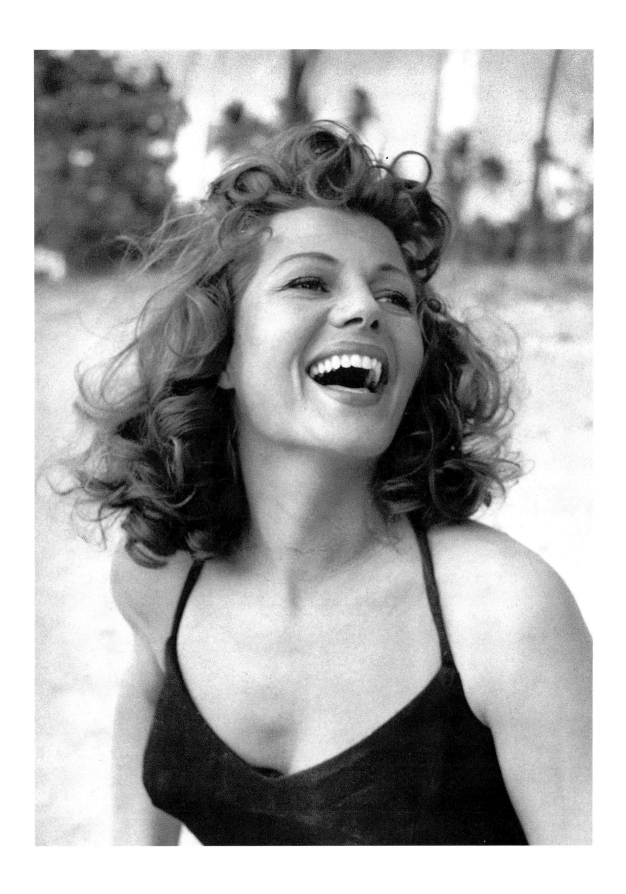

➤ Yasmin and Rebecca stayed with Prince Aly Khan while Rita finished shooting *Fire Down Below* in Trinidad. The crew then moved to London, where Rita and her children had a happy reunion. Jack Lemmon later commented on the relationship between Rita and her two daughters: "It's heartwarming to see Rita with those two kids. I spent a couple of afternoons with the three of them in Rita's flat in Mayfair, and I've never seen a warmer, nicer mother/daughter relationship anywhere." During their London press conference to discuss the film, Mitchum and Lemmon were shocked to hear one tactless reporter ask Rita which name she'd like to be addressed as: Judson, Welles, Khan, or Haymes. Unperturbed, Rita replied matter-of-factly, "Miss Hayworth, if you don't mind."

Rita went on to France after filming ended in order to get in shape for her next role—Vera Simpson, the ex-stripper turned society matron, in the film *Pal Joey* (1957). It would be her last film under the jurisdiction of Harry Cohn and a fitting tribute to her many years at Columbia.

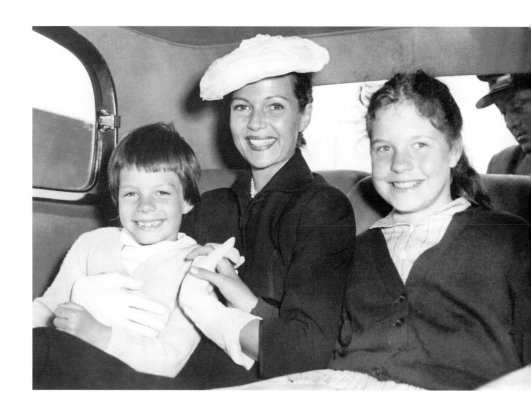

➤ Mother and daughter make a beautiful pair as Yasmin visits Rita on the set of *Pal Joey*.

➤ Rita celebrates the filming of *Pal Joey* with costar Frank Sinatra. Columbia had in fact purchased the film rights for the stage musical years before for Rita Hayworth, when she was going to play the younger woman who wins the leading man. Gene Kelly was to have reprised his Broadway role as the louse, Joey. But the film did not get made at the time, and now Rita was to play the role of the older society hostess, Vera Simpson; Kim Novak played Linda, and Frank Sinatra was Joey. Sinatra was extremely gracious when the subject of billing came up. Expecting fireworks, Columbia executives were surprised when Sinatra conceded top billing to Rita. "Rita Hayworth *is* Columbia," he stated. When asked how he felt about being paired with the team of Novak and Hayworth, he answered, in typical Sinatra style, "I don't mind being in the middle of that sandwich." The movie industry was surprised to find that Kim Novak and Rita got along wonderfully, despite the fact that Novak had replaced Rita as "Queen of the Lot" at Columbia during the time Rita was off the screen. Novak recalled, "Whatever she was feeling inside—because I knew what pressure she was under from Harry Cohn—she wasn't about to let anybody know something was getting to her." By her own admission, Rita was more than happy to pass on her crown and declare her reign over.

➤ Rita gives her hair a quick brushing before filming the "What Do I Care for a Dame?" number with Kim Novak and Frank Sinatra.

⋏ Rita enjoys the attentions of director George Sidney and cinematographer Harold Lipstein during the filming of *Pal Joey*. Rita was made to look rather matronly in the film, despite the fact that she was only thirty-eight years old and still quite young for the part of Vera (in real life she was actually younger than Frank Sinatra). The public didn't care; she stole the show and the film proved to be one of her greatest successes.

➤ "Bewitched, Bothered and Bewildered," Rita's big number in *Pal Joey*, was reminiscent of her earlier films—particularly the "Dearly Beloved" number in *You Were Never Lovelier*—in which she slips into something more comfortable while singing and dreaming about her leading man. Although Rita's vocals were again dubbed (by Jo Ann Greer), "Bewitched" proved that she still had that special something that made her different from any other star, including the young Novak. Here she can be seen filming the number for the cameras (director George Sidney is seated at the far left).

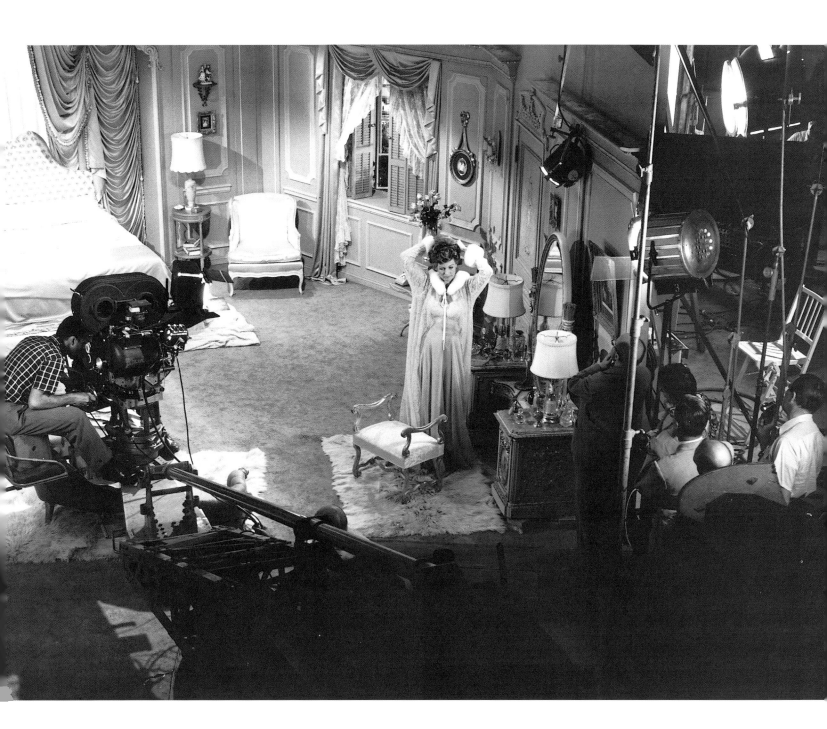

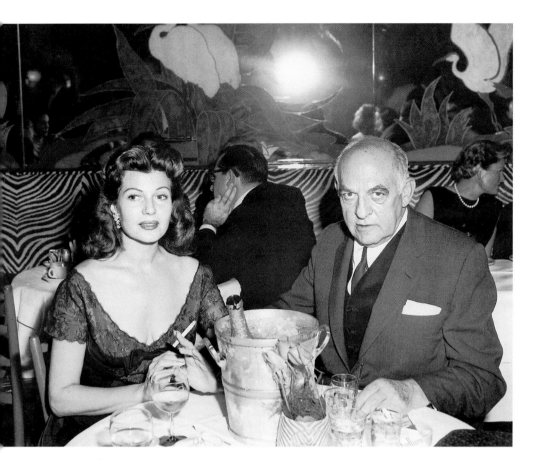

◄ Rita looks uncomfortable as she sits with the stern-faced Harry Cohn at a Hollywood nightspot. Witnesses on the set of *Pal Joey* said that when Rita was performing the "Bewitched" number, Harry Cohn watched wistfully offstage, perhaps contemplating the romance that never was. Now their business relationship was finally over, much to Rita's relief. Many years later, in discussing her relationship with the tyrannical studio boss, Rita revealed, "Power was what he loved. But want to know something? If he could have ever been in love with anyone, I think Harry Cohn was secretly in love with me."

◄ Rita attends the premiere of the film *Around the World in Eighty Days* with George Jessel. Although nothing was to come of their romance, Rita was seen about town for several months with Jessel, a former Broadway star and a fund-raiser in Hollywood. Jessel was an unlikely partner for Rita, but they enjoyed each other's company and, according to Jessel, almost got married after a night of heavy drinking. As they were being driven to Las Vegas for the spontaneous nuptials, Rita, who was sleeping in Jessel's lap, looked up at him and said, "I love you, Phil!" Needless to say, the marriage plans were abandoned.

► The warm relationship between Rita and her younger daughter, seven-year-old Princess Yasmin, can be seen in this photograph taken after Yasmin returned from a six-week visit to her father.

A Free Agent

◄ Arguably at her most beautiful, forty-year-old Rita smiles happily on her way to the Berlin Film Festival in June 1959. The late 1950s would prove to be a fruitful time for Rita, in terms of both her personal and professional endeavors. "I'm in a new phase of my career," she told reporters. "I could have stayed under a studio contract; by not staying, I gave up a lot of money. But I felt that at some point in my life I had to choose my own roles. I looked at all the parts I had done and realized that, no matter how they were sliced, it was still *Salome*."

◄ During the filming of *Pal Joey*, Rita met and began to spend time with producer James Hill, whose production company, Hecht-Hill-Lancaster, was responsible for such films as *Trapeze* and *The Sweet Smell of Success*. Their relationship started on a good note, as they both encouraged each other to pursue their favorite outside interests: for Rita, painting, and for Jim, writing. They shared a love of golf, and Rita appreciated Hill's calm and his willingness to spend quiet time alone with her. Hill also believed that Rita's acting ability had been undervalued, and he set out to find vehicles for her. Rita wanted to take a break from filming, but she was flattered by Hill's confidence in her and wanted to make him happy. She was now a freelance artist, and she recognized the opportunity to make quality pictures.

◄ Rita and Jim Hill sail for Europe shortly after their February 2, 1958, marriage. Rita's relationship with Hill was solid at first, but as Hill would later confess, "I wound up as anxious to use her as all the rest." Ignoring her protests that she wanted to relax, paint, and take a much needed hiatus from filmmaking, Hill pursued serious roles for his wife—in films that would be produced by his company.

➤ In this unretouched publicity
still for *Separate Tables* (1958), Burt
Lancaster's romantic ardor seems to
have given Rita a case of the giggles.
Rita was very proud of the film,
which was produced by Hecht-Hill-
Lancaster. As Ann Shankland, a
woman afraid of losing her beauty,
Rita gave one of her finest perform-
ances. The part reflected her own
feelings in that she, too, like all
actresses who made their livings
off of their looks, feared aging.
Many actresses would have refused
such a part, but Rita looked forward
to becoming a character actress.
She recognized that her looks
would eventually fade, and she
aspired to greater, perhaps less
glamorous, roles. The star-studded
cast of *Separate Tables* included
Burt Lancaster, Wendy Hiller, David
Niven, and Deborah Kerr, and the
film remains a classic.

"I liked the role of Ann because
she had great depth and the part
permitted a good deal of variation,"
Rita later said. It became her favorite
role. The mature contentment she
displayed in the film reflected her
stable marriage. James Hill seemed
the perfect partner for Rita, and
she exuded happiness on and off
the screen.

➤ Burt Lancaster and Rita are
directed by Delbert Mann during
rehearsals for *Separate Tables*.

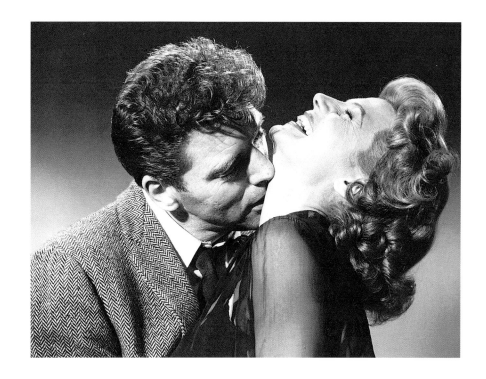

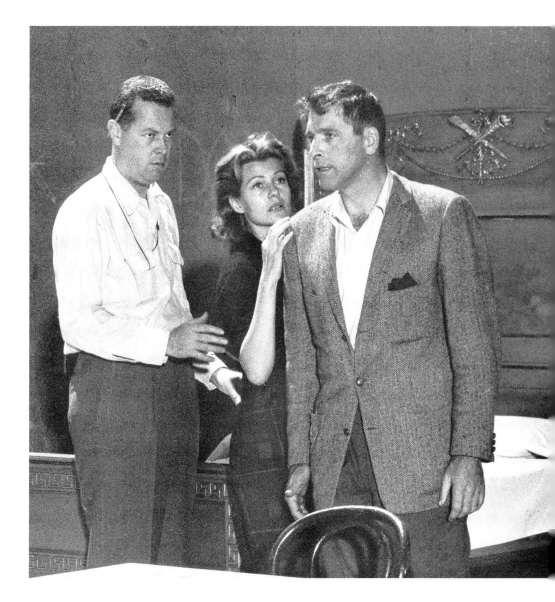

◄ ✔ In her next film, *They Came to Cordura* (1959), Rita again bloomed in the company of another excellent ensemble cast, and at least one reviewer believed that this was the best performance of her career. Her costar, Gary Cooper, who had so often been paired with much younger actresses, appreciated Rita's maturity. The film includes several sensitive and moving scenes between the two of them. Shot on location in Utah, the film was Rita's first western since her Columbia "B"-movie days. Despite her desire to take a break from acting, the film challenged and energized her.

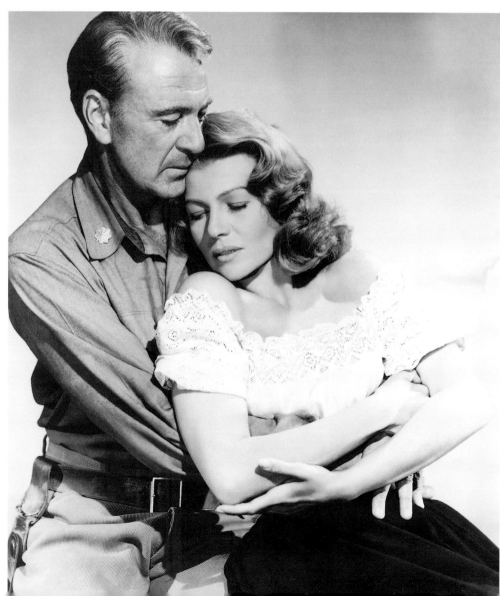

➤ On location, Rita relaxes with James Hill during the shooting of *They Came to Cordura.* Hill's company produced the film, but their business relationship was not helping their marriage. Hill later stated that he could sense Rita's growing resentment during the making of the film. Rita felt used, and the feeling was especially painful because she had been more optimistic about this relationship. She had envisioned growing old together with Hill, but the marriage was simply not working. As Yasmin would later state, "Over a period of time, their relationship turned into almost an alcoholic and drinking partnership." Alcohol did not bring out the best in either of them, and they had explosive arguments. Rita would often not remember the rages and mood swings that were presumably caused by alcohol.

➤ The effects of Rita and Hill's drinking binges and the stress of their relationship can be seen in Rita's face. Hill wanted to have a happy home life with Rita, but he was also an ambitious businessman, and he couldn't resist making use of his wife's talents in his films. He felt there was plenty of time for leisure activities, but only so much time left to make great films and money off of Rita's star power. This conflict would ruin their marriage.

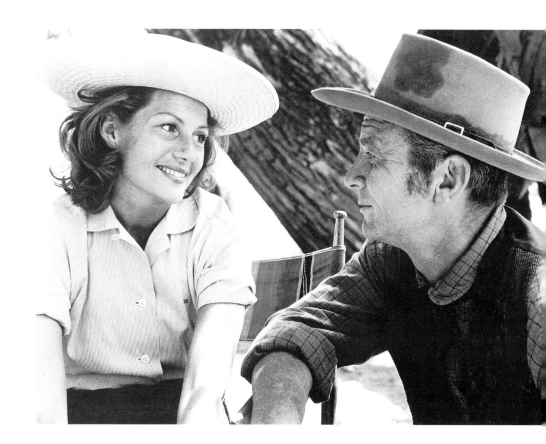

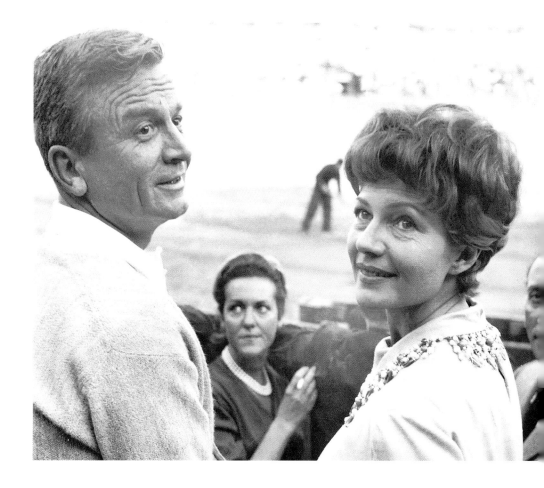

➤ Rita found herself single again at the age of forty-two. Typically, a new love interest was not far on the horizon. Gary Merrill, an accomplished actor and the ex-husband of Bette Davis, became Rita's suitor, and together they traveled through Switzerland, Spain, Hong Kong, and Italy. Their volatile relationship was made worse by heavy drinking; they were often seen walking barefoot in public and arguing loudly in restaurants. Still, Merrill would later remember Rita as his favorite companion.

Together, Rita and Gary set out to conquer an acting medium Rita had yet to try: the Broadway stage. The play *Step on a Crack* both excited and frightened Rita. She had done little in front of live audiences (except for the period when she danced with her father), and she wasn't sure she would be able to memorize the voluminous dialogue necessary. Unfortunately, it turned out that her instincts were correct. Although she was able to save face and back out of the play, she was briefly hospitalized for nervous exhaustion. Merrill, who shared her feelings about the play, still appeared, but the production lasted only one performance.

◀ In 1961, after making two financially unsuccessful films, *The Story on Page One* (1960) and *The Happy Thieves* (1962) (in which Yasmin had a walk-on role), Rita obtained a divorce from James Hill. In court she declared that Hill had said she was "not a nice woman in too loud a voice." Even though they had produced *The Happy Thieves* together (Rita's first venture as a producer under their joint production company, Hillworth), the marriage had been in bad shape for many months.

After the breakup, Rita continued to live in the Beverly Hills home she and Hill had purchased together, and she would remain there for many years. "She wanted that quality of a simple man, of a simple life," Hermes Pan declared. "But she was too big a star." Rita was not proud of the fact that she had married five times, "but it happened that way and that's all there is to it," she stated candidly. "When I look back on my marriages, or the breakups, sure I know the pain I went through, but that's part of life and it has its own value." Even after five failed marriages, she never closed the door on the idea of marrying again. She once joked to a fan that seventeen had always been her lucky number.

❮ Rita's apprehension over a role she realized she could never perform was palpable in meetings for *Step on a Crack*. Here she hides her fear behind a smile as she studies the script. This experience was significant because her difficulties might have been the first, early symptoms of Alzheimer's disease. The inability to remember her lines frightened Rita; in the past she had always been a professional, able to memorize intricate dance routines and long scenes of dialogue. Now she couldn't understand this change in her own behavior. Rita was not diagnosed with Alzheimer's disease until 1981, but her behavior began to change long before then; any strange behavior before her diagnosis was unfortunately construed by others as an alcohol problem.

➤ Rita takes a vacation in Paris, where she purchases hats from a Parisian milliner. Princess Yasmin later recalled that as early as the late 1950s and early 1960s, her mother exhibited odd behavior. "Maybe she'd reorganize her closets—over and over, obsessively. I kept wondering why her clothes were ending up in my closets. I was just a girl. It was almost funny." Yasmin didn't understand until many years later that these inexplicable actions were the early signs of Alzheimer's disease.

∧ Even Rita Hayworth and John Wayne could not save *Circus World* (1964), an epic film that was a poor imitation of Cecil B. DeMille's *The Greatest Show on Earth* (1952). Rita was so anxious to get back to work that she accepted the part without even reading the script. "I knew the writer, the director, and John," Rita later explained, "That's all I had to know. I enjoy working with stim-ulating people." She recognized that the film was going to be a failure, however, and the dual disappoint-ments of that knowledge and the difficulty she was having memorizing her lines often led to drinking. More and more, people viewed her erratic behavior as the result of alcohol; in reality, however, Rita was turning to alcohol out of frustration caused by her undiagnosed disease.

◄ Rita shows off the skimpy costumes from *Circus World*.

∨ Rita presented the award for Best Director at the 36th Annual Academy Awards in 1964. It was a difficult task for her, and she nervously stumbled through her lines. It was the only time she was a presenter at the Oscars.

At the Academy Awards ceremony and dinner, superstar Steve McQueen approached Rita to tell her that she had always been his favorite star. All eyes were upon them as they took to the dance floor that night. The fact that Hollywood's reigning leading man sought her out was a confidence booster for Rita, who sorely needed reassurance that she had not been forgotten. Gina Lollobrigida seems to have eyes only for McQueen.

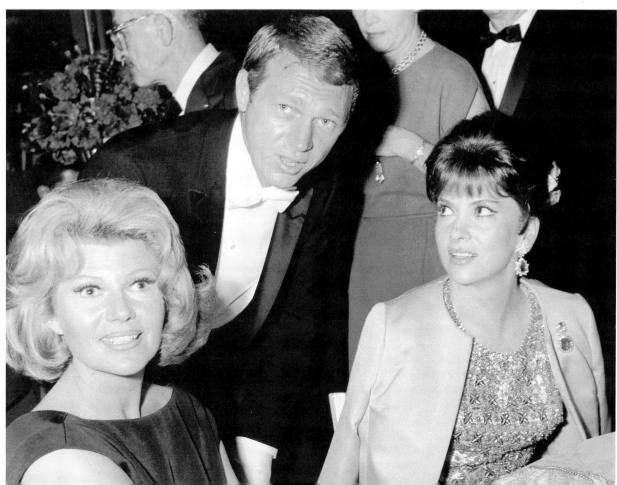

Rita prepares for the "star-at-home" scenes for the 1964 documentary about her life, *The Odyssey of Rita Hayworth*, part of the "Hollywood and the Stars" series produced by David Wolper and Jack Haley, Jr. In a rare audio interview, Rita discussed her rise to stardom, her work ethic, and her thoughts on raising children. Rarely seen today, the documentary presents an insightful look at the real woman behind the movie queen.

Yasmin, Rita, and Rebecca attend a fair in Madrid in 1964. That same year, Rebecca graduated from the Katherine Branson Preparatory School in Marin County, California. She would go on to attend the University of Puget Sound in Washington. "My girls and I have always been together," Rita said. "We've traveled together, lived together—we're everything to each other. I'm strict, they respect me, but I also respect them and we have fun." Rita remained close to both of her daughters, but neither was fond of the limelight and both maintained very private lives as they matured.

> A rare shot of Rita wearing her glasses.

∨ Rita was reteamed with her old love interest, Glenn Ford, in *The Money Trap* (1966), a film that garnered Rita good notices but, unfortunately, did not bring more film offers. One critic described her performance as "flawless." Gone was Rita and Glenn's steamy chemistry of *Gilda*, but in its place was a mature rapport that showed Rita to advantage. It was their last film together.

Rita had remained friends with Ford, and the two were neighbors in Beverly Hills. She laughingly complained that his television antenna spoiled her view: "I could make him take it down, but what the hell!" When Rita appeared on an episode of *This Is Your Life* honoring Ford, she teased him about the tight toreador pants he was forced to wear in one of their previous films, *The Loves of Carmen* (1948). As Ford later recalled, "There was a side of Rita that, because of her shyness, nobody seemed to capture—her sense of humor. She was funny with people she trusted." Indeed, Rita would say in later years that the most important thing to have in show business was a sense of humor. Rita treasured Glenn Ford's friendship her entire life.

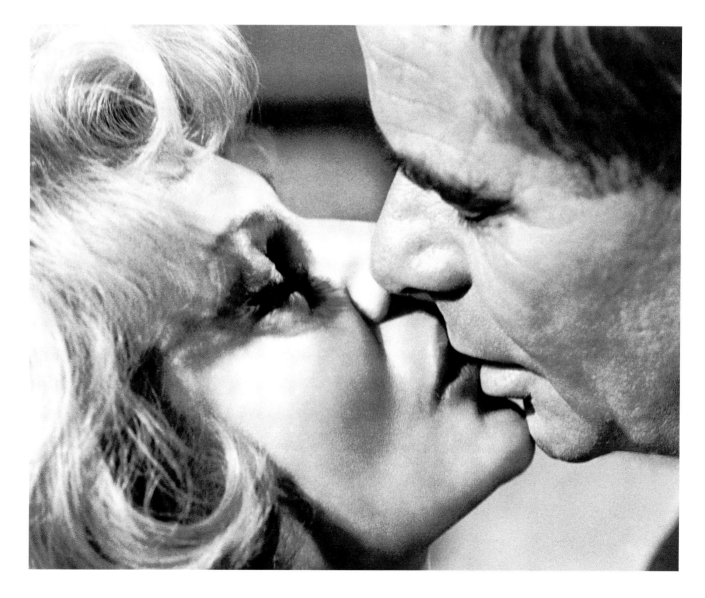

> Rita overlooks the beauty of Sicily while there to promote *The Rover* (1967), a film in which she was paired with her costar from *Blood and Sand*, Anthony Quinn. This was one of the many low-budget films she made because she wasn't able to get work in Hollywood. She entered middle age when middle age wasn't fashionable—actresses such as Joan Crawford and Lana Turner were also accepting roles in small pictures, none of which promoted their careers. Films such as *The Poppy Is Also a Flower* (1966), *Sons of Satan* (1968), *Road to Salina* (1971), and *The Naked Zoo* (1971) were the last films that Rita would make before her final film, *The Wrath of God* (1972). Most of these were never released in the United States. Yet Rita felt that some of her best performances were in these films, and she was disappointed that they were not widely released. Of her 1971 film *Road to Salina* she said, "It was not a big picture but one in which my part had more dimension than anything I've ever done." Rita would often complain that top agents who had at one time clamored for her attention now refused to return her calls.

> Rita, wearing the caftan so popular with older film stars, is interviewed in late 1968 for an NBC program entitled *First Tuesday*, in which she discussed her desire for acting roles that suited her mature status. (She was now fifty years old.)

That same year, Eduardo Cansino died. Rita had not had much of a relationship with her father during her adult years. According to Rita's last husband, James Hill, she even refused to see Eduardo once when he came to their home. "She did not have wonderful, fond, loving feelings towards her father," Yasmin

later stated. Rita resented that her father had made her work so hard when she was young, and she felt that she had not experienced a true childhood; yet she was also proud that she had been the breadwinner of the family at such an early age.

∧ Looking quite chic, Rita poses for a photograph that would accompany a candid newspaper article in 1969. More and more, Rita was asked to participate in "Where are they now?" interviews, which she did not enjoy. She hadn't forgotten the lessons of publicity, however, and often consented to the interviews in order to be seen and perhaps considered for movie roles. But she asked of one interviewer, "Whatever you write about me, don't make it sad."

‹ In *Sons of Satan* (1968), Rita proves that her hoofing talent extended to the modern dances of the 1960s. Rita was quite proud of her performance in this film, small though the role was, and was disappointed that it was not widely released. Rita spoke her own lines in French and Italian for the foreign-language versions of the film.

⌄ William Grefe, director of *The Naked Zoo* (1971), discusses a scene with Rita and costar Stephen Oliver. Grefe later commented that he was surprised at Rita's lack of pretense, considering her past status as a superstar: "I came to the airport to greet a movie star with an entourage and instead there was Rita, alone, even without the maid we had told her to bring along at our expense." *The Naked Zoo*, with its poor plot and gratuitous nude scenes, proved to be an embarrassment for Rita.

In the early 1970s Rita appeared on several television shows that nostalgically looked back at Rita's glamorous days. She made two appearances on *The Merv Griffin Show,* even singing and dancing with Griffin to "I'm Old Fashioned" (from the 1942 Hayworth–Astaire film, *You Were Never Lovelier*). Despite these programs, Rita avoided reminiscing about the past. "It's what's happening now—it's today—not yesterday," she would respond when asked about her years as a superstar.

Rita plays the floozy on *Rowan and Martin's Laugh-In* in 1971. Cohost Dick Martin later recalled, "Rita Hayworth was a wonderful guest on our show. We even took her down the hall at NBC and walked on *The Tonight Show,* surprising the hell out of Johnny Carson. He was a big fan and he talked to her on the air for ten minutes. She said she had fun doing the show and the whole cast loved her. She was a wonderful star."

➤ After having seen a hilarious spoof of *Gilda* (entitled *Golda*) on *The Carol Burnett Show,* Rita called up the comedienne to compliment her. Much to Rita's delight, Burnett asked her to appear on a subsequent show as a guest. Rita sang with her, proud to finally be able to show off her fine singing voice and superb talent as a comedienne. At the end of the show, Rita and Burnett commented on several clips from her films, including the legendary "Put the Blame on Mame" dance from *Gilda.* As they watched the Rita Hayworth of nearly thirty years before captivate the current audience, Carol Burnett asked, "How did you keep that dress up?" "Two good reasons," Rita quipped.

∨ Another chance at a stage production presented itself to Rita in 1971, and she jumped at the opportunity, despite the problems she had experienced with *Step on a Crack*. Lauren Bacall, the star of the Broadway musical *Applause*, needed a replacement for the summer, and Rita was called in. The new casting decision made headlines all over the country, and Rita was understandably nervous about such a heavy project. Again, she had trouble memorizing her lines, and she reluctantly backed out of the show. Rita's press agent at the time, Rupert Allan, explained that the producers miscalculated in hiring Rita, "in not realizing that movie stars without stage experience need much more time to prepare than stage actors." Rita was much more candid: "Listen, when I know that I'm not in shape to do a certain role, I admit it. Why fool myself or anyone else?" Alas, audiences would never see Rita perform on Broadway. For Rita, who had started out performing on the stage, it was an extreme disappointment.

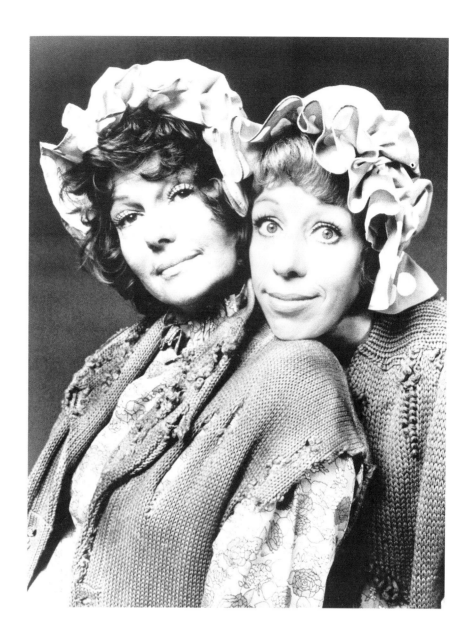

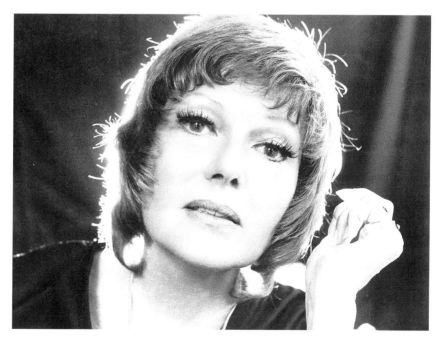

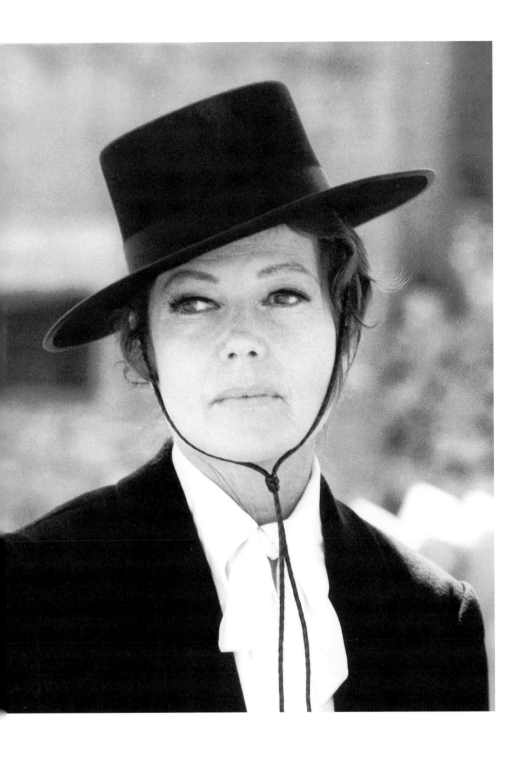

Rita had Robert Mitchum to thank for the part she landed in *The Wrath of God* (1972). Her old pal and costar from *Fire Down Below* felt she was perfect for the part of Señora de la Plata, in a film that poked fun at such westerns as *The Wild Bunch* and *The Magnificent Seven*. For Rita it was a godsend—she was finally working again. Her other costar in the film, Frank Langella, later remembered that Rita had great difficulty with her lines and read from cue cards placed out of camera range. For Rita, the consummate professional, this need for assistance was embarrassing but necessary if she wanted to continue working. Kevin Thomas of the *Los Angeles Times* said of her performance in the film, "Rita Hayworth, elegant and beautiful, fares pretty well. It is unfortunate she is not onscreen more often because she lends *The Wrath of God* a note of dignity it so desperately needs." It would be Rita's last film.

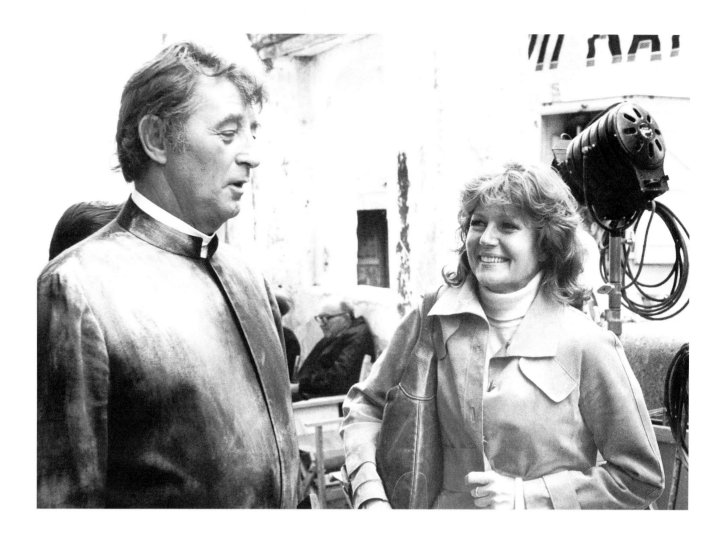

⋀ Rita chats with costar Robert Mitchum on the set of *The Wrath of God.*

➤ A portrait of the mod 1970s Rita. She arrived in London in 1972 to begin shooting a new film, *Tales that Witness Madness*, but she was eventually sued for not showing up for work on the picture. (In an ironic twist, she was replaced by Kim Novak.)

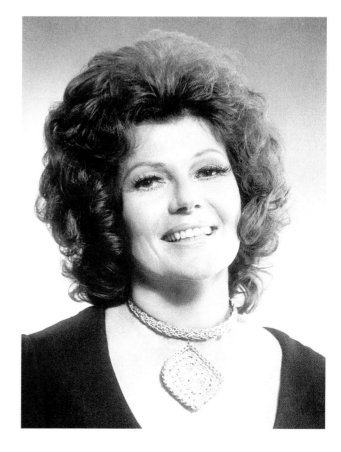

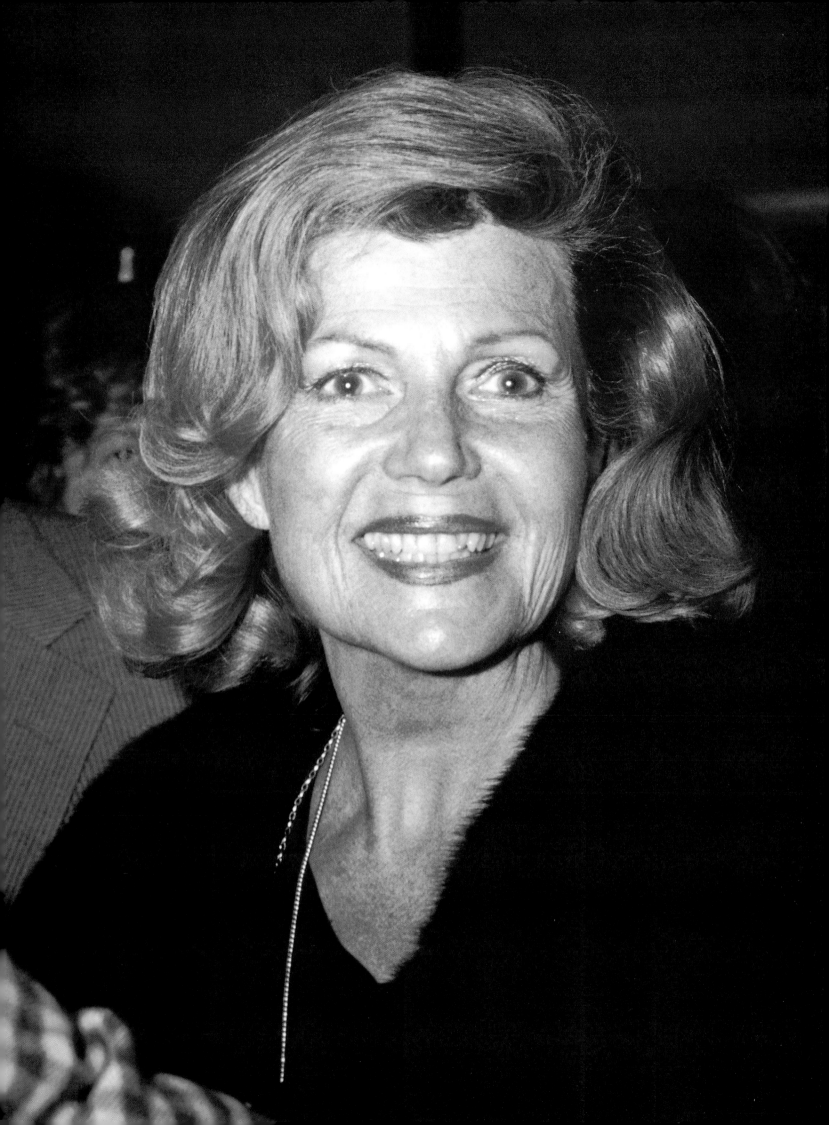

◄ By the mid-1970s, Rita was experiencing real mental handicaps. She had problems with such daily activities as driving a car or riding in an elevator. She had difficulty engaging in simple conversation, often switching from subject to subject incoherently. Movie and television executives knew of her problems and were hesitant to hire her. "Sometimes," Yasmin recalled, "I would tell her about something that happened at school or something about my friends, and she would look at me like I was a stranger and say something completely irrelevant." In 1974 Rita received a double blow when both of her brothers died within a month of each other. Her only family now were her daughters, and she relied on them and her closest friends.

➤ In January 1976 Rita made news all over the world in the first public indication that something was terribly wrong. She was flying to London to appear on a television talk show, but when the plane landed Rita became hysterical and refused to leave the plane. It took the crew thirty minutes to calm her down enough to finally leave. Unfortunately, during that half hour a barrage of reporters and photographers flocked to the airport to take a series of disturbing photographs of Rita, confused and in complete disarray. The headlines screamed that Rita was an alcoholic who desperately needed help. Years would pass before everyone would understand that this incident was clearly the result of Alzheimer's disease.

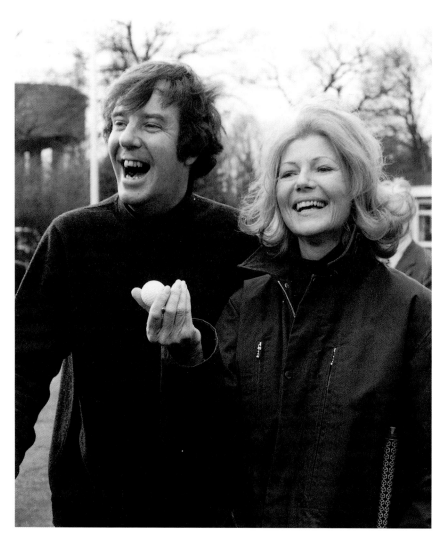

‹ In London two days later, Rita appeared in good spirits and seemed to remember nothing of the previous debacle. She joked with the press while playing golf with the British television personality Russell Harty (shown here). She continued her travels despite her problems, but it was evident to all that she couldn't go on in this state. Soon thereafter, a friend checked her into Hoag Memorial Hospital, in Newport Beach. Doctors pronounced Rita "gravely disabled as a result of mental disorder or impairment by chronic alcoholism."

The Court of Orange County, California, took control over her affairs, but friend and lawyer Leonard Monroe stepped in to help Rita. He checked her out of the hospital and informed Yasmin. Still operating under the assumption that her mother's problem was alcoholism, Yasmin checked Rita into an alcoholic treatment center, the Silver Hill Clinic, in Connecticut.

The doctors at the clinic were shocked to find that even without alcohol, Rita's behavior remained the same. She still had problems remembering the simplest things, and she often didn't recognize some of her closest friends. On one occasion, she even failed to remember former husband, Orson Welles. "My blood ran cold," Welles said, when Rita failed to recognize him at a social function.

ʌ In July 1977 Rita arrived at the Tiffany Theater on the Sunset Strip in Hollywood to enjoy a special screening of two of her films, *Miss Sadie Thompson* (1953) and *Down to Earth* (1947). A large crowd greeted her with massive applause and cheering. She had not been forgotten. She was later presented with a plaque honoring her "outstanding contribution to movies."

➤ At her home in Beverly Hills, Rita is flanked by four of her most loyal friends and companions in the final years of her public life: front row, from left, assistant Judy Ault, Rita, friend Gloria Luchenbill; back row, friend Phillip Luchenbill (who would later be a pallbearer at Rita's funeral) and Rita's attorney, Leonard Monroe. Both publicly and privately, this group spent many happy evenings together. During this time, Rita donned elegant clothes and became a part of the Hollywood social scene again, albeit briefly. Yasmin or frequent escort Mac Krim often accompanied her to various functions. She traveled abroad with friends, and she received several awards for her contributions to film. Rita told reporters that she had been offered film roles and was considering a comeback. She looked stunning. When asked how she wanted to spend the rest of her life, Rita stated, "Do what I'm doing. Work. Be happy. Have health. And hope I didn't make anybody miserable." She seemed to be moving in a positive direction, but as friends would later relate, the vacant, glazed look in her eyes indicated she was simply going through the motions. The reality was that she was becoming more impaired every day. "She had to know," Yasmin would later say. "She had to know her mind was being robbed. It was as if she had mislaid her life."

➤ Rita, Judy Ault, and Mac Krim attend a Hollywood event. For Rita, it was always an honor to sign autographs for her fans.

˄ It was a tremendous comfort
and relief to have her beloved
daughter Yasmin to take care of her,
when Rita had so often felt alone
and frightened.

≺ Rita was the guest of honor at the 22nd Annual Thalians Ball, in November 1977. She was presented with the "Ms. Wonderful" award for her "enduring contributions to films spanning forty years." The evening, which consisted of memories from dozens of costars and clips from her films, was emotional for Rita. She seemed to have come full circle, and although she wasn't working, she was being appreciated for her body of work. When it came time to give her speech in front of the entire audience of peers and fans alike, Rita shyly and softly said, "I don't know what to say . . . just thank you, thank you, thank you."

In the wake of all this attention, Rita's behavior became increasingly puzzling. In 1980 a doctor named Ronald Fieve, professor of clinical psychiatry at Columbia Presbyterian Medical Center, in New York, and medical director of the Foundation for Depression and Manic Depression, suspected that Rita was suffering from Alzheimer's disease, an illness that slowly destroys a person's memory and dismantles the mind. Finally, in 1981, Rita was officially diagnosed with the disease, and the news made headlines all over the world. Yasmin was named conservator of her mother's affairs, and Rita moved to New York to live in an apartment adjoining Yasmin's.

≺ Rita talks about old times with two other stars of the Golden Age of Hollywood, Ann Miller and June Allyson.

➤ By 1981 Rita was no longer seen in public. In her new apartment in New York, she had round-the-clock nursing care and was visited every day by Yasmin. Always nearby in the apartment was a favorite keepsake: a bronze sculpture of Rita's and Prince Aly Khan's hands, palms pressed together and entwined, mounted on heavy black marble. Rita had always proudly declared that it was the one thing Aly wanted to keep after the divorce. After the prince died, Aly's son, Karim, gave it to her. It was one of Rita's most treasured possessions.

Over the years, Rita's physical condition changed little, and Yasmin made sure that Rita was dressed and that her hair was done every day. Rita's new grandson, Andrew, was brought in to visit his grandmother and sit with her on her bed. Undoubtedly, Andrew would have been the light of Rita's life, but her mind continued to slowly deteriorate, and she was hardly able to communicate with those around her. "She can't walk. She can't talk," Yasmin explained at the time. "She can't feed herself. Her swallowing mechanism does not work correctly. Therefore, when we feed her, part of the food will go down into her lungs. Some days she goes from the bed to the shower. Other days she'll have a bed bath. Then we'll dress her, put her in a wheelchair and take her to her special chair in the living room. Her legs and arms go up, and her head goes back. She's more comfortable that way." To Yasmin, it was a torturous and frustrating scene to witness. Eventually, Rita completely lost the capacity for speech. She had brief moments of recognition—sometimes she would come to life when she heard music. Typical of Alzheimer's sufferers, she would often remember events from

her past. Perhaps she was recalling the many dances she performed on the stage as a child and on the screen as the world's Love Goddess. "It's so hard to know what she's feeling," Yasmin said. "I don't know what she can understand, but there are fleeting moments when I'm sure that she's at least a little bit aware. I do know that she needs my love, and in some way I bring her joy."

Eventually, Rita received no visitors. "It's a tragedy that's painful to think about," Glenn Ford said. "We were close friends and I was very fond of her."

Princess Yasmin became the president of Alzheimer's Disease International and vice president of the Alzheimer's Disease and Related Disorders Association (now called the Alzheimer's Association), and she has remained active in the fight against the disabling disease. "My emotional involvement and my desire to do the best that I could for my mother gave me no other choice but to start working with ADRDA, the organization that is doing the most. It was not a major decision," Yasmin stated, "just a natural one." Yasmin's involvement in the organization has been instrumental in bringing national and international attention to the disease. The Rita Hayworth Gala, an annual event coordinated by the Alzheimer's Association and held in New York and Chicago, has already raised millions of dollars in the fight against the disease.

Rita Hayworth spent her last years in a childlike state, and in February 1987, she slipped into a coma. "All I ever wanted to do was to give Rita Hayworth peace in her last years," Yasmin said simply. Rita died on May 14, 1987, just a few weeks before the death of her former costar and dancing partner, Fred Astaire. After Rita's death, Princess Yasmin found among her personal effects a book about losing one's mind. Rita Hayworth had endured the most horrible journey that anyone can fathom.

The world mourned the loss of one of its favorite wartime pinups, one of the last of the great stars of the Golden Era of films, and one of the most beautiful women in the world. Her funeral was well attended by the friends who loved her. A grim-faced Glenn Ford said, "I've lost my best friend in the whole world."

◥ Rebecca and Yasmin place flowers on their mother's coffin. Rita was buried at Holy Cross Cemetery in Culver City, California. Her simple headstone sums up the importance she held for so many family members and close friends: "To Yesterday's Companionship and Tomorrow's Reunion."

Rita Hayworth was so much more than just a queen of the silver screen. Part of her appeal lies in the fact that she was, in real life, the antithesis of a movie star. She wasn't interested in the trappings of fame. She was a real woman, strong and able to take care of herself, but in search of a happiness that, ultimately, eluded her. Through it all she remained a gentle spirit, a loving mother and friend, and a woman of pride. She participated in life with a boundless passion, and she walked away with few regrets. Rita Hayworth also gave, and continues to give, joy to millions of film lovers the world over. That will never stop. Her struggle with Alzheimer's disease and the subsequent publicity surrounding it has allowed millions of sufferers to better understand and cope with their situations. Certainly she has left an inspirational legacy.

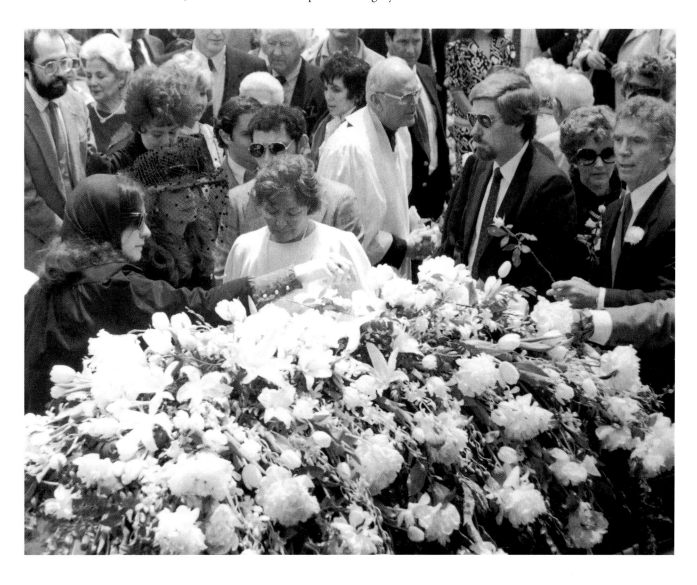

Billed as *Rita Cansino*

Under the Pampas Moon, Fox, 1935.
Produced by Buddy G. De Sylva. Directed by James Tinling. Screenplay by Ernest Pascal and Bradley King, based on a story by Gordon Morris. Camera by Chester Lyons. Edited by Alfred de Gaetano. With: Warner Baxter, Ketti Gallian, J. Carrol Naish, John Miljan, Jack LaRue.

Charlie Chan in Egypt, Fox, 1935.
Produced by Edward T. Lowe. Directed by Louis King. Screenplay by Robert Ellis and Helen Logan, based on the Earl Derr Biggers character. Camera by Daniel B. Clark. Edited by Alfred de Gaetano. With: Warner Oland, Pat Paterson, Thomas Beck, Frank Conroy, Nigel de Brulier.

Dante's Inferno, Fox, 1935.
Produced by Sol M. Wurtzel. Directed by Harry Lachman. Screenplay by Philip Klein and Robert Yost, based on a story by Cyrus Wood as adapted originally by Edmund Goulding. Camera by Rudolph Maté. Edited by Alfred de Gaetano. With: Spencer Tracy, Claire Trevor, Henry B. Walthall, Scotty Beckett, Alan Dinehart.

Paddy O'Day, Fox (distributed by Twentieth-Century Fox), 1935.
Produced by Sol M. Wurtzel. Directed by Lewis Seiler. Screenplay by Lou Breslow and Edward Eliscu, based on their own story. Camera by Arthur Miller. Edited by Alfred de Gaetano. With: Jane Withers, Pinky Tomlin, Jane Darwell, Michael Visaroff, Francis Ford.

Human Cargo, Twentieth-Century Fox, 1936.
Produced by Sol M. Wurtzel. Directed by Allan Dwan. Screenplay by Jefferson Parker and Doris Malloy, based on the novel *I Will Be Faithful* by Kathleen Shepard. Camera by Daniel B. Clark. Edited by Louis R. Loeffler. With: Claire Trevor, Brian Donlevy, Alan Dinehart, Ralph Morgan, Helen Troy.

Meet Nero Wolfe, Columbia, 1936.
Produced by B. P. Schulberg. Directed by Herbert Biberman. Screenplay by Howard J. Green, Bruce Manning, and Joseph Anthony, based on the novel *Fer de Lance* by Rex Stout. Camera by Henry Freulich. Edited by Otto Meyer. With: Edward Arnold, Joan Perry, Lionel Stander, Victor Jory, Nana Bryant.

Rebellion, Crescent, 1936.
Produced by E. B. Derr. Directed by Lynn Shores. Screenplay and story by John T. Neville. Camera by Arthur Martinelli. Edited by Donald Barratt. With: Tom Keene, Duncan Renaldo, William Royle, Gino Corrado, Allen Cavan.

Trouble in Texas, Grand National, 1937.
Produced by Edward F. Finney. Directed by R. N. Bradbury. Screenplay by Robert Emmett, based on an original story by Lindsley Parsons. Camera by Gus Peterson. Edited by Frederick Bain. With: Tex Ritter, Horace Murphy, Earl Dwire, Yakima Canutt, Dick Palmer.

Old Louisiana, Crescent, 1937.
Produced by E. B. Derr. Directed by I. V. Willat. Screenplay by Mary Ireland, based on an original story by John T. Neville. Camera by Arthur Martinelli. Edited by Donald Barratt. With: Tom Keene, Robert Fiske, Raphael Bennett, Allen Cavan, Will Morgan.

Hit the Saddle, Republic, 1937.
Produced by Nat Levine. Directed by Mack V. Wright. Screenplay by Oliver Drake. Based on a book by William Colt MacDonald. Original story by Drake and Maurice Geraghty. Camera by Jack Marta. Edited by Tony Martinelli. With: Robert Livingston, Ray Corrigan, Max Terhune, Edward Cassidy, J. P. McGowan.

Billed as *Rita Hayworth*

Criminals of the Air, Columbia, 1937.
Produced by Wallace MacDonald. Directed by Charles C. Coleman, Jr. Screenplay by Owen Francis, based on an original story by Jack Cooper. Camera by George Meehan. Edited by Dick Fantl. With: Rosalind Keith, Charles Quigley, John Gallaudet, Marc Lawrence, Patricia Farr.

Girls Can Play, Columbia, 1937.
Produced by Ralph Cohn. Directed by Lambert Hillyer. Screenplay by Hillyer, based on the original screen story *Miss Casey at Bat* by Albert DeMond. Camera by Lucien Ballard. Edited by Byron Robinson. With: Jacqueline Wells, Charles Quigley, John Gallaudet, George McKay, Patricia Farr.

The Game that Kills, Columbia, 1937.
Produced by Harry L. Decker. Directed by D. Ross Lederman. Screenplay by Grace Neville and Fred Niblo, Jr., based on an original story by J. Benton Cheney. Camera by Benjamin Kline. Edited by James Sweeney. With: Charles Quigley, John Gallaudet, J. Farrell MacDonald, Arthur Loft, John Tyrrell.

The Shadow, Columbia, 1937.
Produced by Wallace MacDonald. Directed by Charles C. Coleman, Jr. Screenplay by Arthur T. Horman, based on an original screen story by Milton Raison. Camera by Lucien Ballard. Edited by Byron Robinson. With: Charles Quigley, Marc Lawrence, Arthur Loft, Dick Curtis, Vernon Dent.

Paid to Dance, Columbia, 1937.
Produced by Ralph Cohn. Directed by Charles C. Coleman, Jr. Screenplay by Robert E. Kent, based on an original story by Leslie T. White. Camera by George Meehan. Edited by Byron Robinson. With: Don Terry, Jacqueline Wells, Arthur Loft, Paul Stanton, Paul Fix.

Who Killed Gail Preston?, Columbia, 1938.
Produced by Ralph Cohn. Directed by Leon Barsha. Screenplay by Robert E. Kent and Henry Taylor, based on the original screen story "Murder in Swingtime" by Taylor. Camera by Henry Freulich. Edited by Byron Robinson. With: Don Terry, Robert Paige, Wyn Cahoon, Gene Morgan, Marc Lawrence.

There's Always a Woman, Columbia, 1938.
Produced by William Perlberg. Directed by Alexander Hall. Screenplay by Gladys Lehman (and, uncredited, Joel Sayre, Morrie Ryskind and Philip Rapp), based on a short story by Wilson Collison. Camera by Henry Freulich. Edited by Viola Lawrence. With: Joan Blondell, Melvyn Douglas, Mary Astor, Frances Drake, Jerome Cowan.

Convicted, Columbia, 1938.
Produced by Kenneth J. Bishop. Directed by Leon Barsha. Screenplay by Edgar Edwards, based on the story "Face Work" by Cornell Woolrich. Camera by George Meehan. Edited by William Austin. With: Charles Quigley, Marc Lawrence, George McKay, Doreen MacGregor, Bill Irving.

Juvenile Court, Columbia, 1938.
Produced by Ralph Cohn. Directed by D. Ross Lederman. Original screenplay by Michael L. Simmons, Robert E. Kent and Henry Taylor. Camera by Benjamin Kline. Edited by Byron Robinson. With: Paul Kelly, Frankie Darro, Hally Chester, Allan Ramsey, David Gorcey.

The Renegade Ranger, RKO, 1938.
Produced by Bert Gilroy. Directed by David Howard. Screenplay by Oliver Drake, based on an original story by Bennett Cohen. Camera by Harry Wild. Edited by Frederic Knudtson. With: George O'Brien, Tim Holt, Ray Whitley, Lucio Villegas, William Royle.

The Lone Wolf Spy Hunt, Columbia, 1939.
Produced by Joseph Sistrom. Directed by Peter Godfrey. Screenplay by Jonathan Latimer, based on the novel *The Lone Wolf's Daughter,* by Louis Joseph Vance. Camera by Allen G. Siegler. Edited by Otto Meyer. With: Warren William, Ida Lupino, Virginia Weidler, Ralph Morgan, Tom Dugan.

Homicide Bureau, Columbia, 1939.
Produced by Jack Fier. Directed by Charles C. Coleman, Jr. Original screenplay by Earle Snell. Camera by Benjamin Kline. Edited by James Sweeney. With: Bruce Cabot, Marc Lawrence, Gene Morgan, Moroni Olsen, Norman Willis.

Only Angels Have Wings, Columbia, 1939.
Produced and directed by Howard Hawks. Screenplay by Jules Furthman, based on an original story by Hawks. Camera by Joseph Walker. Edited by Viola Lawrence. With: Cary Grant, Jean Arthur, Richard Barthelmess, Thomas Mitchell, Allyn Joslyn.

Special Inspector, Columbia, 1939.
Produced by Kenneth J. Bishop. Directed by Leon Barsha. Original screenplay by Edgar Edwards. Camera by George Meehan. Edited by William Austin. With: Charles Quigley, George McKay, Bill Irving, Eddie Laughton, John Spacey.

Music in My Heart, Columbia, 1940.
Produced by Irving Starr. Directed by Joseph Santley. Screenplay by James Edward Grant, based on his original story, "Passport to Happiness." Camera by John Stumar. Edited by Otto Meyer. With: Tony Martin, Edith Fellows, Alan Mowbray, Eric Blore, George Tobias.

Blondie on a Budget, Columbia, 1940.
Produced by Robert Sparks. Directed by Frank R. Strayer. Screenplay by Richard Flournoy, based on an original story by Charles Molyneux Brown and comic strip characters created by Chic Young. Camera by Henry Freulich. Edited by Gene Havlick. With: Arthur Lake, Penny Singleton, Larry Simms, Danny Mummert, Don Beddoe.

Susan and God, MGM, 1940.
Produced by Hunt Stromberg. Directed by George Cukor. Screenplay by Anita Loos, based on a play by Rachel Crothers. Camera by Robert Planck. Edited by William H. Terhune. With: Joan Crawford, Fredric March, Ruth Hussey, John Carroll, Nigel Bruce.

The Lady in Question, Columbia, 1940.
Produced by B.B. Kahane. Directed by Charles Vidor. Screenplay by Lewis Meltzer, based on a story by Marcel Achard. Camera by Lucien Androit. Edited by Al Clark. With: Brian Aherne, Glenn Ford, Irene Rich, George Coulouris, Evelyn Keyes.

Angels Over Broadway, Columbia, 1940.
Produced by Ben Hecht. Co-directed by Ben Hecht and Lee Garmes. Screenplay and original story by Ben Hecht. Camera by Lee Garmes. Edited by Gene Havlick. With: Douglas Fairbanks, Jr., Thomas Mitchell, John Qualen, George Watts, Ralph Theodore.

The Strawberry Blonde, Warner Brothers, 1941.
Produced by Hal B. Wallis. Directed by Raoul Walsh. Screenplay by Julius J. Epstein and Philip G. Epstein, based on the play *One Sunday Afternoon*, by James Hagan. Camera by James Wong Howe. Edited by William Holmes. With: James Cagney, Olivia de Havilland, Alan Hale, Jack Carson, George Tobias.

Affectionately Yours, Warner Brothers, 1941.
Produced by Hal B. Wallis. Directed by Lloyd Bacon. Screenplay by Edward Kaufman, based on a story by Fanya Foss and Aleen Leslie. Camera by Tony Gaudio. Edited by Owen Marks. With: Dennis Morgan, Merle Oberon, Ralph Bellamy, George Tobias, James Gleason.

Blood and Sand, Twentieth-Century Fox, 1941.
Produced by Darryl F. Zanuck. Directed by Rouben Mamoulian. Screenplay by Jo Swerling, based on the novel *Sangre y Arena,* by Vicente Blasco Ibáñez. Camera by Ernest Palmer and Ray Rennahan. Edited by Robert Bischoff. With: Tyrone Power, Linda Darnell, Nazimova, Anthony Quinn, J. Carrol Naish.

You'll Never Get Rich, Columbia, 1941.
Produced by Samuel Bischoff. Directed by Sidney Lanfield. Screenplay by Michael Fessier and Ernest Pagano. Camera by Philip Tannura. Edited by Otto Meyer. With: Fred Astaire, John Hubbard, Robert Benchley, Osa Massen, Frieda Inescort.

My Gal Sal, Twentieth-Century Fox, 1942.
Produced by Robert Bassler. Directed by Irving Cummings. Screenplay by Seton I. Miller, Darrell Ware and Karl Tunberg (and, uncredited, Helen Richardson), based on the story "My Brother Paul," by Theodore Dreiser. Camera by Ernest Palmer. Edited by Robert Simpson. With: Victor Mature, John Sutton, Carole Landis, James Gleason, Phil Silvers.

Tales of Manhattan, Twentieth-Century Fox, 1942.
Produced by Boris Morros and S.P. Eagle. Directed by Julien Duvivier. Screenplay and original stories by Ben Hecht, Ferenc Molnar, Donald Ogden Stewart, Samuel Hoffenstein, Alan Campbell, Ladislas Fedor, L. Gorog, L. Vadnai, Henry Blankfort, and Lamar Trotti. Camera by Joseph Walker. Edited by Robert Bischoff. With: Charles Boyer, Thomas Mitchell, Ginger Rogers, Henry Fonda, Charles Laughton.

You Were Never Lovelier, Columbia, 1942.
Produced by Louis F. Edelman. Directed by William A. Seiter. Screenplay by Michael Fessier, Ernest Pagano and Delmer Daves, based on the original story "The Gay Señorita," by Carlos Olivari and Sixto Pondal Rios. Camera by Ted Tetzlaff. Edited by William Lyon. With: Fred Astaire, Adolphe Menjou, Leslie Brooks, Adele Mara, Xavier Cugat.

Cover Girl, Columbia, 1944.
Produced by Arthur Schwartz. Directed by Charles Vidor. Screenplay by Virginia Van Upp, adapted by Marion Parsonnet and Paul Gangelin, based on an original story by Erwin Gelsey. Camera by Rudolph Maté and Allen M. Davey. Edited by Viola Lawrence. With: Gene Kelly, Phil Silvers, Eve Arden, Lee Bowman, Jinx Falkenburg.

Tonight and Every Night, Columbia, 1945.
Produced and directed by Victor Saville. Screenplay by Lesser Samuels and Abem Finkel, based on the play *Heart of a City,* by Lesley Storm. Camera by Rudolph Maté. Edited by Viola Lawrence. With: Janet Blair, Marc Platt, Lee Bowman, Leslie Brooks, Florence Bates.

Gilda, Columbia, 1946.
Produced by Virginia Van Upp. Directed by Charles Vidor.
Screenplay by Marion Parsonnet, based on an original story
by E.A. Ellington, adapted by Jo Eisinger. Camera by
Rudolph Maté. Edited by Charles Nelson. With: Glenn Ford,
George Macready, Joseph Calleia, Steven Geray, Joe Sawyer.

Down to Earth, Columbia, 1947.
Produced by Don Hartman. Directed by Alexander Hall.
Screenplay by Edwin Blum and Don Hartman, based on
characters created by Harry Segall for the play *Heaven Can
Wait.* Camera by Rudolph Maté. Edited by Viola Lawrence.
With: Larry Parks, Marc Platt, Roland Culver, James
Gleason, Edward Everett Horton.

The Lady from Shanghai, Columbia, 1948.
Produced, directed, and screenplay written by Orson Welles.
Based on the novel *If I Should Die Before I Wake* by
Sherwood King. Camera by Charles Lawton, Jr. Edited
by Viola Lawrence. With: Orson Welles, Everett Sloane,
Glenn Anders, Ted de Corsia, Erskine Sanford.

The Loves of Carmen, Columbia, 1948.
Produced and Directed by Charles Vidor. Screenplay by
Helen Deutsch, based on the story *Carmen* by Prosper
Mérimée. Camera by William Snyder. Edited by Charles
Nelson. With: Glenn Ford, Ron Randell, Victor Jory,
Luther Adler, Arnold Moss.

Champagne Safari, Jackson Leighter Associates
Incorporated, released by Defense Film Corporation, 1952.
Commentary written by Lawrence Klingman and Jackson
Leighter. Camera by Leighter. Edited by Myron L. Broun.
With: Prince Aly Khan, Jackson Leighter, Lola Leighter.

Affair in Trinidad, Columbia, 1952.
Produced and directed by Vincent Sherman. Screenplay
by Oscar Saul and James Gunn, based on an original story
by Virginia Van Upp and Bernie Giler. Camera by Joseph
Walker. Edited by Viola Lawrence. With: Glenn Ford,
Alexander Scourby, Valerie Bettis, Torin Thatcher,
Howard Wendell.

Salome, Columbia, 1953.
Produced by Buddy Adler. Directed by William Dieterle.
Screenplay by Harry Kleiner, based on an original story
by Kleiner and Jesse L. Lasky, Jr. Camera by Charles Lang.
Edited by Viola Lawrence. With: Charles Laughton,
Stewart Granger, Judith Anderson, Sir Cedric Hardwicke,
Alan Badel.

Miss Sadie Thompson, Columbia, 1953.
Produced by Jerry Wald. Directed by Curtis Bernhardt.
Screenplay by Harry Kleiner, based on the story *Rain,*
by W. Somerset Maugham. Camera by Charles Lawton, Jr.
Edited by Viola Lawrence. With: Jose Ferrer, Aldo Ray,
Russell Collins, Diosa Costello, Harry Bellaver.

Fire Down Below, Columbia, 1957.
Produced by Irving Allen and Albert R. Broccoli. Directed
by Robert Parrish. Screenplay by Irwin Shaw, based on
the novel by Max Catto. Camera by Desmond Dickinson.
Edited by Jack Slade. With: Robert Mitchum, Jack Lemmon,
Herbert Lom, Bonar Colleano, Bernard Lee.

Pal Joey, Columbia, 1957.
Produced by Fred Kohlmar. Directed by George Sidney.
Screenplay by Dorothy Kingsley, based on the musical play
by John O'Hara, Richard Rodgers and Lorenz Hart. Camera
by Harold Lipstein. Edited by Viola Lawrence and Jerome
Thoms. With: Frank Sinatra, Kim Novak, Bobby Sherwood,
Hank Henry, Barbara Nichols.

Separate Tables, United Artists, 1958.
Produced by Harold Hecht, James Hill, and Burt Lancaster.
Directed by Delbert Mann. Screenplay by Terence Rattigan
and John Gay, based on the play by Rattigan. Camera by
Charles Lang, Jr. Edited by Marjorie Fowler and Charles
Ennis. With: Burt Lancaster, Wendy Hiller, Deborah Kerr,
David Niven, Gladys Cooper.

They Came to Cordura, Columbia, 1959.
Produced by William Goetz. Directed by Robert Rossen.
Screenplay by Ivan Moffat and Robert Rossen, based on the
novel by Glendon Swarthout. Camera by Burnett Guffey.
Edited by William A. Lyon. With: Gary Cooper, Van Heflin,
Tab Hunter, Richard Conte, Michael Callan.

The Story on Page One, Twentieth-Century Fox, 1960.
Produced by Jerry Wald. Directed by Clifford Odets.
Screenplay by Odets. Camera by James Wong Howe. Edited
by Hugh S. Fowler. With: Gig Young, Anthony Franciosa,
Mildred Dunnock, Hugh Griffith, Sanford Meisner.

The Happy Thieves, United Artists, 1962.
Produced by Rita Hayworth and James Hill. Directed by
George Marshall. Screenplay by John Gay, based on the
novel *The Oldest Confession,* by Richard Condon. Camera
by Paul Beeson. Edited by Oswald Hafenrichter. With:
Rex Harrison, Joseph Wiseman, Gregoire Aslan, Alida Valli,
Virgilio Texera.

Circus World, Paramount, 1964.
Produced by Samuel Bronston. Directed by Henry Hathaway. Screenplay by Ben Hecht, Julian Halevy, and James Edward Grant, based on an original story by Philip Yordan and Nicholas Ray. Camera by Jack Hildyard. Edited by Dorothy Spencer. With: John Wayne, Claudia Cardinale, Lloyd Nolan, Richard Conte, John Smith.

The Money Trap, MGM, 1966.
Produced by Max E. Youngstein and David Karr. Directed by Burt Kennedy. Screenplay by Walter Bernstein, based on the novel by Lionel White. Camera by Paul C. Vogel. Edited by John McSweeney. With: Glenn Ford, Elke Sommer, Joseph Cotten, Ricardo Montalban, Tom Reese.

The Poppy Is Also a Flower (The Opium Connection), Comet Films, 1966.
Produced by Euan Lloyd. Directed by Terence Young. Screenplay by Jo Eisinger, based on a story idea by Ian Fleming. Camera by Henri Alekan. Edited by Monique Bonnot, Peter Thornton and Henry Richardson. With: E.G. Marshall, Trevor Howard, Senta Berger, Angie Dickinson, Yul Brynner.

The Rover (*L'Avventuriero*)*,* Cinerama, 1967. (Released in the U.S. in 1971.)
Produced by Alfredo Bini. Directed by Terence Young. Screenplay by Luciano Vincenzoni and Jo Eisinger, based on the novel by Joseph Conrad. Camera by Leonida Barboni. Edited by Peter Thornton. With: Anthony Quinn, Rosanna Schiaffino, Richard Johnson, Ivo Garrani, Mino Doro.

Sons of Satan (*I Bastardi*)*,* Warner Brothers–7 Arts, 1968.
Produced by Turi Vasile. Directed by Duccio Tessari. Screenplay by Tessari, Ennio De Concini, Mario Di Nardo, based on a story by Di Nardo. Camera by Carlo Carlini. Edited by Mario Morra. With: Giuliano Gemma, Klaus Kinski, Margaret Lee, Serge Marquand, Claudine Auger.

The Naked Zoo, Film Artists International, 1970. (Released in the U.S. in 1971.)
Produced and directed by William Grefe. Screenplay by Ray Preston. Story idea by Grefe. Camera by Gregory Sandor. Edited by Julio Chavez. With: Fay Spain, Stephen Oliver, Ford Rainey, Fleurette Carter, Willie Pastrano.

Road to Salina (*Sur la route de Salina*)*,* Avco Embassy, 1971.
Produced by Robert Dorfmann and Yvon Guezel. Directed by George Lautner. Screenplay by Lautner, Pascal Jardin and Jack Miller, based on the novel by Maurice Cury. Camera by Maurice Fellous. Edited by Michelle David. With: Mimsy Farmer, Robert Walker, Ed Begley, Bruce Pecheur, David Sachs.

The Wrath of God, MGM, 1972.
Produced by Peter Katz. Directed by Ralph Nelson. Screenplay by Nelson, based on the novel by James Graham. Camera by Alex Phillips, Jr. Edited by J. Terry Williams, Richard Bracken and Albert Wilson. With: Robert Mitchum, Frank Langella, John Colicos, Victor Buono, Ken Hutchison.

Selected Bibliography

"500 Rita Hayworth Mourners Told of Her Shyness and Gentle Nature." *Los Angeles Times*, May 19, 1987.

Addison, Richard. "When Rita Hayworth Said Goodby to Vic Mature." *Photoplay*, March 1943.

Agan, Patrick. *The Decline and Fall of the Love Goddesses*. Los Angeles: Pinnacle Books, 1979.

Amory, Cleveland. "Weekend Jamboree." *This Week*, December 3, 1967.

"An Unfrumptious Wedding." *Time*, October 5, 1953.

Ardmore, Jane. "The Men I Have Loved." *Modern Screen*, October 1968.

———. "I Am Not Yesterday's Magic." *Ladies Home Journal*, 1977.

Astaire, Fred. *Steps in Time*. New York: Harper and Brothers. 1959.

Beatty, Jerome. "Sweetheart of the AEF." *American Magazine*, December 1942.

Breen, Jay. "How Rita Hayworth's Children Were Neglected!" *Confidential*, 1954.

Brown, Peter Harry. *Kim Novak: Reluctant Goddess*. New York: St. Martin's Press, 1986.

"California Carmen." *Time*, November 10, 1941.

Cansino, Eduardo. "She Was a Good Girl." *Modern Screen*, 1948.

Cansino, Vernon. "The Rita You've Never Met." *Movie Show*, August 1948.

Cassini, Igor. "Rita's Greatest Challenge." [n.p.] April 1950.

Charles, Arthur L. "What Now, Princess?" *Modern Screen*, November 1951.

Corwin, Jane. "The Not So Private Life of Rita Hayworth." [n.p.], 1952.

Coughlan, Robert. "The Aga, the Aly and the Rita." *Life*, May 16, 1949.

Davis, Ivor. "Hollywood's Former Glamour Queens: They Don't Want to Fade Away." *Globe and Mail*, Jan. 8, 1971.

Dick, Bernard F. *The Merchant Prince of Poverty Row: Harry Cohn of Columbia Pictures*. Lexington, Kentucky: University Press of Kentucky, 1993.

Dieterle, William. "I Couldn't Be Tough with Rita." *Picturegoer*, 1953.

Douglas, Kirk. *The Ragman's Son*. New York: Simon & Schuster, 1988.

Dunn, Stanley. "We All Believe in Rita." *Picturegoer*, July 18, 1953.

Edgars, Franklin. "She Dances But Prefers Acting." *Movies*, September 1939.

Fairbanks, Jr., Douglas. *The Salad Days*. New York: Doubleday, 1988.

Ford, Charlotte. "Yasmin Khan: My Mother, Rita Hayworth." *McCalls*, May 1987.

Franchey, John R. "Sultry Siren." *Silver Screen*, February 1941.

Friedrich, Otto. *City of Nets*. New York: Harper and Row, 1986.

Goodman, Ezra. *The Fifty-Year Decline and Fall of Hollywood*. New York: Simon and Schuster, 1961.

Graham, Sheilah. "What Really Happened Between Rita and Aly." *Modern Screen*, November 1952.

———. "Cinderella's Tired." *Modern Screen*, February 1953.

———. "Rita and Aly: Two Years Later, Everything's Still Hot and Cold." *Modern Screen*, 1952.

Grant, Neil (compiled by). *Rita Hayworth: In Her Own Words*. London: Hamlyn, 1992.

Hallowell, John. "Rita Hayworth." *Los Angeles Times West Magazine*, June 16, 1968.

———. "Don't Put the Blame on Me, Boys." *New York Times*, October 25, 1970.

Hamilton, Jack. "Out of Bondage." *Look*, 1958.

Handsaker, Gene. "Revisiting Rita Hayworth: Love Goddess of WWII Hits Her 50s." *The Courier-Journal & Times*, October 12, 1969.

Hayworth, Rita (as told to Jane Ardmore). "If I Lived My Life Over." *Cosmopolitan*, November 1963.

———. "This Was My Favorite Role." *Photoplay*, January 1973.

Hendrickson, Paul. "When the Memories Fade." *Washington Post*, April 6, 1989.

Hill, James. *Rita Hayworth: A Memoir*. New York: Simon & Schuster, 1983.

Hirschhorn, Clive. *Gene Kelly*. New York: St. Martin's Press, 1974.

Hopper, Hedda. "Is Rita Hayworth Washed Up in Hollywood?" *Look*, 1949.

Hover, Helen. "Born to Dance Together." *Hollywood*, October 1941.

Jacobi, Ernest. "Rita Hayworth's Comeback." *Screenland*, March 1957.

Jessel, George, and John Austin. *The World I Lived In*. Chicago: Henry Regnery, 1975.

Johansen, Arno. "The Most Fabulous Love Story Ever Told." *Movieland*, May 1949.

Johnson, Grady. "Does Rita Want Career or Love?" *Coronet*, January 1952.

Keyes, Evelyn. *Scarlett O'Hara's Younger Sister*. Secaucus, N.J.: Lyle Stuart, Inc., 1977.

Kleiner, Dick. *Hollywood's Greatest Love Stories*. New York: Pocket Books, 1976.

Kobal, John. *Rita Hayworth: The Time, the Place and the Woman*. New York: W. W. Norton & Co., 1977.

———. *People Will Talk*. New York: Alfred A. Knopf, 1985.

Langley, Roger. "Whatever Happened to Rita Hayworth?" [n.p.] 1969.

Leaming, Barbara. *If This Was Happiness: A Biography of Rita Hayworth*. New York: Viking, 1989.

Liebling, A. J. "The Wayward Press." *The New Yorker*, June 11, 1949.

Loney, Glenn. *Unsung Genius: The Passion of Dancer-Choreographer Jack Cole*. New York: Franklin Watts, 1984.

MacDonald, Alan. "Fascinating Facts About Rita." *Motion Picture*, 1953.

Mann, Roderick. "Goddess of Love Retired—But Not From Loving." *New York World Telegram*, November 6, 1965.

Manners, Dorothy. "How's Rita Hayworth?" *Stage & Cinema*, December 15, 1967.

Maxwell, Elsa. "The Fabulous Life." *Photoplay*, October 1949.

———. "The Girl Who Came Back." *Photoplay*, 1952.

———. "Love Affair." *Photoplay*, 1948.

———. "Transatlantic Call to Rita and Prince Aly." *Photoplay*, 1949.

———. "The Princess Abdicates." *Photoplay*, August 1951.

Maynard, John. "Princess from Brooklyn." *Motion Picture*, 1951.

McBride, Joseph. *Hawks on Hawks*. Los Angeles: University of California Press, 1982.

Merrill, Gary. *Bette, Rita, and the Rest of My Life*. Maine: Lance Tapley, 1988.

Mills, Janet Rae. "The Love Goddess." *Photoplay*, February 1958.

Morella, Joe, and Edward Z. Epstein. *Rita: The Life of Rita Hayworth*. New York: Delacorte Press, 1983.

Morris, Jane. "Is Rita Hayworth Just a Lonesome Gal?" *Movieland*, May 1953.

Mosby, Aline. "Rita Just Can't Take That Welles Genius." [n.p.] October 1, 1947.

"Onward and Upward." *Time*, May 7, 1951.

"Oui, Oui." *Time*, June 6, 1949.

Parish, James Robert, and Don E. Stanke. *The Glamour Girls*. New York: Arlington House Publishers, 1975.

Parker, Susanah. "Love and Rita Hayworth." *Photoplay*, July 1942.

Parrish, Robert. *Hollywood Doesn't Live Here Anymore*. Boston: Little, Brown and Company, 1988.

Parsons, Louella. *Tell It to Louella*. New York: G. P. Putnam's Sons, 1961.

Peary, Danny. *Close-Ups*. New York: Workman Publishing, 1978.

Peary, Gerald. *Rita Hayworth*. New York: Pyramid Publications, 1976.

Proctor, Kay. "The Strange Love." *Movieland*, March 1947.

Quinn, Anthony, and Daniel Paisner. *One Man Tango*. New York: HarperCollins, 1995.

Ray, Aldo. "Oh Oh, What a Gal." *Movie Stars Parade*, August 1953.

Ringgold, Gene. *The Films of Rita Hayworth*. Secaucus, New Jersey: Citadel Press, 1974.

"Rita Hayworth." *Hollywood and the Great Stars*, vol. 4 [n.d.].

Rita Hayworth: Dancing into the Dream. Produced by Arthur Barron and Carolyn King, 60 min., 1990.

"Rita Hayworth: Over Fifty Isn't Over the Hill!" *Hollywood*, April 1973.

"Rita Revisited." *Modern Screen*, February 1968.

"Rita's Back at Work." *Toronto Daily Star*, September 23, 1967.

St. John, Michael. "Rita Hayworth: Yesterday, Today and Tomorrow." *TV Stars Parade*, July 1975.

Sargeant, Winthrop. "The Cult of the Love Goddess in America." *Life*, November 10, 1947.

Silverman, Stephen M. *Dancing on the Ceiling: Stanley Donen and His Movies*. New York: Alfred A. Knopf, 1996.

Stanke, Don. "Rita Hayworth." *Films in Review*, [n.d.].

Terry, Polly. "I Have No Regrets." *Photoplay*, June 1972.

Thomas, Bob. *Astaire: The Man, The Dancer*. New York: St. Martin's Press, 1984.

———. *King Cohn*. New York: G. P. Putnam's Sons, 1967.

Vidor, Charles. "Exciting Woman." *Photoplay*, August 1946.

Waterbury, Ruth. "The Romance Hollywood Doesn't Like." *Photoplay*, November 1942.

Wayne, Jane Ellen. *Cooper's Women*. New York: Prentice Hall Press, 1988.

Wilkerson, Tichi, and Marcia Borie. *The Hollywood Reporter*. New York: Arlington House, 1984.

Wilson, Earl. "This We Swear." *Motion Picture*, 1953.

Winner, Karen. "A Star Always Shines." *W*, October 4, 1974.

"Yasmin." *Time*, January 9, 1950.

Acknowledgments

My dream for a photo book about Rita Hayworth began about 1986, and now, fifteen years and thousands upon thousands of photographs later, the dream has finally been realized. I would like to thank the many people who assisted me in this endeavor.

I'd like to thank my sweet husband, Paul Frenzel, and my two little sweethearts, Rita and John, for being so patient, supportive, and loving.

At Harry N. Abrams, Inc., I'd like to thank publisher Paul Gottlieb for his initial interest in the project. As my editor, Nicole Columbus was always very pleasant, supportive, and, most of all, extremely tolerant of my many questions! I'm very thankful to her for all the ways in which she helped me. Maria Miller designed the book exactly as I had always dreamed it would look—thank you, Maria! Many thanks also to director of photo and permissions John Crowley and senior editor Elisa Urbanelli.

Choosing the photographs for this book was one of the most difficult and enjoyable tasks I've ever undertaken. Because I'm also a collector of original photographs of Rita Hayworth, I was like a kid in a candy store every time I visited a research facility or photographic archive. My goal was to present photographs that have rarely been seen, which show Rita Hayworth as the sensitive, warm human being she was, and not to bring out the same photos of Rita that have been floating in and out of publications for the last twenty years. In some instances this was impossible, as in the case of Rita's famous World War II pinup. But in most cases, I was able to find lesser-known images that were even more interesting than the ones most often seen by the public. Many of these were from my personal collection, but others were culled from various archives, news agencies, and personal photographers. I'd like to thank the following people and institutions for their invaluable assistance: Michael Shulman, Arlene Santos, Mitch Blank, and Kathy Lavelle at Archive Photos; Bill Fitzgerald and Jorge Jaramillo at Wide World Photos; Ed Colbert; Darlene Hammond; Bob Scott; Bob Cosenza at the Kobal Collection; Tiffany Miller, Mark Porcelli, and Kevin Rettig at Corbis/Bettmann; Harriet Culver at Culver Pictures; Howard Mandelbaum and Ron Mandelbaum at Photofest; Tom Gilbert at Time/Life Syndication; Ray Whelan, Jr., at Globe Photos; Elizabeth Kerr at Camera Press, London; and Gloria Luchenbill, whose help, enthusiasm, and encouragement mean so much to me.

I would also like to express my thanks to the following people for the many different ways in which they've helped and supported this project: Peter and Laurie Frenzel, Cathy Hoeffel, Sonja Dapper, Sonja Sanda, Sue Steveken, Robin Van Horn, and Terri Santoorjian; Jeanine Basinger at Wesleyan Cinema Archives; Roger Nelson, whose encouragement and special attention I've never forgotten; Gregory Economos and Christa Medeiros (legal assistant extraordinaire!) at Sony Pictures; Suzanne Vaughan; Greg Sebald of Merchant & Gould; and Elias Savada of Motion Picture Information Service.

Special thanks to Princess Yasmin Aga Khan and her assistant, Victoria Mahairas.

Photograph Credits

All photographs are Collection of the Author except as otherwise noted below. Photographs listed by photographer are all Collection of the Author. Every effort has been made to locate and obtain permission from owners and photographers; please contact the author with any errors or omissions.

AP/Wide World Photos: 78 (top); 133 (top); 148 (bottom); 158 (top); 161 (bottom); 162 (bottom); 170 (top); 185; 187 (bottom); 190 (top); 203 (top); 209; 218 (top); 221; 224; 225; **Archive Photos:** 46 (bottom); 56 (top); Fotos International: 80 (bottom); Hulton Getty: 104 (bottom); 113 (top); Photo Gene Lester: 133 (bottom); 147 (top); 152 (bottom); 178 (bottom); 179; **Ed Colbert:** 207 (top); **Collection of the Author/Acme:** 142 (bottom); 149 (top); 153 (top); **Collection of the Author/Camera Press:** 201 (bottom); 203 (bottom); 208 (top); **Collection of the Author/Courtesy of Columbia Pictures and Sony Pictures Consumer Products:** 3; 38 (bottom); 42; 48; 55 (top); 60; 61; 70; 71 (bottom); 73 (top); 84–85; 86; 90 (bottom); 91; 92; 99 and endsheets; 104 (top); 107; 108; 116; 118 (top, bottom); 119 (top); 120; 121; 124 (top, bottom); 129 (top); 136 (top,

bottom); 137 (left, right, bottom); 140–41; 145; 148 (top); 150; 167; 168; 169 (top); 176; 188 (top); 190 (bottom); 200 (bottom); 226; Photo Robert Coburn: 19; 88 (bottom); 90 (top); 112; 113 (bottom); 122 (top); 123; 131; 134; 146 (top); 186; 192 (left); Photo Robert Coburn, Jr.: 200 (top); Photo Eddie Cronenweth: 119 (bottom); 125; 138; 139 (top, bottom); 146 (bottom); 147 (bottom); 165; 169 (bottom); 191 (bottom); 193; Photo Ellison: 128; Photo Don English: 89 (bottom); Photo Tad Gillum: 106 (bottom); Photo Irving Lippman: 44; 45; 76 (bottom); 166; Photo Shirley V. Martin: 122 (bottom); Photo M. B. Paul: 37; 54; 55 (bottom); 58 (bottom); Photo St. Hilaire: 106 (top); 109; 110 (top); Photo A.L. Schafer: 41; 49 (bottom); 51; 53; 63; 59; Photo Ned Scott: 6; 97; 100; 101; 105; 126; 129 (bottom); 130 (top, bottom); 132 (and front cover); **Collection of the Author/Globe Photos:** 184 (bottom); 212 (top); 218 (bottom); 222 (top, bottom); **Collection of the Author/INP:** 156; 160 (top, bottom); 183 (bottom); **Collection of the Author/Gloria Luchenbill Archives:** 220 (top); **Collection of the Author/Pictorial Parade/Archive Photos:** 189 (and back cover); **Collection of the Author/ TimePix:** 111 (bottom); 143 (bottom);

161 (top); 164 (top, bottom); 206 (bottom); **Collection of the Author/ UPI:** 202 (top); 208 (bottom); 219; **Collection of the Author/AP/Wide World Photos:** 142 (top); 153 (bottom); 155; 157 (top); 174 (bottom); **Courtesy Collection of Gloria Luchenbill:** 223; **Corbis-Bettmann:** 32 (left); 39 (UPI); 102 (right); 103; 154 (bottom); 157 (bottom); 162 (top); 171 (top); 172 (UPI); 178 (top); 182; 194 (top); 195; 196; 198 (top); **Culver Pictures:** 32 (right); 69 (top); 71 (top); 83 (top); 110 (bottom); 111 (top); 144 (left); Photo Bell: 175; 176; Photo Madison Lacy: 64 (top); Photo Charles Rhodes: 80 (top); Photo A. L. Schafer: 57; **Globe Photos:** 181; 206 (top); **Darlene Hammond:** 191 (top); 194 (bottom); 220 (bottom); **Kobal Collection:** 10; 15; 16 (bottom); 25 (top, bottom); 27; **Gene Kornman:** 30; 35; 36 (bottom); **Photofest:** 26; 56 (bottom); 98; 127 (top); 158 (bottom); 212 (bottom); 159; 174 (top); 187 (top); 198 (bottom); 201 (top); 202 (bottom); 205 (bottom); 212 (bottom); Photo Irving Lippman: 46 (top); 47; 86 (top); Photo Len Weissman: 94; **Bob Scott:** 216; **TimePix:** Photo Robert Landry: 73 (bottom); 75; Photo Tony Linck: 143 (top); March of Time: 96; Photo Peter Stackpole: 62; 114; 115; **Laszlo Willinger:** 50

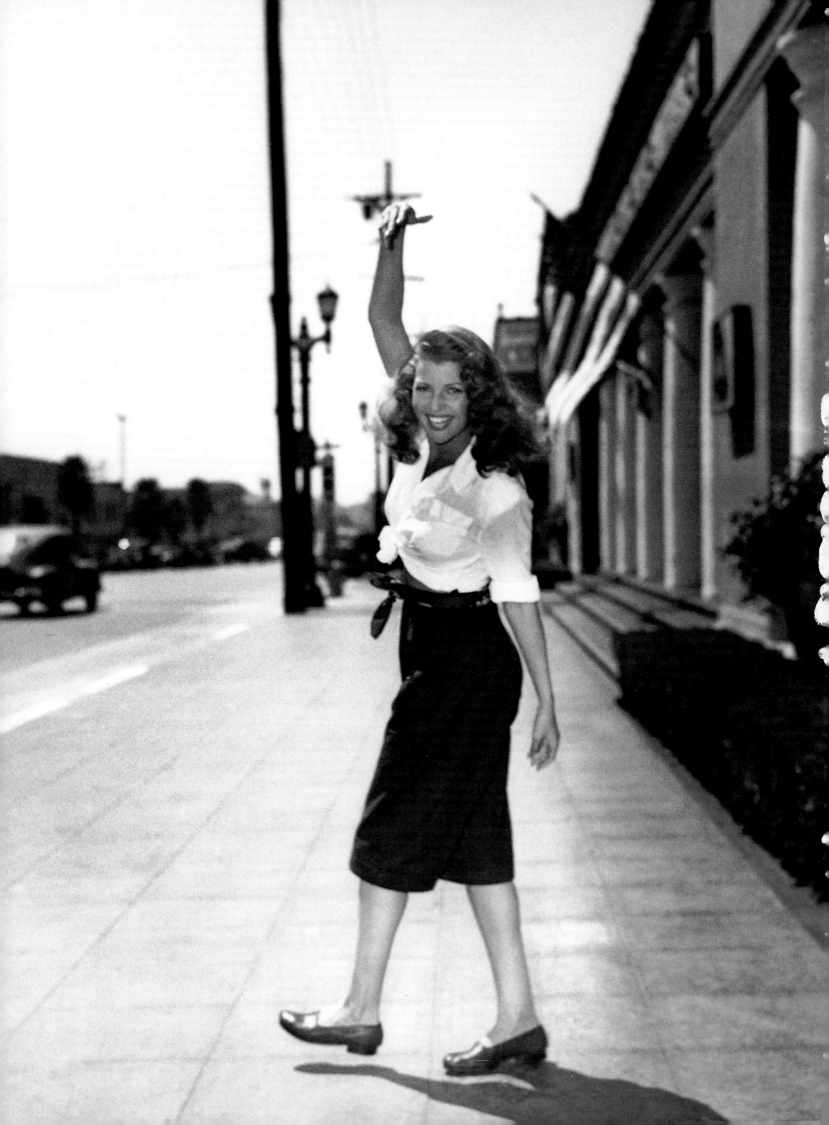

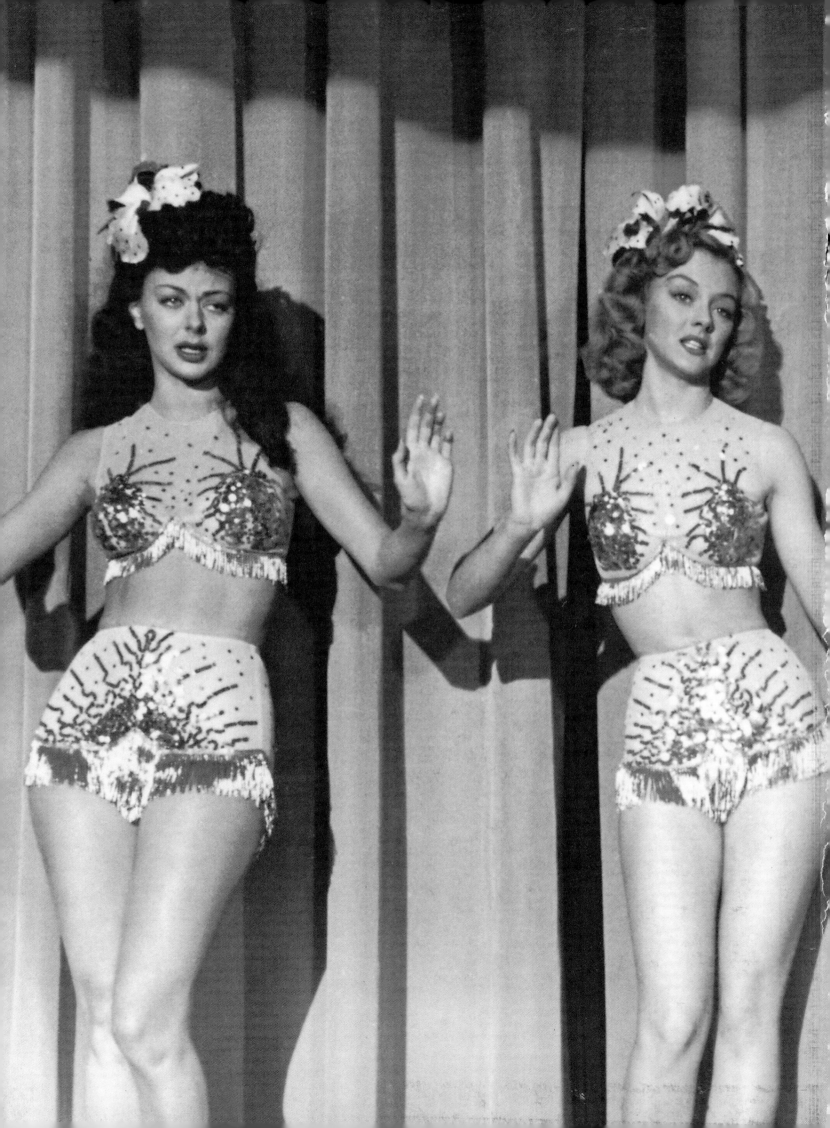